EDWARD WESTON THE EARLY YEARS

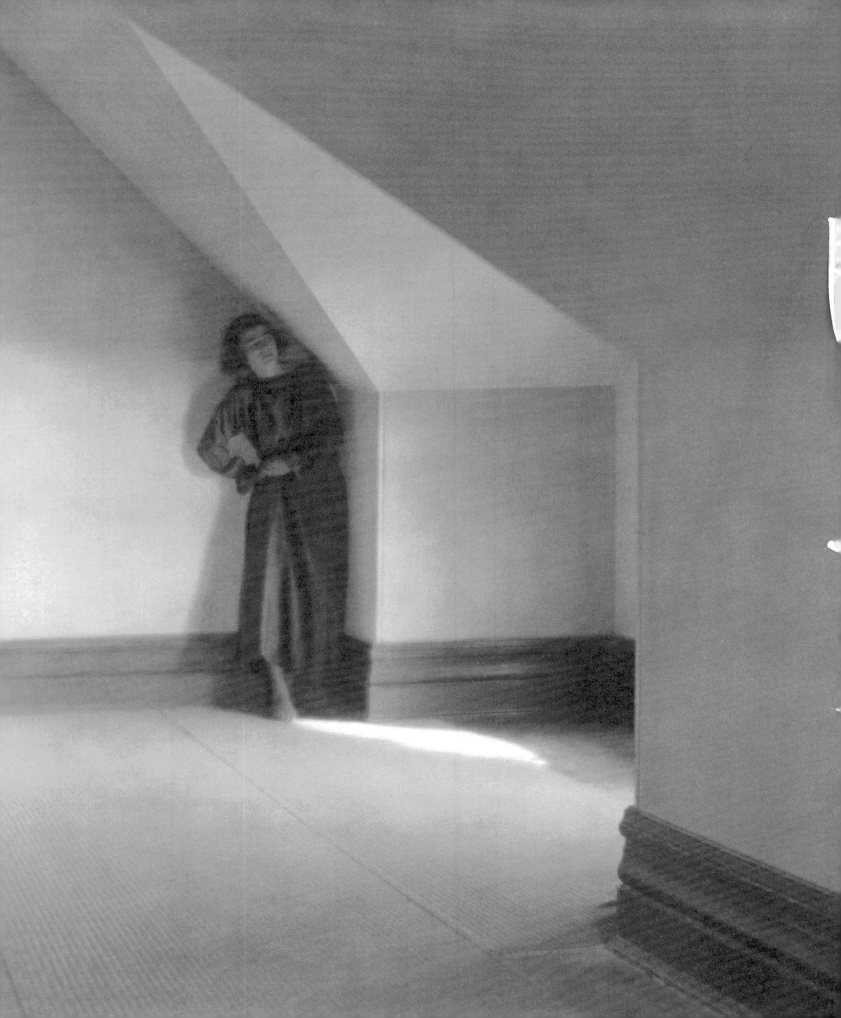

EDWARD WESTON THE EARLY YEARS

KAREN E. HAAS

WITH MARGARET WESSLING

MFA PUBLICATIONS | MUSEUM OF FINE ARTS, BOSTON

CONTENTS

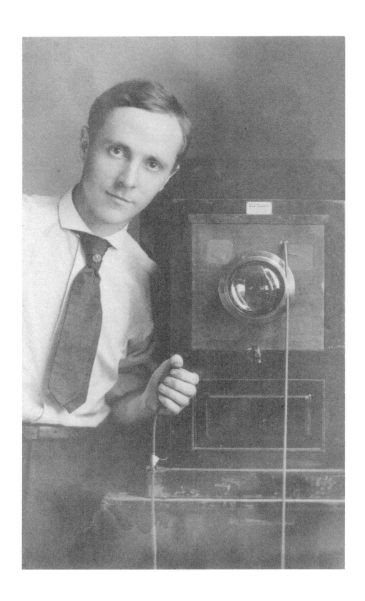

Fig. 1 *Self-Portrait with Camera*, 1908

PROLOGUE: BECOMING EDWARD WESTON

Most accounts of Edward Weston's career as a photographer begin with his years in Mexico, 1923 to 1926 — a period during which he is understood to have become the celebrated American modernist we know today.[1] Weston himself contributed to this version of his history: In 1925 he destroyed large numbers of his early negatives, prints, and daybook journals, resulting in an almost wholesale erasure of his first two decades of work. Yet during the artist's formative years before 1923, while he was working in Chicago and Los Angeles, he received the first serious acclaim for his photography and produced an impressive corpus of varied, experimental, and forward-looking imagery.

At several points later in his life, Weston revisited this time and re-evaluated the photographs he created during it. His landmark retrospective exhibition at the Museum of Modern Art in New York in 1946 was only the second such large-scale monographic photography show at the museum. For Weston it was a crowning success, but also a critical moment for looking back from the perspective of four decades and taking stock of his career. Although the exhibition featured more than 250 works in all, only seventeen of them represented his first twenty years as a photographer. In a letter from 1945, Weston recounts having to borrow one of his own early platinum prints for the exhibition: "For the first time I have wanted to buy a Weston! I have no examples of the period 1913–20; I destroyed even the negatives, it was part of a mistaken past. Now I realize my mistake in destroying the past."[2]

In 1950, Weston undertook to compile his daybooks with the help of his friend and editor Nancy Newhall, a project that would not find a publisher until some years after his death.[3] These journals combined detailed records of his professional work with diary entries about events in his personal life, and ran until the mid-1930s. In the course of this project, Weston managed to locate only a handful of pages that survived from the period before he left for Mexico in 1923, but it nevertheless gave him the opportunity to reconnect with friends and colleagues from that formative period, including Margrethe Mather.

And finally, in the early 1950s, suffering from Parkinson's disease and no longer able to make new work, Weston embarked on the creation of more than eight hundred Project Prints of his best-known images, produced under his supervision and printed in the darkroom by his son Brett.

The surviving daybooks provide insights into his artistic motivations and chronicle the inner workings of his mind, unlike sources available for any other photographer of the period. But because most scholarship has relied so heavily on these journals, it often passes over these early decades, when he was most actively promoting and exhibiting his work. The resulting skewed perspective on Weston's career omits discussion of the seminal influences on the young artist, and of the challenges he faced trying to make a living as a small-town studio photographer. Yet these factors help explain Weston's decision to adapt to the pictorialist style then in vogue to compete for prizes at salons and camera club exhibitions, as well as his efforts to publish his camera work and writings in photography journals in order to gain recognition beyond his home state of California.

With the recent gift to the MFA of the nearly 2,300 prints by Weston in the Lane Collection, the entire sweep of Weston's photography — from some of the first prints he made as a teenager to the last photograph he is known to have taken, in 1948 — can now be explored in much greater breadth and depth. The study of Weston's production during his early years also provides an opportunity to consider the ways in which the contemporary predilection for modernism has colored the reading and reception of his pictorialist-era photographs. Like many of his fellow photographers, Weston early on felt the need to set his fine art images apart from the products of the newly ubiquitous Kodak "snapshooters." Among the ways he did so were to give his prints titles borrowed from poetry or subjects drawn from history, produce carefully staged genre scenes, or create soft-focused images reminiscent of graphite drawings or heavily inked etchings. It is easy to overlook the virtual absence of a market for fine art photography at the time. There were almost no commercial

galleries dedicated to the sale of photographs, and photographers had few opportunities outside the system of camera clubs, photography journals, and salons to show their work to the larger public. Weston dedicated considerable time and effort toward these activities, in pursuit of his deep-seated ambition to be recognized as a serious artist.

Although his early years coincided with the height of the pictorialist movement, Weston was far from a strict practitioner of the style. He would later claim that "my photographs of thirty years ago are closer in approach . . . to my latest work," and "even as I made the soft 'artistic' work . . . I would secretly admire sharp, clean, technically perfect photographs in showcases of very mediocre photographers."[4] Viewers today have so completely adopted straight, sharp-focus modernism as the norm in photography that they are inclined to see pictorialism, with its soft, atmospheric prints and tendency to imitate the look of art in other media, as little more than a detour in the history of the medium. But, just as Weston explored variety within his own early practice, pictorialism was never a single monolithic style. Instead, it was an international movement that lasted longer and represented a wider range of photographic approaches, subject matter, and printing techniques than is usually acknowledged.

The disproportionate concentration on Weston's modernist still lifes, nudes, and landscapes has also obscured the reality that during most of his professional career he was forced to fall back on portraiture as a way to make a living. It was only after he received a Guggenheim Fellowship in 1937—the first ever awarded to a photographer—that he was finally (at the age of fifty-one) free to focus solely on his personal work. The "bread and butter" portraits that are so prominent in his early work can be thought of as the building blocks of much of his later photography. Reinserting this studio work back into the larger story of Weston's artistic production illuminates not only the central place of portraits and nudes within his oeuvre, but also the critical importance of his technical expertise with the large-format camera and in the darkroom, which paved the way for his sharp-focused, modernist prints of the late 1920s and 1930s. It is during these first, often overlooked decades that Weston established himself as a nationally and even internationally known artist, and his modest little portrait studio was where it all began. As one critic asserted in 1915: "Out in the town of Tropico, a beautiful suburb of Los Angeles, stands a shack studio of rough boarding that is so full of art that its range of influence reaches to the ends of the earth."[5]

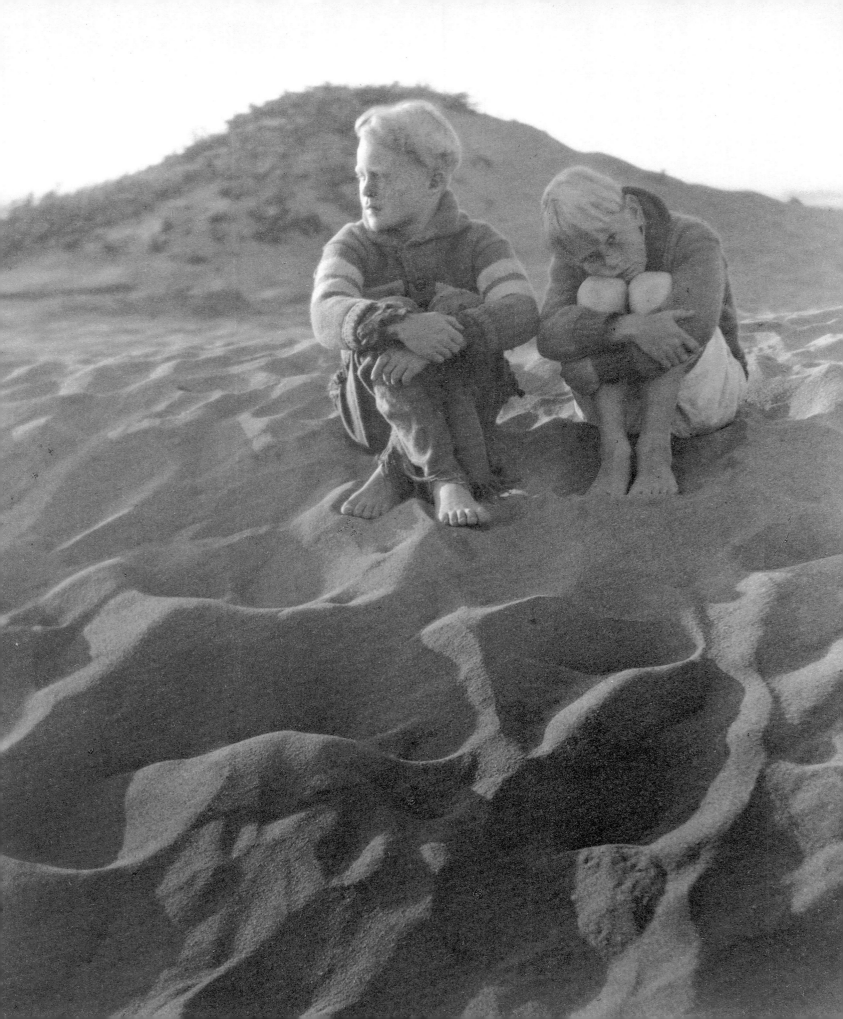

BEGINNINGS

EDWARD HENRY WESTON was born on March 24, 1886, in the small town of Highland Park, Illinois, just north of Chicago on the edge of Lake Michigan. A short time later, he and his parents and sister, Mary Jeannette (May), moved to the bustling South Side of Chicago. His father, Edward Burbank Weston, was a successful obstetrician, and the family lived a comfortable middle-class life until the sudden and devastating death of his wife, Alice, during the pneumonia epidemic in the winter of 1892. May, who was nine years older than her brother, took on the role of surrogate mother, forming a close bond that was to last throughout their lives. Their father's subsequent decisions to remarry and to move his household several times over the next few years strained family relations and seem to have worsened his son's troubles with formal schooling.[1]

Even so, it was Edward's father who sent him his first camera — a Kodak Bull's-Eye #2 — in 1902, when he was sixteen years old and spending the summer on a relative's farm in Michigan. His father's note accompanying the simple box camera was full of practical suggestions for the novice: he recommended that his son start by shooting only outdoors (thus avoiding anything but the simplest camera settings) and that he remember always to keep the sun behind him and to forward the film after each exposure. Edward responded with enthusiasm: "Received camera in good shape. It's a dandy. . . . Took a snap at the chickens. I think it's a good one as I was right near them. . . . It makes me feel bad to think of the fine snaps I could have taken if I had had the Kodak the other day. . . . I suppose I'll have plenty of chances and I'm going

to wait for good subjects."[2] It did not take long for Edward to aspire to a better camera than the very rudimentary Kodak, with its waist-level viewfinder and 3½-inch-square negatives. He promptly set out to save enough money to purchase a second-hand 5 x 7-inch view camera, complete with tripod and filter, and it soon became his almost constant companion. As he later recorded in his daybook journal: "I needed no friends now—I was always alone with my love. School was neglected—I played 'hookey' whenever possible."[3]

His earliest surviving photographs date from 1903 and 1904, when Weston was still a teenager. They record outdoor spaces that would have been familiar to the newly minted young photographer, eager to test out his camera and teach himself to develop and print in his makeshift attic darkroom. One is a starkly simple snow scene taken in Jackson Park, an expansive public space in the Woodlawn section of the city that had been the lakeshore site of the 1893 Chicago World's Fair (pl. 1). Most of the structures had burned to the ground after the fair's closing, leaving a barren and neglected landscape. Edward would later recount in his daybook his feelings about an image very much like this one: "The first print I made from my first 5 x 7 negative—a snow scene— [I recall] the tightening—choking sensation in my throat—the blinding tears in my eyes when I realized that a 'picture' had really been conceived. . . . I can see every line of the composition yet—and it was not half-bad—I can only wish I had kept the print at least for memory's sake—and not destroyed it with many others in some moment of dissatisfaction."[4]

In 1903 Weston also made a view of the marshy wetlands at what is today Grand Mere State Park, in the southwestern corner of Michigan (pl. 2). Probably taken while on a family visit, this small print records one of a string of inland ponds that run along the sandy lakeshore and were originally formed by ancient glaciers. With its tangle of delicate reeds and wooden pilings that sharply recede into space, and its spare, asymmetrical composition and watery subject, it has the look of a Japanese woodblock print. The following year Weston captured a more dramatic image of breaking waves, once again on Lake Michigan, that survives in a number of prints and was one of the rare early works that he chose to include—along with the Jackson park image—in his retrospective at the Museum of Modern Art in New York more than four decades later (pl. 3). Inscribed "Old Lake Michigan" on the verso, this was one of his earliest photographs to go beyond the workmanlike record of a landscape. The newfound ability to render the cresting wave and the bands of foaming surf indicate the young man's growing artistic ambitions.

In 1897 Edward's sister married her teenage sweetheart, John Hancock

Seaman, and the couple moved to southern California in 1903, separating the siblings for the first time. Not long afterward Edward dropped out of high school, and May began an extended campaign of heartfelt letters urging him to come west to visit: "Never mind what you wear, grease your pants and slide here if you have to. . . . The ocean is waiting to be bathed in. . . . The mountains are waiting to be climbed — strawberries are in bloom. . . . This is the place for you without an atom of a doubt. Every year you spend back east is so much lost to you."[5] Weston took her up on her invitation and arrived on May 29, 1906, in the small settlement of Tropico (later Glendale), just outside Los Angeles, for what was supposed to be a brief visit. Almost immediately he decided to remain in California, and soon thereafter he met May's close friend Flora Chandler — seven years his senior and several inches taller than him — and promptly fell in love. After a courtship of a few years, they would be married in January 1909. Her father, Cornelius C. Chandler, was actively involved in real estate and land speculation in the area. Having recognized Tropico's potential early on, Cornelius Chandler used some of his substantial wealth to acquire a twenty-acre tract of land along the Southern Pacific Railroad tracks, the eventual site of the Weston family home and of Edward's photography studio.

Edward soon realized that he was not cut out for the job of railroad surveyor that his brother-in-law had secured for him on the San Pedro, Los Angeles, and Salt Lake line.[6] During the brief time in 1907 that he worked on the train route, which ran between Los Angeles and Salt Lake City via Las Vegas, he apparently took along a camera. One of the few southwestern landscapes from this period that survive records an arid expanse of the Mojave Desert and includes the bleached form of a cow's skull and skeleton in the left foreground (pl. 4). Weston's decision to photograph a vast empty space with so little obvious pictorial appeal is especially interesting, as he went on to make more desert views than almost any other landscape type over the course of his career. Years later, he advised his friend and fellow photographer Toyo Miyatake that the way to break out of a creative slump was to visit the desert, because, "standing in the desert you will realize how insignificant your existence is."[7]

Weston's first serious foray into making a living with his camera involved taking up a postcard camera and going door-to-door to drum up business as an itinerant photographer, compelling him to make likenesses of virtually anything that could be placed before the camera: "brides, pets, everything from the newborn in its cradle to the corpse in its coffin."[8] Kodak had sparked a craze for real photo postcards when, in 1903, the company introduced a

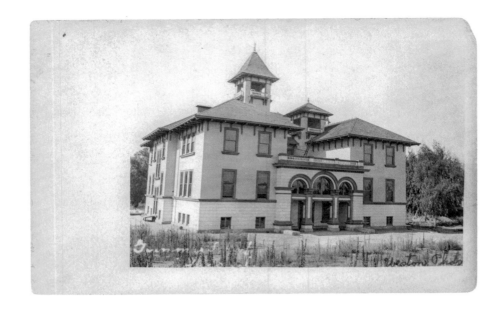

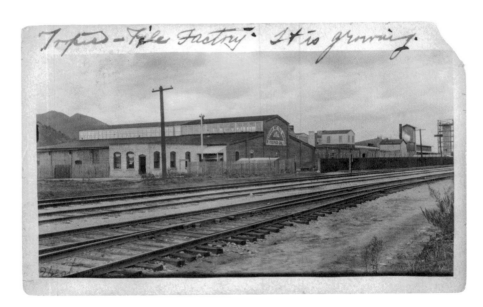

lightweight and affordable folding pocket camera that allowed its users to take
3 ½ x 5 ½-inch images that could then be printed on commercially available
papers and mailed as a penny postcard. Two of Edward's real photo postcards,
sent in 1907 to Flora's cousin Fleta Kinne, in Chicago, feature straight, sharp-
focus images of the Tropico Grammar School on nearby Cerritos Avenue
(with the annotation "This is the new school building. We are quite proud of
it!") and the nearby Tropico Tile Factory and Pottery Works (inscribed "It is
growing") (figs. 2, 3). These postcards represent the kind of local boosterism
that Cornelius Chandler would have heartily approved. The grade school was

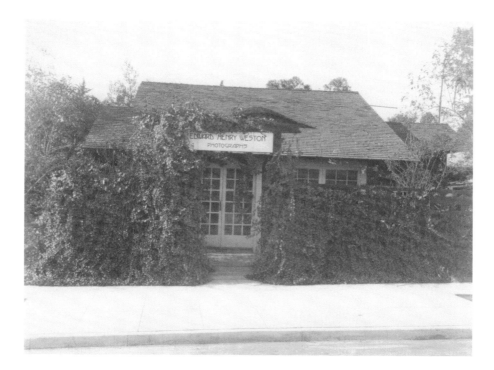

Fig. 4
Façade of Edward Weston's Studio, Tropico, about 1920

the one in which Flora Chandler taught, and the factory was a major employer in the area, rapidly gaining a reputation for producing some of the finest art tiles on the West Coast.

A few years later, in 1914, Weston was hired to work on a photographically illustrated brochure entitled *Tropico: The City Beautiful*. Weston was commissioned by a local fraternal organization, the Knights of Pythias, to create a visual record of highlights of the newly incorporated city. The text describes its close proximity to downtown Los Angeles and direct connection by electric train, which made it possible for citizens easily and economically to commute into the city for work and return home to a bucolic setting featuring "hundreds of vine-covered dwellings, scores of velvety lawns, flowers of every description, and fields of tender, palatable plants."[9] Weston's photographs include one of a greatly expanded tile works (compared with the postcard view of only a few years earlier). Also among the booklet's straightforward documentary images of Tropico's churches, schools, and broad tree-lined avenues is an anomalous picture of some of the region's produce—a pyramid of large local peaches stacked up next to a wooden ruler and a much smaller pile of smaller fruit apparently meant to represent the inferior produce grown elsewhere (pl. 5). A few years later he recorded another Tropico sight, his own modest bungalow-style studio, with its board-and-batten siding, hand-hewn log supports, and distinctive "eyebrow" window above the front door, built in 1911 (fig. 4).

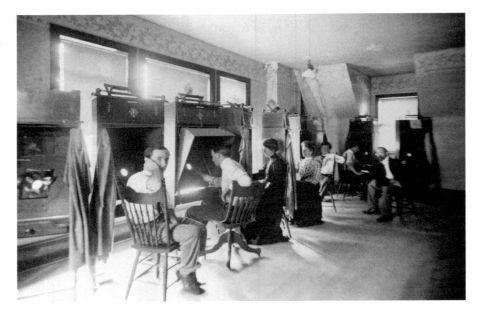

While still in the itinerant stage of his career, and perhaps in the hope of impressing his fiancée and her family with his seriousness of purpose, Weston decided to engage in more formal study of photography. Because there was nowhere in California to gain practical instruction, Weston headed back to the Midwest in 1908 to get a degree at the Illinois College of Photography in Effingham, a small town in the southeastern part of the state. There over the next six months he learned a range of darkroom techniques, as well as lighting, retouching, and how to run a professional portrait studio. Although he left the school just shy of receiving his formal diploma, on his return to Los Angeles Edward managed to find work in some of the city's most highly regarded studios. This included almost two years of employment, from 1909 to 1911, in the prominent downtown portrait studio of A. Louis Mojonier, initially as a retoucher and eventually as a staff photographer. An image of the studio taken about 1910 (fig. 5) shows him seated at a retouching booth (at left). Working in such a large studio would have helped forge social connections useful for his future career as an independent practitioner.

Throughout his courtship of Flora Chandler, Edward recorded hiking and camping trips that the couple made with friends in the nearby San Gabriel Mountains. Already an avid outdoorsman and a reader of *Physical Culture* magazine, he often brought along his camera and tripod during these treks, sometimes employing a long cable release and bulb that tripped the shutter remotely and allowed him to appear in his own photographs. In some of these prints he retouched out any signs of the cable, as in a scene portraying the

couple in bathing dress seated together on the rocky edge of a mountain stream (pl. 6). Edward appears with his arm awkwardly outstretched and his empty fist clenched; Flora managed to make light of the cable's ghostly presence in her accompanying inscription, "We simply can't drown—see the lifeline?"

In a picture made during the couple's honeymoon, Edward and Flora share a picnic along a trail on the summit of Mount Wilson, with a pack mule at their side and Edward's cable release snaking into the foreground (pl. 7). Weston later cropped and printed only the detail of his own head from this casual shot in order to create the profile portrait that won him first prize in *Photo-Era* magazine's category of "Outdoor Portraits" in 1911 (pl. 8).[10] For a self-described shy person, Weston was surprisingly eager to capture his own likeness and he made numerous self-portraits at this early stage in his career, although he later cringed at some of his youthful affectations: "That whole soft focus period in retrospect seems like a staged act; I even dressed to suit the part: windsor tie, green velvet jacket—see, I was an artist!"[11]

The influence of pictorialism can be seen in several images Weston created in 1908 and 1909. These images, which drew on nostalgic themes, represent a genre that had become a separate photographic category in many of the pictorialist exhibitions and competitions that Weston had begun to enter. Two of these intimate scenes feature carefully staged vignettes—one of Flora, and the other of her two young nieces, Lillian and Emily Ellias—set in domestic spaces and dressed in colonial-style costumes. The image of Flora, which Edward entitled *Priscilla* and which won honorable mention in the competition sponsored by *American Photography* magazine in August 1908, portrays her seated at an old-fashioned spinning wheel in front of a blazing hearth (pl. 9).[12] The title evokes the heroine of Longfellow's poem *The Courtship of Miles Standish* (1858), set in the Plymouth Colony. Subjects that harked back to America's past were common in the work of artists who wished to appeal to viewers alienated by the fast-paced growth of cities and industry. Weston made only a handful of images of demure young women engaged in handicrafts or serenely seated on an old-fashioned high-backed settle, as in *In Reverie* (pl. 10), but such reassuringly domestic and stereotypically American subjects placed him squarely within the fine art photography trends of the day. Similar scenes regularly appeared in the work of contemporary New England photographers, including Wallace Nutting, Chansonetta Stanley Emmons, and the sisters Frances Allen and Mary Allen.[13] Even the renowned art critic Sadakichi Hartmann, writing in *Camera Work* magazine in October 1910, touted the simple, homespun charm of "Old Colonial Rooms."[14] Weston himself shot a number of what he described

as "artistic interiors," devoid of figures but replete with historical references, which were published in *Photo-Era* magazine in 1911.[15]

Weston's portrait of Flora as Longfellow's virtuous Priscilla would have been recognized as a suitably chaste depiction of one's fiancée. It stands in stark contrast to two other photographs Edward made of her during the first year of their marriage, which presumably were not meant for exhibition or publication. The first portrays Flora seated with hands behind her head, a pose that along with her sleeveless white chemise highlights her hourglass figure; an intimate smile flashes between the photographer and his new bride (pl. 11). The second is Weston's earliest known nude — a romantic, soft-focus tableau of Flora seated in a leafy bower and reaching up into its branches like a modern-day Eve (pl. 12). According to her note on the verso of one of Edward's platinum prints of this image, Flora was four months pregnant with their first child, Chandler, who was born in April 1910.[16]

Several less domestic genre scenes from these years were shot outdoors in natural light, on the winding trails that threaded through the woods and hills of Griffith Park, in Los Angeles. The massive municipal park located on the eastern edge of the Santa Monica Mountains provided the photographer with respite from the demands of portrait sittings and the confines of his small studio. The park's natural beauty, a mix of rugged and more manicured terrain, inspired Edward to take at least one landscape photograph that shows the progress he had made since his earliest efforts in this genre as a teenager (pl. 13). In this simple, serene image a single tall tree flanks a wide walking path at left, balancing the softly rolling hills that recede into the distance on the right. Many years later, Weston recounted the importance of these early landscape studies: "I have thought back to my beginnings. . . . Though city-bred I always preferred the country, all that hills and valley, lakes and skies symbolize. But I think my first great realization came through my camera: at least it brought me into closer contact with nature, taught me to observe more carefully, awakened me to something more than casual noting and romantically enjoying. Even then I was trying to understand, getting closer, becoming identified with nature."[17]

A Griffith Park trail and distant mountain view form the background of Weston's double portrait of himself and his friend Nell Cole, *In Vacation Time* (pl. 14).[18] Although no cable shutter release is visible, the image was described as "Mr. Weston's photograph" and "very pleasing" by the editors of *Photo-Era* magazine in October 1910. Inscribed on its verso "for a Kodak ad," this meticulously staged scene captures Edward with his camera case and tripod

Detail, plate 11

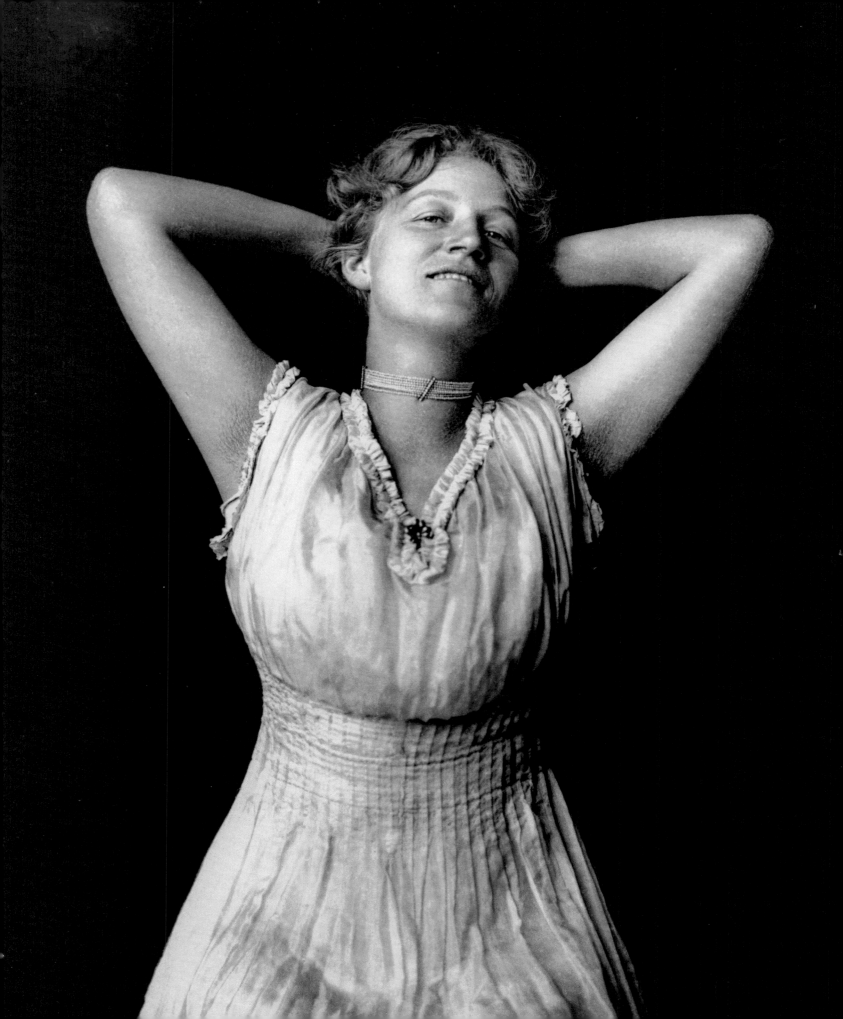

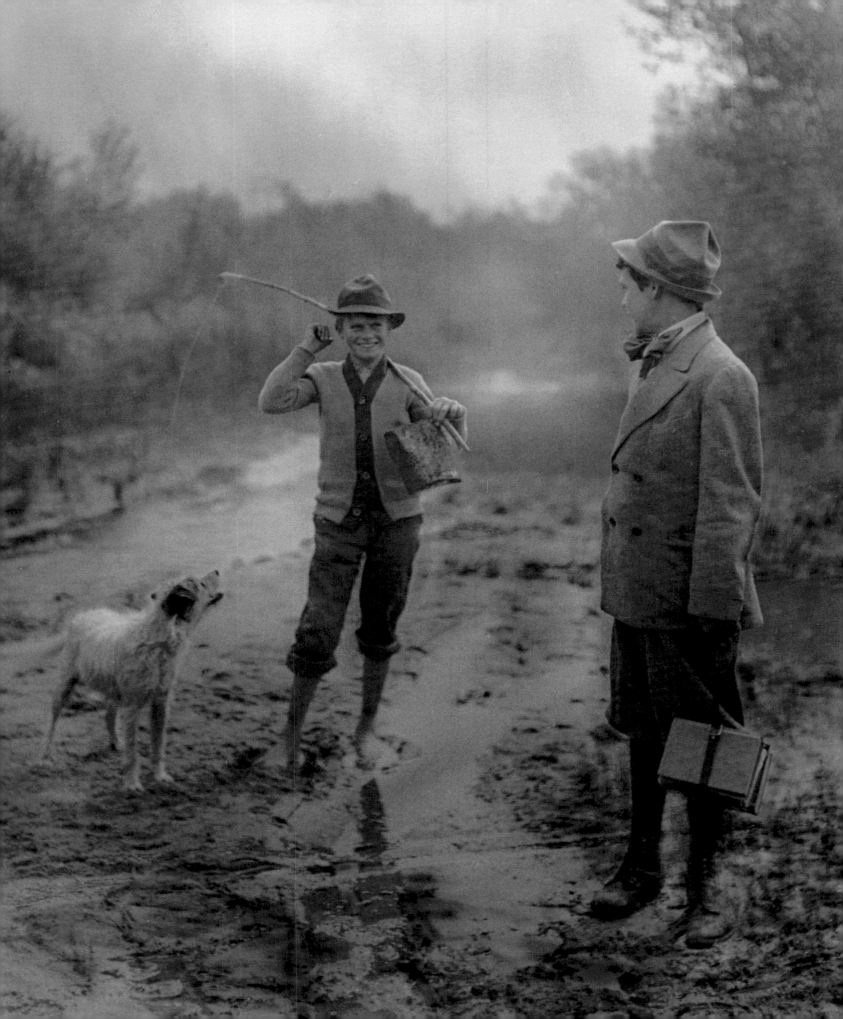

about to head out on a hike with his Tropico neighbor.[19] Nell wears a broad straw hat, long skirt, and sturdy boots, and has brought along a camera as well, although hers is a small folding model that she carries in a leather case with a long shoulder strap. Two other views of the pair, clearly taken on the same day, show, in one instance, Edward helplessly looking up at her seated high on a rocky outcropping, unable to join her because of his large camera and tripod; in another, he is trudging home, apparently worn out by the weight of his heavy equipment and glass negatives, while Nell, smiling and barely winded, leads the way, with her more portable camera.

Another image of a related *plein air* subject is entitled *Let's Play Hookey* and was made in the same year (pl. 15). This rich, warm-toned gelatin silver print features two young boys and a dog standing in a muddy path — one child, smiling broadly, with rolled-up pants and bare feet, proudly wields a fishing rod, while the other wears a jacket and tie and carries a bundle of books, torn between going to school or following the lead of his truant friend. This Tom Sawyer-like scene must have resonated with Weston, who had so often played hooky from school himself.[20] He won first prize for this picture in the *American Photography* monthly competition in September 1912, and the magazine's editors praised it as "a perfect example of genre."[21] They noted that the artist had used a second negative to create the sky, although when *The Camera* had awarded the same picture an honorable mention the year before, it was singled out for "the presentation of atmosphere and relief . . . without having any recourse to faking." When a reader queried the magazine's editor on this point, Weston responded with a defense of his methods consistent with a pictorialist approach: "If after-manipulation is not allowable, how can photography aspire to the realm of art? How many paintings are literal records of what the artist saw before him?"[22]

For an artist who would later be so identified with landscape studies, it is striking that relatively few of Weston's early photographs actually record the natural world. Two rare environmental photographs from his early years stand out from the scenic views, genre scenes, and straight documentary images made during hikes in the San Gabriel Mountains. The first of these is a shadowy and atmospheric gelatin silver print entitled *Chicago River Harbor* that was most likely made during his return to Illinois for schooling in 1908 (pl. 16). This velvety dark image, with its pictorialist soft focus, was exhibited on at least two occasions, in 1911 and again in 1915.[23] Taken on what Weston recorded as a foggy spring day, it shows two steamships and a tugboat docked at the mouth of the Chicago River, shrouded in a heavy haze that makes it

difficult to distinguish the grain elevators and factories on the shore or recognize what is likely the Rush Street train trestle in the background.[24]

Another unusual landscape was apparently taken in about 1913 (pl. 17). Looking like a delicate graphite drawing and reminiscent of work by the master pictorialist photographers Clarence H. White, Rudolf Eickemeyer, and Karl Struss, this ethereal image of windswept trees was exhibited along with *Chicago River Harbor* at the Shakespeare Club in Pasadena in 1915. It made its first appearance at the 1913 Wanamaker exhibition in Philadelphia. There it appeared with the title *Gaunt Driven Boughs in the Sweep of Open Wold*, an apparent reference to James Russell Lowell's Arthurian poem *The Vision of Sir Launfal* (1848), which includes the lines: "Down swept the chill wind from the mountain peak, / From the snow five thousand summers old; / On open wold and hill-top bleak / It had gathered all the cold." Although it was not his common practice, Weston sometimes borrowed from literary sources for the titles of his work, perhaps to enhance their public reception. Lowell's poem was a staple of elementary school readers during his youth, which may have been where he encountered it.[25] By the time this print was shown again, in 1915, the title had been simplified to *The Valley of the Long Winds*, and an appreciative critic for the *Pasadena News* characterized it simply as "well composed and full of breezy atmosphere."[26]

Just prior to the birth of his second son, Brett, in December 1911, Weston decided to strike out on his own. That year, he built a very simple studio building on busy Brand Boulevard in Tropico, a few blocks from the family's home. He then set out to promote his new enterprise; one of his earliest advertisements read: "Make an appointment NOW with the WESTON STUDIO — a quiet retreat, away from the noise and confusion of the city."[27] In the spring of 1913 Weston published an article in *American Photography* on the challenges of running an independent portrait studio, in contrast to what he called "picture factories" like Mojonier's, with their large staffs and assembly-line production of everything from shooting and developing to retouching and mounting. In this piece he detailed the positive aspects of working independently, while recognizing that controlling every facet of the operation left little time for "the study of art and technique."[28] This is a revealing comment from a photographer who now found himself balancing the demands of his paying clients and trying to earn a living to support his young family, all the while hoping to expand his reputation.

Weston now had to be resourceful in finding ways both to satisfy his regular sitters and to carve out time for his own creative work. Motivated by the

images that he encountered in contemporary journals like Stieglitz's *Camera Work* (New York), *Photo-Era* (Boston), and *Camera Craft* (San Francisco), he had begun to send self-consciously "artistic" photographs to magazine and camera club competitions around the country and even as far away as Europe, as a way to gain the approbation of exhibition judges, critics, and potential customers beyond southern California. Several of Weston's photographs became regular entrants in the most prestigious pictorialist salons at the time. He typically made three or fewer prints of each image, which traveled the world in the service of building his reputation. The evident skill with which they were made helped establish him as an artist with a distinctive, immediately recognizable style that was regularly singled out for praise.

Summer Sunshine, a photograph Weston made in 1914, quickly became one of his most popular pictures on the pictorialist circuit, reproduced in numerous journals and exhibited in several salon competitions under a range of different titles (pl. 18). It is a romantic image of his studio assistant, Rae Davis, dressed in a picture hat and diaphanous white dress, carrying a large spray of roses, and bathed in dappled sunlight. Many of Weston's photographs that won medals and honorable mentions and were reproduced in photography journals during this period have been lost, some of them presumably among those he destroyed — along with his daybooks — in the mid-1920s. Others, like *Summer Sunshine*, Weston enlarged into platinum prints and showed extensively; this picture, for example, in 1914 alone was exhibited in Toronto, Atlanta, Los Angeles, and London, and reviewed in *Amateur Photography and Photographic News*, *Photograms of the Year*, and *Platinum Print* magazine. What might read to modern eyes as the subject's slightly insipid expression was praised at the time for its liveliness and beauty. Weston seems to have been pleased with the public response, as he also submitted this picture to the Panama-Pacific Exposition and illustrated it in his studio brochure at about the same time.[29]

The ten-month-long Panama-Pacific International Exposition, which celebrated the opening of the Panama Canal and San Francisco's reconstruction after the 1906 earthquake and fire, was something of a bellwether for Weston and his fellow photographers in California. Long before the fair opened in early 1915, the organizers announced that photography would be exhibited in a separate section of the Liberal Arts Building rather than alongside paintings, sculpture, prints, and drawings. This slight to serious practitioners of the medium caused an uproar in journals and the local press along with calls for boycotts of the exhibition from camera club members, and confirmed for many that the fight to elevate photography to the realm of fine art was still far from

won. Rather than boycott the fair, however, Weston submitted three works (one of which received a bronze medal) and attended in person.[30]

Afterward, he delivered a talk to the Los Angeles College Women's Club that outlined his frustration at seeing photography relegated to second-class status at the exposition; in it he pointed out that a number of major museums across the country had begun to exhibit photography as fine art, which made it doubly disappointing to see it shown in the Liberal Arts building lumped together with "telescopes, talking machines, butter churns and patent nursing bottles!" In the context of the Exposition's overall emphasis on new technologies, this decision in effect reduced photography to the product of a machine. Weston's response is in keeping with his thinking at the time, rather than the modernist attitudes he would later adopt: "A painter if he uses only his hand and brush is a mere draughtsman, but, if he uses his brain to make the brush — and hand — create an idea and express his personality, then and then only is he an artist. Why not apply the same reasoning to a photographer?"[31]

By the mid-1910s, pictures of children — or, as he described them in an essay on this topic, "the ever-moving mite of humanity" — had become something of a specialty for Weston. He explained the particular appeal of these young subjects, as well as the difficulty of photographing them: "Every child is the very embodiment of unconscious natural grace, and to try to pose children is a farce."[32] Early in his career as a professional portraitist, he had acquired a 3¼ x 4¼-inch Graflex, a hand-held camera that didn't require a tripod, in order to simplify photographing active young children in the studio.[33] The camera allowed him to document his own sons, shooting them both indoors and out, as they grew and matured. The survival of much of this personal work is largely thanks to Flora, who compiled several albums of photographs as gifts for family members that document the couple's courtship and early marriage as well as the first years of each boy's life.[34]

Edward found his young sons very appealing — and readily available — subjects with which to experiment with his camera. In *I Do Believe in Fairies*, Weston created a reprise of his earlier nude portrait of Flora, this time depicting Chandler in what appears to be the same bower-like outdoor space (pl. 19).[35] The sturdy little boy is seen from the back looking up into the leafy tree, as if searching for the fairies referred to in the picture's sentimental title. Like *Summer Sunshine*, this image was subsequently enlarged into a pale, high-key platinum print, and it was widely exhibited and well received by the critics.[36]

Most of Edward's early portraits of his sons employ a simple and direct approach, as in his 1915 *Portrait of My Son*, a surprisingly monumental close-up

Detail, plate 19

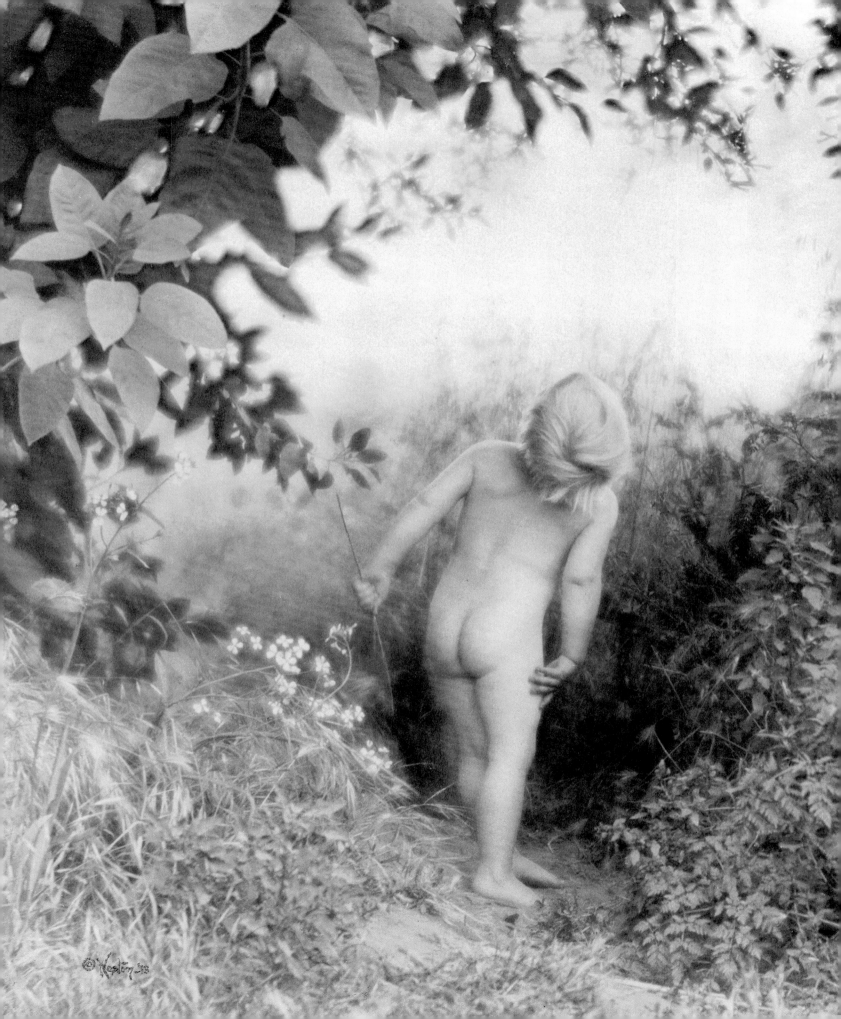

of Chandler in a soft, floppy hat (pl. 20). Although the generic title may refer to other images, it appears that this was a photograph that Weston submitted to numerous venues, including the London Salon and the prestigious Wanamaker exhibition in Philadelphia, for which Alfred Stieglitz was a juror; he also used it to illustrate his article on how to photograph children in the August 1916 issue of *Photo-Miniature*.[37] Chandler and Brett were joined by another brother, Neil, in 1916, and a fourth son, Cole, was to arrive in 1919. Over the next few years, Weston's images of his sons took on a wider variety of styles, many of them prefiguring approaches to lighting and composition he used later in studio portraits of his growing circle of friends—artists, writers, musicians, and dancers.

In a 1919 photograph of Brett, for example, Edward experimented with powerful directional lighting that exaggerated the child's round cheeks and startled expression and cast a looming, dark shadow on the wall behind him (pl. 21). The result is very different from the sunny, smiling children's portraits that he would have typically presented to his commercial clients. Instead it closely relates to several of Weston's likenesses of adults made during the same period, which are similarly dominated by strong, raking shadows. Another series of images from 1920 of Chandler in the boy's shop depicts him wearily slumped on the floor next to a wooden workbench and vise, next to a bicycle wheel and other parts (pl. 22). The palpable tenderness that emanates from intimate family pictures like these speaks to the depth of Weston's love for his boys and suggests that he may also have recognized elements of himself in them—the dreamer, the tinkerer, and the child who was happier working with his hands than sitting behind a desk in school.

Two slightly later images of Neil, at the age of about five, are some of Weston's finest child portraits from this early period. Edward often remarked that his third son was always happiest when he was naked and seemed completely unselfconscious and at ease before the camera. This series of unaffected poses was shot in the studio, emptied of its usual decorative props. The pictures were taken during a tumultuous moment in the family's life, when Neil was particularly affected by his father's decision to move out of the home. In the more distant view, the asymmetrical composition and yawning empty space above the boy emphasize his small stature and accentuate the elegant S-curve of his *contrapposto* pose (pl. 23). The close-up, modestly cropped so as to not include his genitals, focuses instead on the marble-smooth surface of his torso, his curly blond hair, and his rather pensive expression (pl. 24). This latter portrait, in particular, anticipates the even more abstract images of Neil's torso that his father took in 1925.

It is tempting to read into the elegiac mood of many of the family portraits from the early 1920s the photographer's awareness of coming separation. Although not a particularly sentimental person, Weston throughout his life sought to capture images of his loved ones when he knew they might be parted from him. After his separation from Flora in 1922, he made increased efforts to record the likenesses of his children. One particularly poignant example is *Two Boys*, in which the forms of his two oldest sons are echoed by a sand dune, which seems to hold them in a kind of comforting embrace; Chandler stares off into the distance, while Brett huddles next to him, his head resting on his knees (pl. 25).[38]

Perhaps anticipating another departure, Edward made a striking profile portrait of his father in the spring of 1917 on the occasion of the elder Weston's visit to California, just one year before his death (pl. 26). The timing of this sitting seems to have coincided with May and John Seaman's decision to move back to the Midwest, this time to Middletown, Ohio. Almost certainly inspired by James McNeill Whistler's famous painting of his mother, *Arrangement in Grey and Black No. 1* (1871), Weston's extremely pared-down portrait shows a newly simplified approach to his subjects. This image does not rely on studio props or costumes, only on deftly capturing the natural light falling across his father's stern face, as if recording features he might never see again.

Weston chose to send *Portrait of My Father* to the London Salon of Photography that same year, where it was greatly admired, although described by one critic as "extremely severe."[39] That occasion also coincided with his being elected to membership at the prestigious London Salon, where he was one of only six Americans and the only West Coast photographer to be so honored. These international accolades were auspicious signs that Weston had finally gained the broad public recognition to which he had aspired since the early years of his career.

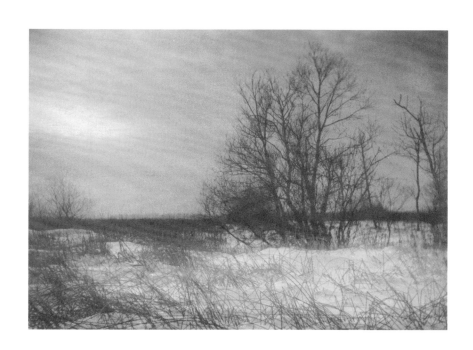

1 | SNOW SCENE, JACKSON PARK, CHICAGO, 1903

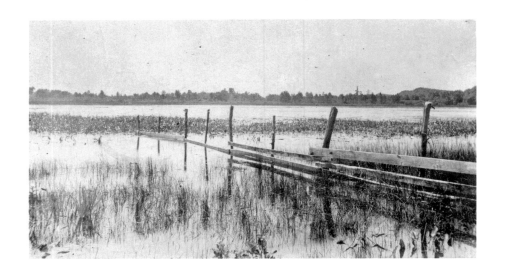

2 | GRAND MERE, 1903

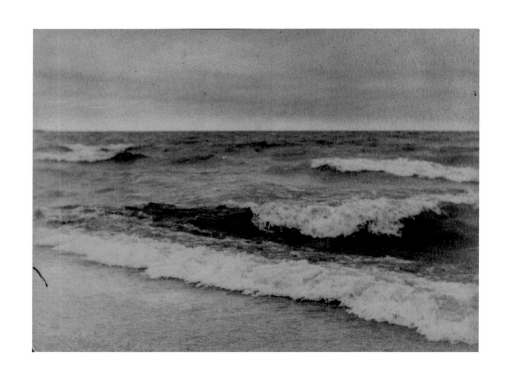

3 | OLD LAKE MICHIGAN, ABOUT 1904

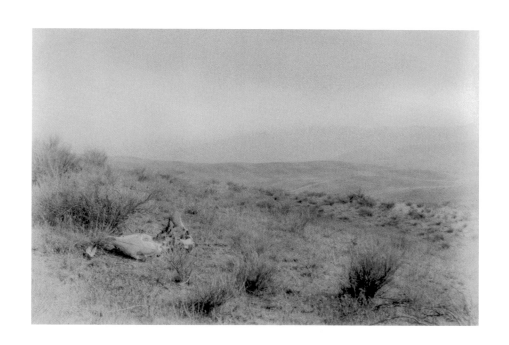

4 | LANDSCAPE WITH SKULL, MOJAVE DESERT, 1907

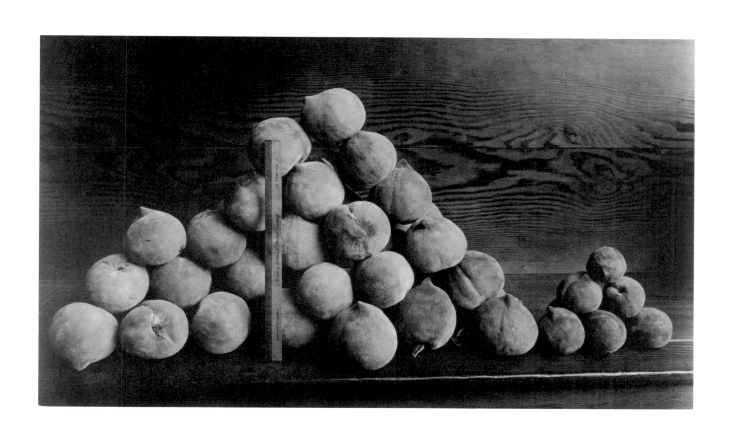

5 | PEACHES, 1914

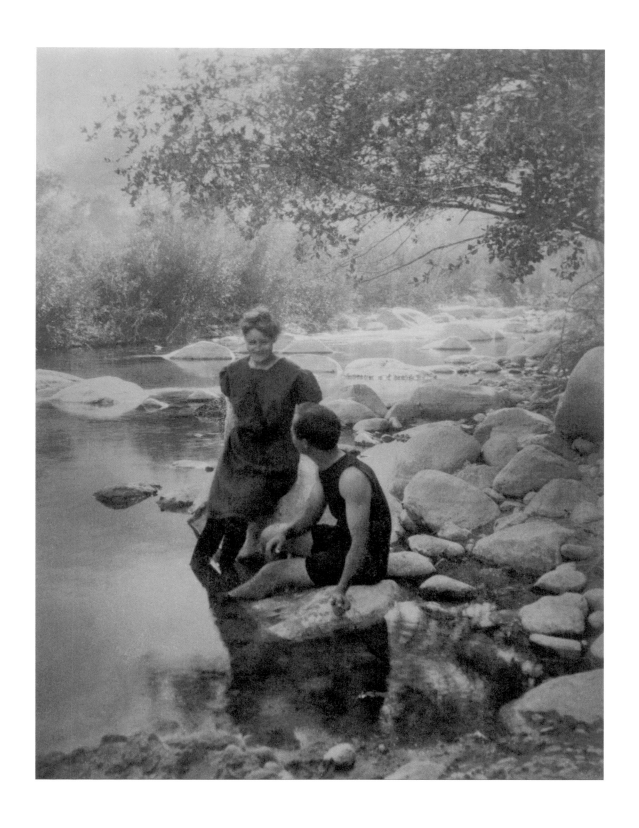

6 | SELF-PORTRAIT WITH FLORA CHANDLER, 1907

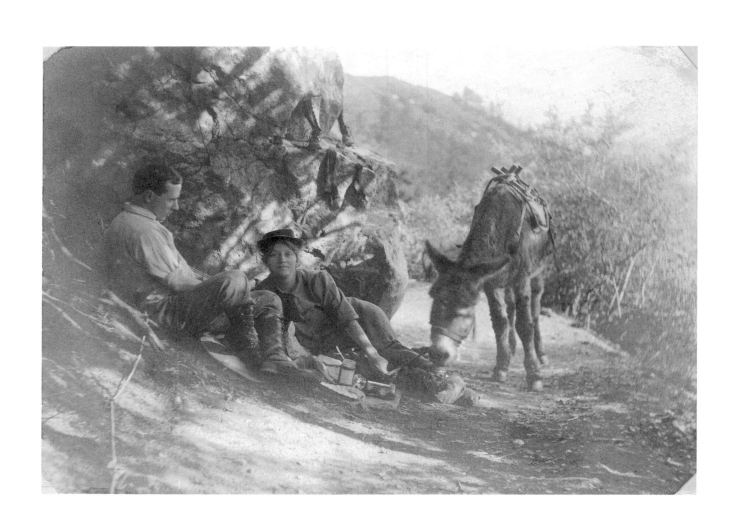

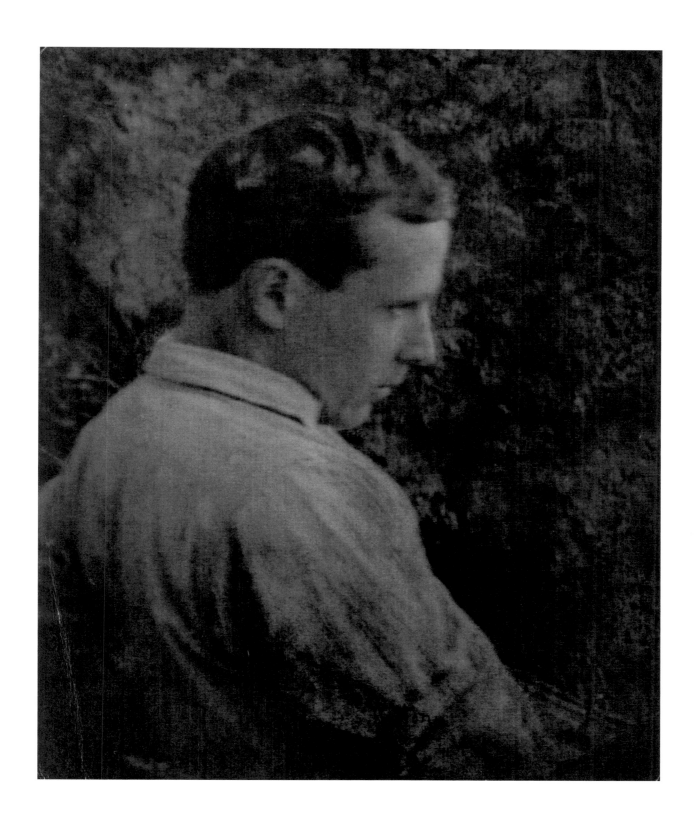

8 | SELF-PORTRAIT, 1909 (PRINTED 1911)

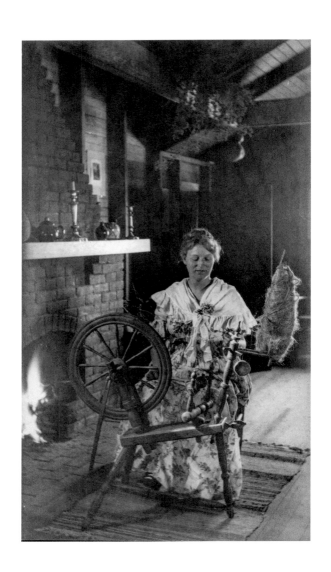

9 | PRISCILLA, 1908

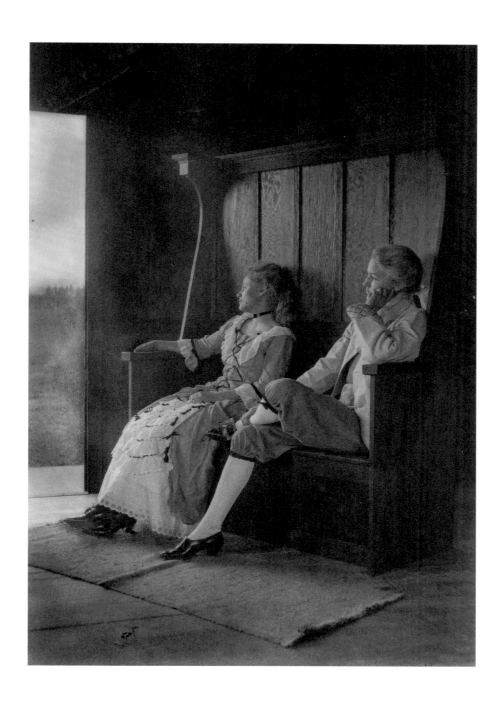

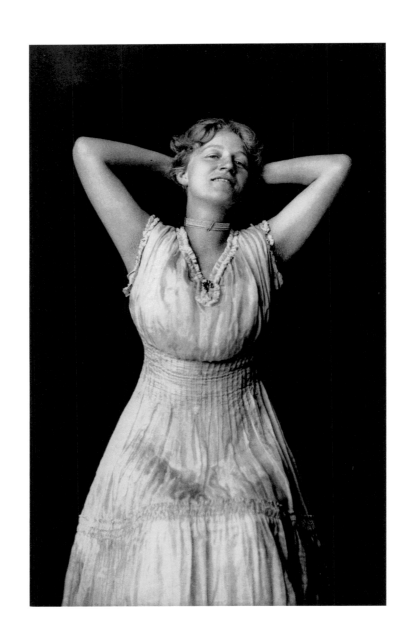

11 | FLORA CHANDLER WESTON, 1909

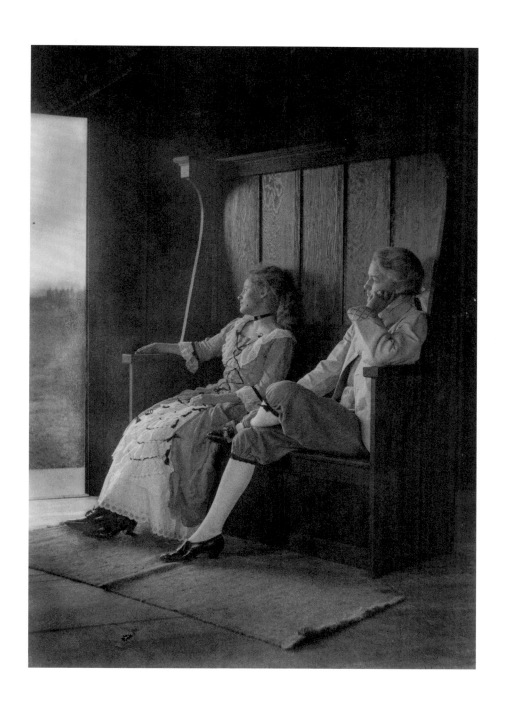

10 | IN REVERIE, 1909

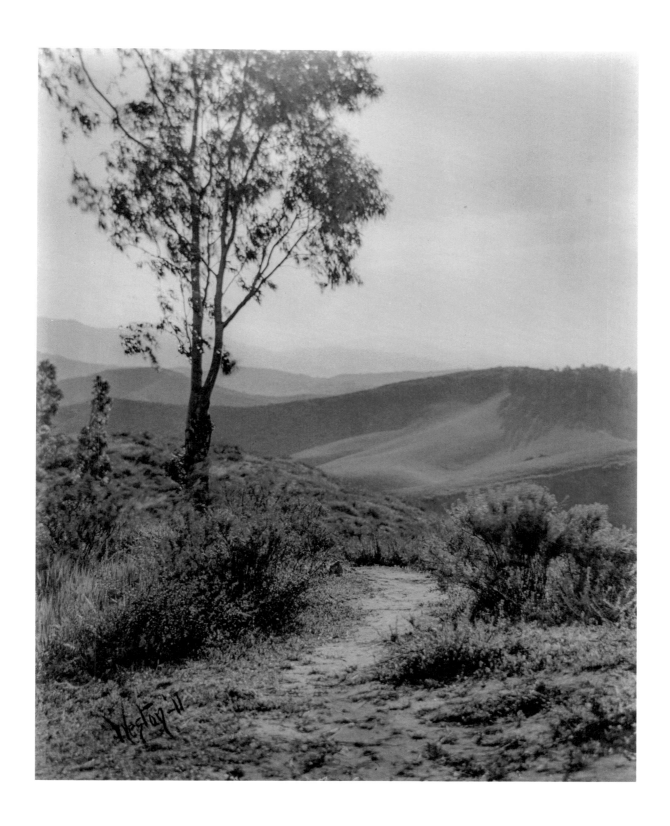

13 | SAN FERNANDO VALLEY, GRIFFITH PARK, 1911

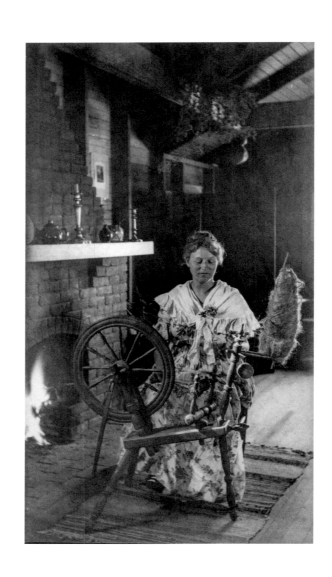

9 | PRISCILLA, 1908

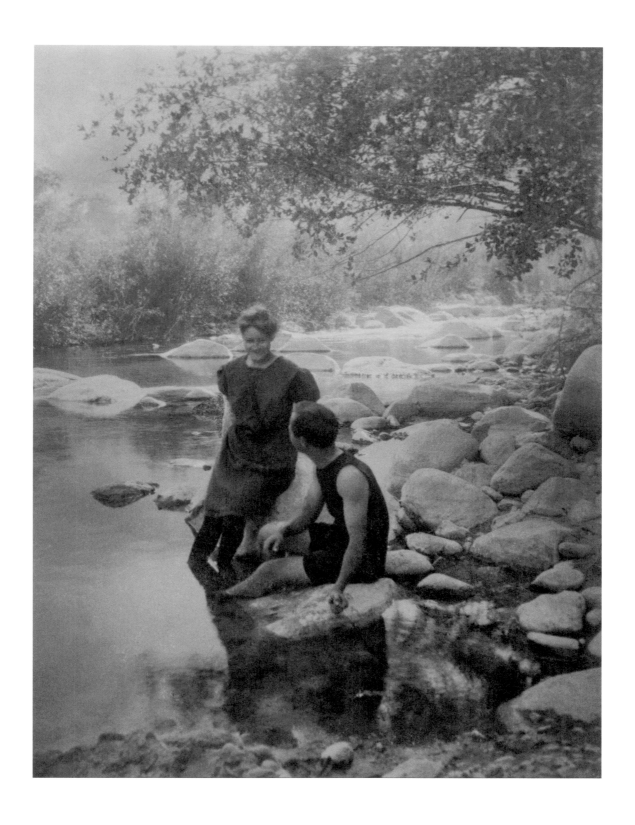

6 | SELF-PORTRAIT WITH FLORA CHANDLER, 1907

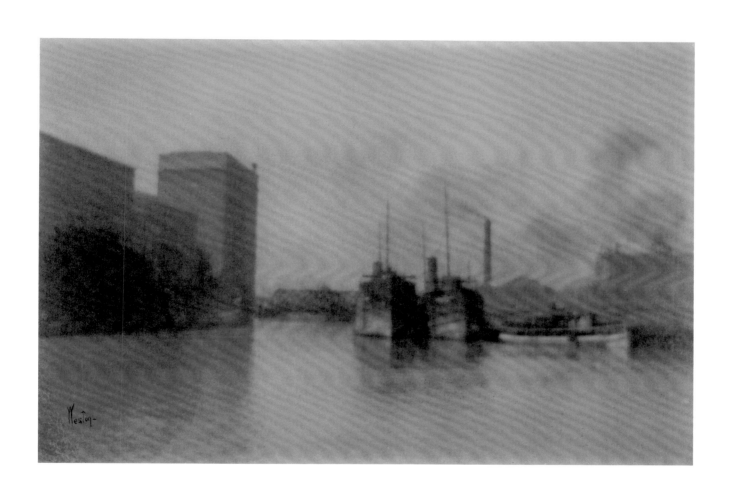

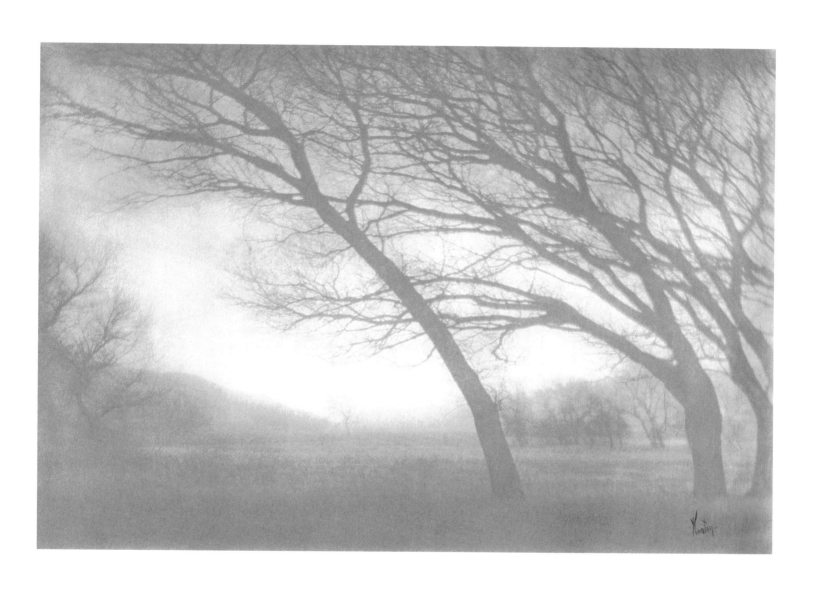

17 | VALLEY OF THE LONG WINDS, 1913

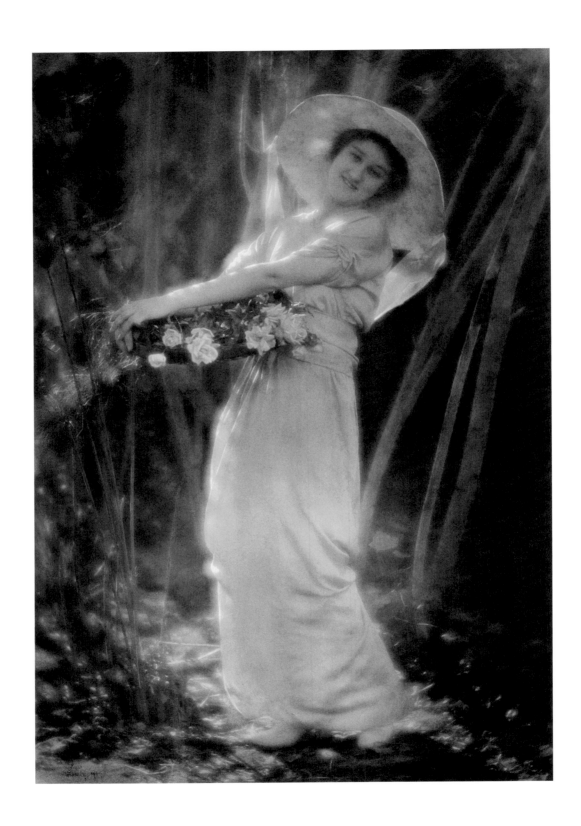

18 | SUMMER SUNSHINE (RAE DAVIS), 1914

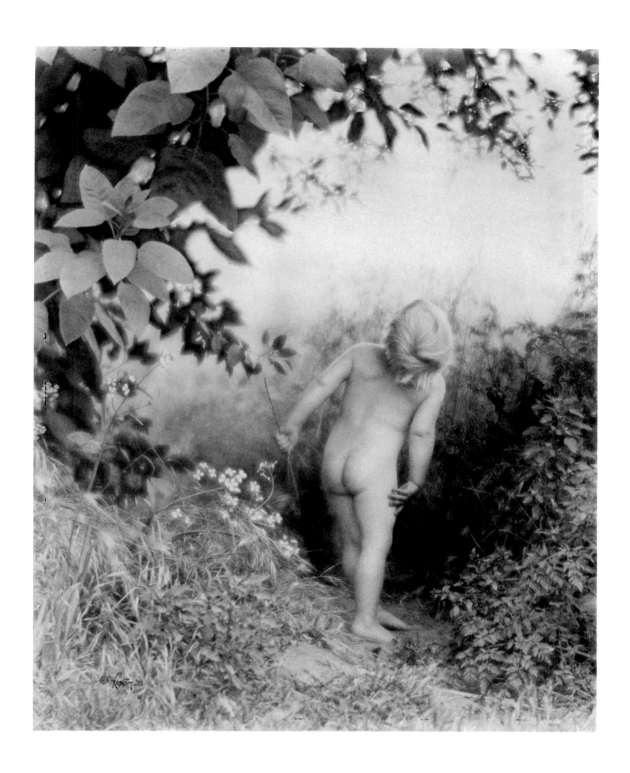

19 | I DO BELIEVE IN FAIRIES, 1913

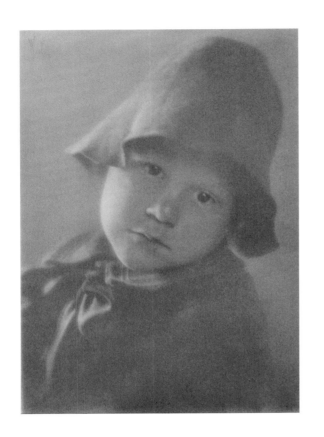

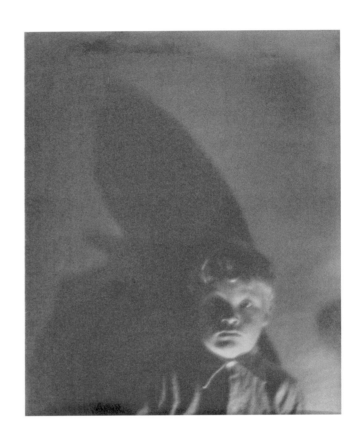

20 | PORTRAIT OF MY SON, 1915

21 | BUST OF BRETT, ABOUT 1919

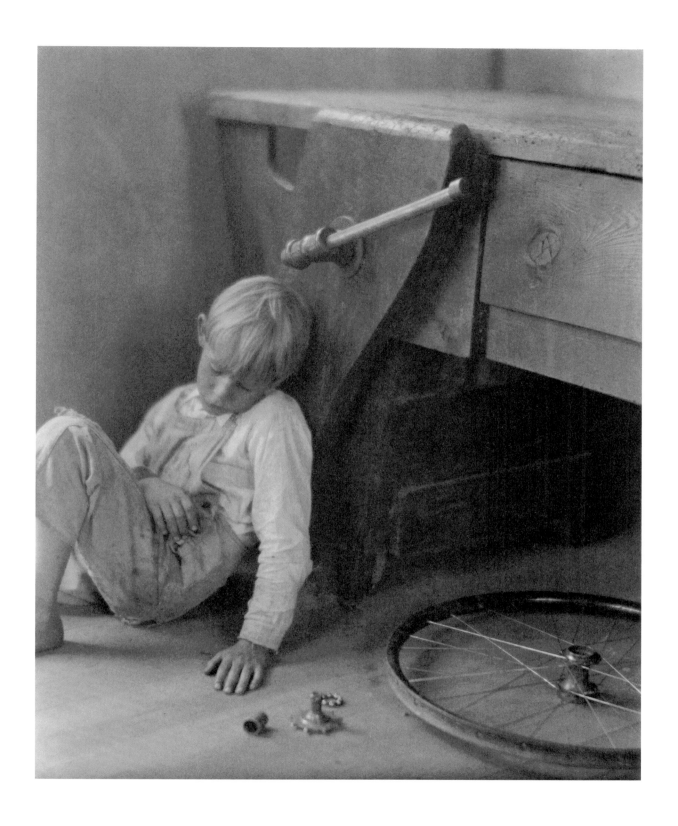

22 | CHANDLER IN HIS SHOP, 1920

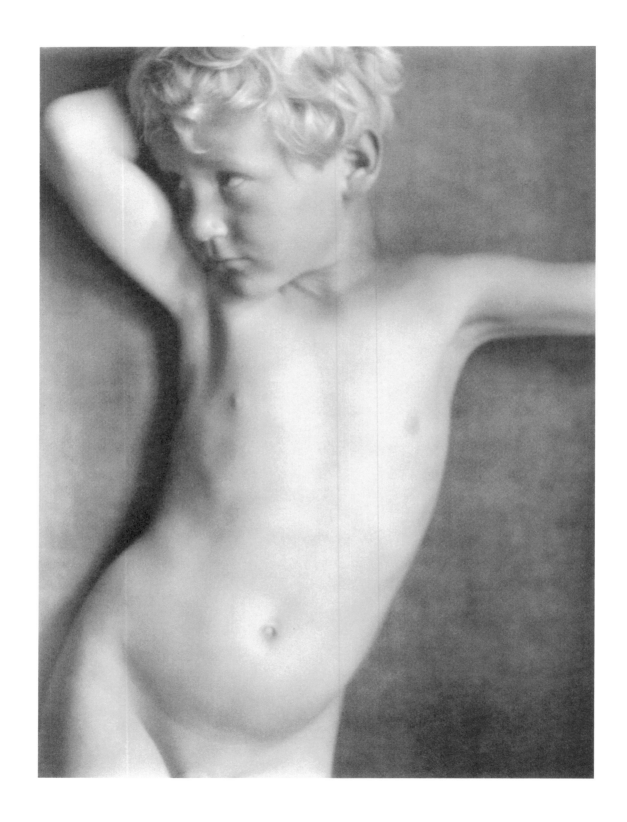

23 | NEIL, 1922

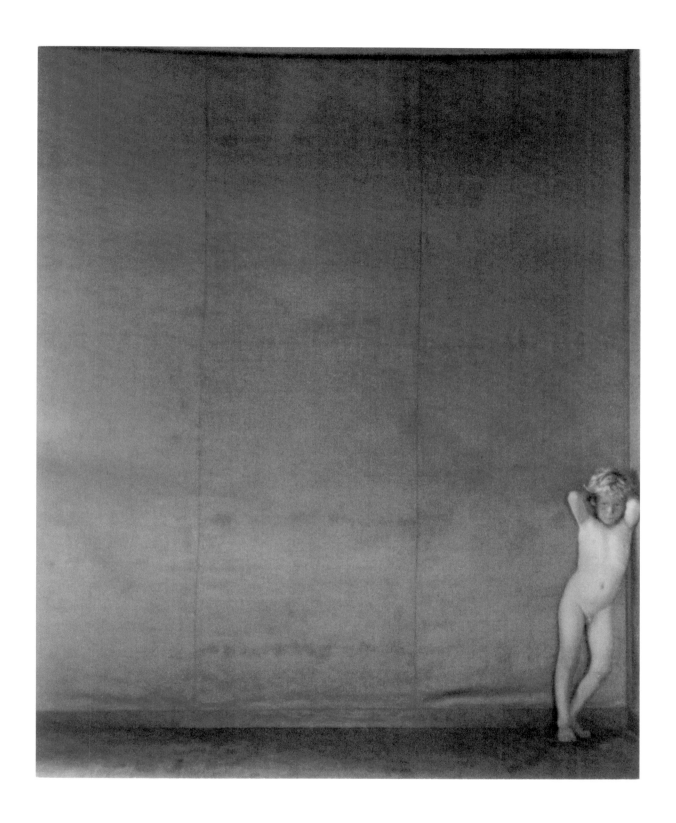

24 | NEIL, 1922

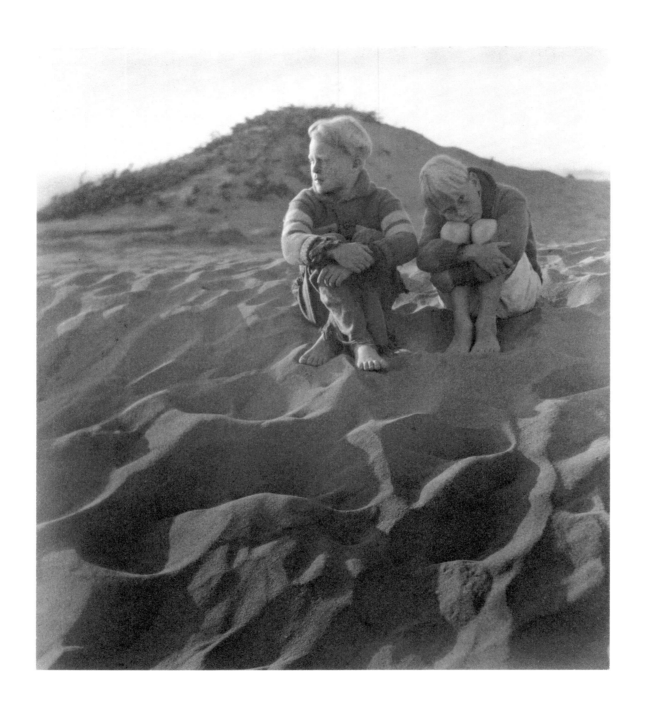

25 | TWO BOYS, 1922

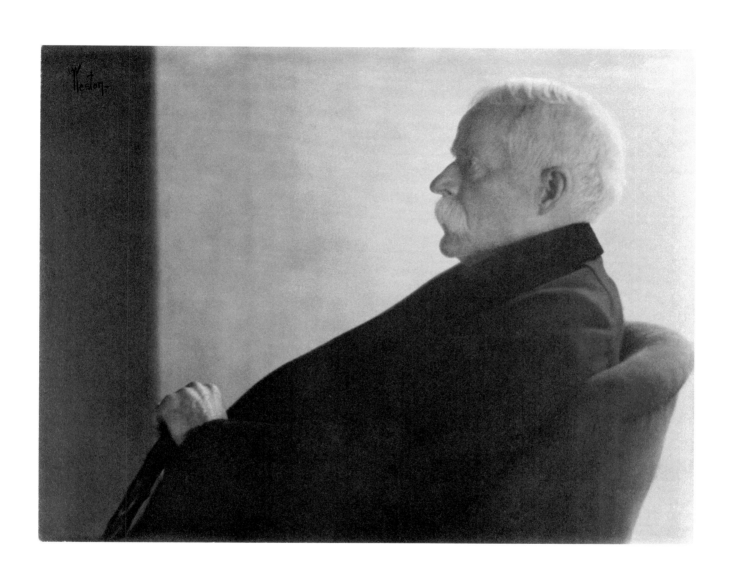

26 | PORTRAIT OF MY FATHER, 1917

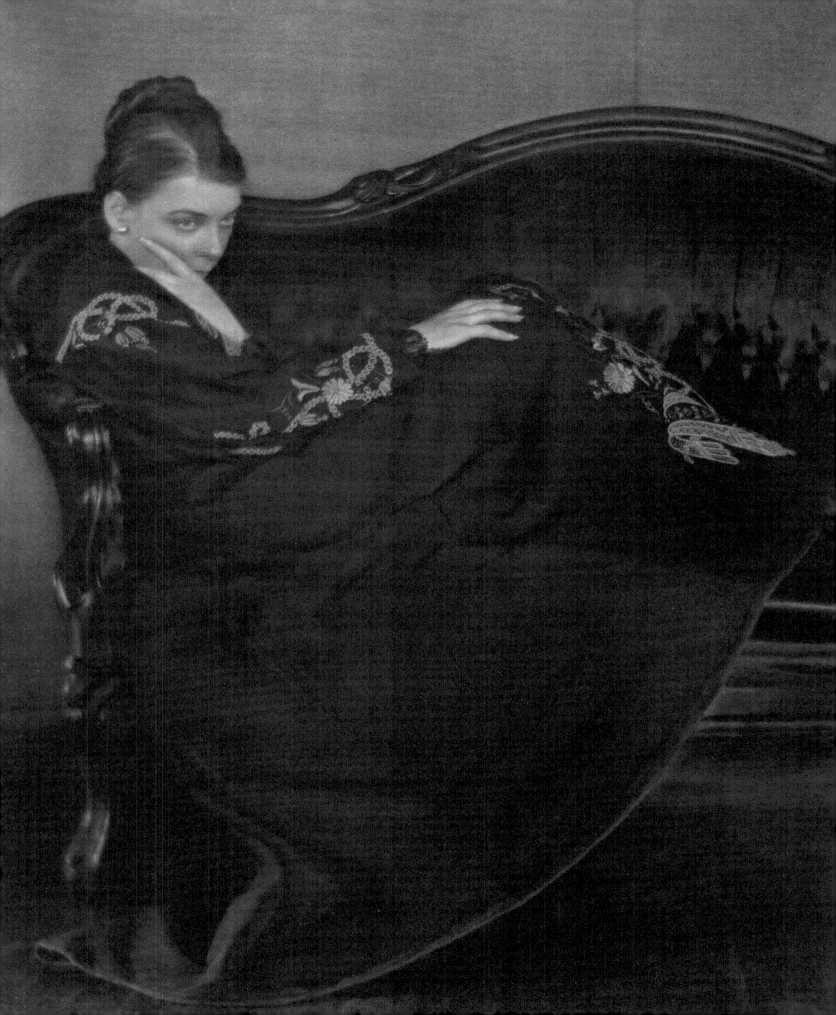

AN EXPANDING CIRCLE

MUCH OF THE GROWING professional acclaim that Weston experienced after 1913 can be ascribed to his affiliation with the photographer Margrethe Mather. Following a first chance meeting in his Tropico studio in the fall of that year, she soon became his mentor, favorite model, studio assistant, lover, and eventually his business partner. Writing in his daybook years later, Weston described their relationship as "a mad but beautiful life and love," and Mather as "the first most important person in my life."[1] Born to Mormon parents in Salt Lake City, Margrethe had lost her mother and gone out on her own at an early age. She was by far the more independent and worldly of the two; at the time they met, Edward was still, he admitted, a "naïve and unsophisticated" young man.[2] Their mutual friend the photographer Imogen Cunningham—who captured the two at work in their studio—agreed about Mather's importance to his artistic development, asserting that she was the "first and best influence on Edward Weston at a time when he was really a slick commercial photographer and an expert retoucher" (fig. 6).[3]

Margrethe introduced Edward to a greatly expanded circle of friends, and he was to credit her with opening his eyes to the worlds of fine art, music, literature, and dance. Of his new acquaintances and newly complex personal life—still married to Flora, but deeply involved with Margrethe—Edward wrote, "I was suddenly thrown into contact with a sophisticated group. . . . They were well-read, worldly wise, clever in conversation—could garnish with a smattering of French; they were parlor radicals, could sing I.W.W. [Industrial Workers of the World] songs, quote Emma Goldman on free love;

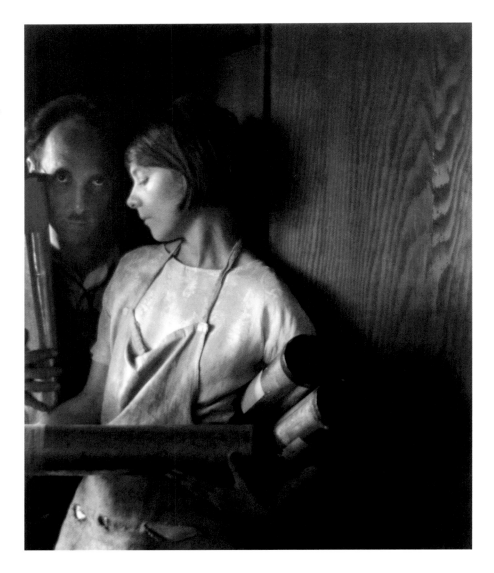

they drank, smoked, had affairs. . . . I was dazzled — this was a new world —
these people had something I wanted; actually they *did* open up new channels,
started me thinking from many fresh angles, looking toward hitherto uncon-
sidered horizons."[4]

With her contacts in the Los Angeles arts community, Mather also helped
forge important professional connections for Weston. She was, from the start,
the more established photographer. During the spring of 1914, Margrethe
apparently pushed Edward to take part in the creation of the Camera Pic-
torialists of Los Angeles, which she envisioned as a more elite and profes-
sional organization than the Los Angeles Camera Club, to which she already
belonged. Limited to only fifteen members, the Camera Pictorialists was one
of the few groups of its kind that Weston willingly joined. Even though his

involvement with the club was short-lived, he benefited from the opportunity to show work in its annual salon, held at the Los Angeles County Museum in Exposition Park, as well as from his association with fellow members — such as Louis Fleckenstein, an early promoter of fine art photography in southern California who had an international reputation.

The earliest likeness of Mather that Weston is known to have made is a straitlaced and sharp-focused portrait that dates from about 1913 (pl. 27). In it the free-spirited and bohemian Margrethe appears dressed incongruously in a conservative ruffled blouse, suit, and hat. She is seated next to a vase of flowers, with her hands resting gracefully in her lap; her light gray-blue eyes look directly into the camera's lens. The serious expression and strictly frontal pose contribute to a tongue-in-cheek collaboration that conjures up vernacular studio portraiture of a much earlier era. The resulting image is unlike any other that Edward took of her over the course of their decade-long relationship.

The following year Weston experienced his first major public success, with a photograph of Mather that he entitled *Carlota* (pl. 28). Carlota, the Belgian-born wife of Emperor Maximilian of Mexico, was a tragic figure who suffered from mental illness and lived in seclusion after her husband's execution in 1867. This romantic image demonstrates Weston's continued reliance on costume dress and invented titles to gain the attention of exhibition jurors and magazine editors. Unlike his more direct evocation of Longfellow's Priscilla, however, this shadowy profile portrait only subtly suggests its royal namesake through Mather's grief-stricken expression, dark fringed shawl, and fan. *Carlota* garnered much praise and attention at the London Salon, with one reviewer writing, "Mr. Weston is evidently a man of original ideas, sound technic, a refined artistic perception, and sense for decoration."[5]

For Weston, Mather seems to have been a fascinating yet elusive companion. She was known to have had both male and female lovers, and she would often disappear from his life for days or weeks at a time. Many of his images of her convey a sense of sadness or perhaps ennui. In 1918 he portrayed her outdoors wearing a broad-brimmed straw hat and clasping a bunch of flowers to her breast, like an illustration lifted from Robert Louis Stevenson's *A Child's Garden of Verses*, a book that the couple read aloud together and gave to each other as gifts (pl. 29).[6] Margrethe would sometimes leave haiku or love notes with flowers pressed between their pages during her frequent absences.

Edward's close-up image of Margrethe peering out from under a dark fur hat, taken two years later, is imbued with a similar melancholy (pl. 30). Her gaze does not meet his directly, and her delicate features are softened by the

subdued light of the studio. In contrast to the theatrical Symbolist-inspired portraits that were popular at the time, Weston's photographs of Mather rarely include more than the most modest of studio props, whether a horsehair settee with steeply curved back, a ceramic vase of flowers, or a framed mirror hung on plain fabric-covered walls (pls. 31–33). Some of these recurring objects are shown arranged in their spare surroundings in an image of the studio taken in 1919 (fig. 7). One of the most striking of his photographs of Margrethe is one of the simplest: It captures her turned away from the camera, with her head tilted slightly and eyes closed, and a single white cyclamen blossom held in her upraised hand (pl. 34).

The two most groundbreaking images of Mather that Weston made during their time together were *Epilogue*, in 1919 (pl. 35), and *Prologue to a Sad Spring*, in 1920 (pl. 36). Although he soon came to think of them as pendant portraits, these pictures met with a disparate public reception.[7] Critics of *Epilogue* were confused by the strange disequilibrium in scale between the shadowy still life in the foreground and the seated figure, as well as by the way the brilliant light that falls across Margrethe's face transforms her features into a pale, expressionless mask, and by the mysterious title. Imogen Cunningham wasn't troubled by the novelty of the composition or its title, praising it as an "intellectual type of photograph."[8] A writer in *Photo-Era* magazine was less generous: "The beholder who would decide for himself the significance of the episode expressed by Edward Weston in his capricious design, *Epilogue*, needs the gift of a fertile imagination."[9]

Prologue to a Sad Spring, with its less graphic and more lyrical, naturalistic style, did not meet with the same objections when Weston submitted it to a number of salons and exhibitions, from Los Angeles to Kansas City to Copenhagen. Not surprisingly, Cunningham admired this image as well, describing it in a letter to Weston as "poetic" and "full of dreams."[10] It portrays Mather wearing one of her characteristically timeless dark, flowing garments, with her face nearly hidden by the broad brim of her hat and her figure highlighted against the white barn boards and balanced by the sinuous shadow of a leafless tree. This photograph was among the very few early images included in Weston's 1946 MoMA retrospective, where he replaced its enigmatic title with the simpler *Shadow on Barn and Margrethe*, and it was also one of the photographs included in his later Project Prints.

Time to make pictures like these was scarce, however, as Weston found himself struggling to keep his studio financially solvent by taking portraits for paying customers of all ages, shapes, and sizes, and frequently chafing

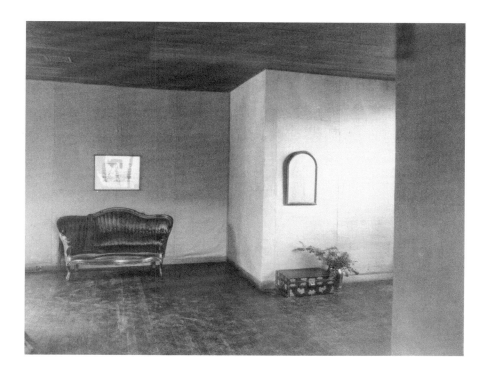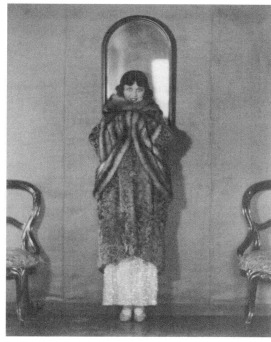

against sitters' demands for unrealistically smooth, unlined faces and slim figures. He also took on a small number of advertising or commercial assignments; one of a series of portraits he made of the popular silent film actress Margarita Fischer was featured in an ad for Willard George Furriers of Los Angeles that appeared in the Christmas 1919 issue of *Vogue* magazine (fig. 8). Enveloped in a luxurious mink coat over a sparkling evening gown, the smiling Fischer seems somewhat out of place in Weston's rustic studio, posed in front of a large mirror and flanked by a pair of simple wooden chairs. The same mirror appears in a more characteristic picture of Margrethe from this period, in which her back is turned to the camera (see pl. 33).

A rather formal portrait of two young girls in white dresses, hair ribbons, and matching striped socks records the angled corner of Weston's studio that had become a favorite spot for posing his subjects (pl. 37). Weston expertly transformed his tiny workspace to meet the needs of his sitters, changing the mirror or print on the wall, or deploying a vase or Chinese trunk as props. In other instances he was more concerned with controlling the constantly shifting natural light in the space, as in a dramatic, soft-focus close-up of a bride with a pearl-encrusted veil, taken about 1920 (pl. 38). In one of his several articles on the challenges inherent in portrait photography, he wrote, "I have a room full of corners—bright corners, dark corners, alcoves! An endless change takes place daily as the sun shifts from one window to another."[11]

Weston's approach to running a portrait studio and establishing himself as a fine art photographer reflected his California location, as pictorialist photography enjoyed a much more lasting influence on the West Coast than it did in the East. The New York photographer and Photo-Secession founder Alfred Stieglitz had been a major advocate for pictorialism through his gallery "291" and his quarterly journal *Camera Work*; the effects of his eventual conversion to modernism, during the 1910s, were somewhat delayed for Weston and his fellow California photographers because of geographical distance and a lack of West Coast representation among Photo-Secession members. California's lively Arts and Crafts scene helped prolong the public's taste for the decorative and handcrafted aspects of pictorialism, and its two major cities — San Francisco and Los Angeles — and many active camera clubs continued to be laboratories for the production of soft-focus fine art photography well into the first half of the twentieth century.[12]

The influence of Japanese art and culture was also felt more powerfully on the West Coast, and it was certainly important for Weston, whose studio sat only a few miles from Los Angeles's Little Tokyo district. He seems to have first fallen under the spell of Japanese design, in the same way that many of his contemporaries had, by immersing himself in the artist and educator Arthur Wesley Dow's influential book *Composition* (1899). Even before meeting Margrethe Mather or the scholar of Asian art and philosophy Ramiel McGehee — the two friends who most encouraged his fascination with everything from Japanese art, music, dance, and theater, to *sake* drinking — Weston recommended *Composition* in an article he wrote for *American Photography* magazine in 1912.[13] Dow's book focuses on the Japanese concept of *notan* — the harmonious, often asymmetrical arrangement of flat areas of dark and light and the balance of positive and negative space within an image (fig. 9). Weston's poetic photograph of a flowering almond branch from that same year resembles several of the publication's line drawings (pl. 39). The combination of its sharply focused foreground and indistinct, horizonless background presents a characteristically Japanese subject in a way that highlights the ephemerality of nature and the cycle of the seasons.[14]

Weston's photography throughout his early years as a pictorialist reflects his interest in Japanese art, in particular woodblock prints, which he would have had many opportunities to see in southern California. He often, for example, pairs the figure of Mather with a delicate still life of a few blossoming branches in a vase, conflating the female and the flower in a typically Japanesque manner. In *Margrethe in My Studio*, one of the flowering limbs bends

Fig. 9
Arthur Dow,
Composition,
page 25

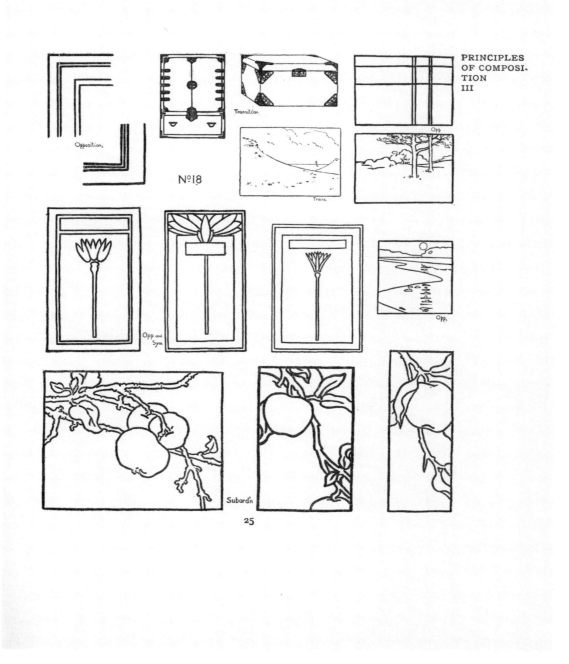

gracefully toward her hands, which hold a small lacquer box (pl. 40). The
viewer's eye is drawn to her softly lit profile and the single framed photograph
(another Weston image of Mather, titled *The Fan*) that she turns toward in the
otherwise empty space. A reviewer in the *Los Angeles Times* described this
print as "full of distinction in spacing, a poem without words."[15] Margrethe
also experimented with close-up still lifes of typically Japanese subjects, such

Fig. 10
Margrethe Mather,
Water Lily, 1922

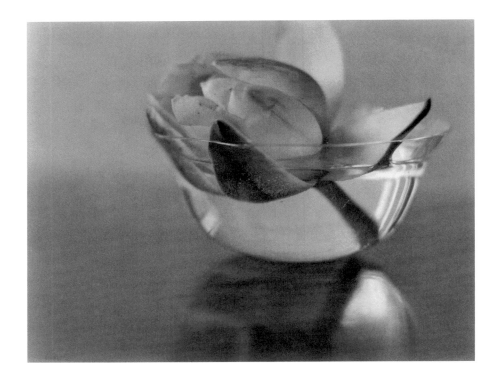

as water lilies or pine boughs, carefully placed and photographed in natural light in the studio (fig. 10).

In late 1915 or early 1916 Weston photographed his friend the modern dancer and choreographer Ruth St. Denis in a kimono reminiscent of those she had worn in *Omika*, a Japanese dance she had debuted a few years earlier and was then preparing to reprise for the vaudeville stage (pl. 41).[16] Shot in shadowy outdoor light, the photograph captures a single bright fleck of sunlight on the dancer's pale powdered cheek — a small but lovely detail not lost on jurors and critics in Cleveland, New York, and London, where the work was exhibited to very positive reviews. Weston autographed this image using a stylized vertical signature meant to suggest the signature blocks of Japanese prints. This short-lived pretension on his part may have been prompted by an exhibition of more than three hundred *ukiyo-e* prints at the Los Angeles Museum of History, Science, and Art in 1916 that he almost certainly would have seen.[17]

Weston went on to make another portrait of a person in a kimono, this time the Japanese-born writer, poet, and art critic Sadakichi Hartmann, perhaps best known for his numerous articles and reviews in Stieglitz's *Camera Notes* and *Camera Work* magazines (pl. 42). This sitting was their first meeting; Hartmann was apparently inspired to request it by his appreciation for Weston's photographs of others, including what the writer called the "Fantasie Japonaise" of Ruth St. Denis. In 1915 Hartmann wrote to him, "My dear

Weston, you are surely one of the anointed. . . . It seems that I have to get to [Tropico] one of these days to have myself counterfeited by you. My collection would be incomplete without it."[18] This rendering of Hartmann's elegant and ascetic figure is signed by both men directly on the print. It is one of several likenesses that Weston produced during this period that rely on natural light entering through an unseen window to cast a strong silhouette on the adjacent wall. In this case, the raking light also flattens the subject's dark form within the shallow space and defines the distinctive, rather careworn features that reflect Hartmann's mixed German and Japanese heritage.

Ruth St. Denis and Weston both acknowledged that their good friend Ramiel McGehee taught them much of what they knew about Japanese culture, especially its classical dance. McGehee had lived and studied in China and Japan for a number of years, and after returning to southern California often gave public lectures on topics from folklore to Zen Buddhism to Noh theater. His own dance performances, typically presented in authentic Asian costumes, had a profound effect on Weston. This connection may have led the photographer to make a spectacular image of a traditional Japanese fencer in 1921, a few years after first meeting McGehee (pl. 43). The Japanese martial art of *kendo* involves striking and parrying with bamboo swords, with the combatants protected by leather and fabric helmets. Here, Weston strongly illuminated one side of a helmet so that the bars of its metal grille create a network of lines on the wall, and the anonymous figure is transformed into an otherworldly insect-headed human.

The 1910s and 1920s were a period of burgeoning interest in modern dance in America in general, and southern California in particular. Los Angeles's hospitable climate that allowed for outdoor performances all year round, emphasis on physical fitness, melting pot of cultures, and ties to vaudeville and the silent film industry in Hollywood all helped it become a major hub for the medium of dance. The city rapidly developed into a center for experimental dance companies led by well-known artists, such as the Denishawn dancers founded by Ruth St. Denis and her husband, Ted Shawn. In 1916, the San Francisco–based photographer Arnold Genthe published his influential *Book of Dance*, in which he sought to document the dramatic movements of modern dance at a time when it was still challenging to record such fleeting and ephemeral gestures with a large-format camera. Weston most likely was familiar with Genthe's lavishly illustrated book, and its widespread popularity may have helped inspire the photographer's submissions to competitions and salons during the mid-teens that consisted almost exclusively of images of dancers. As early as October

1915, Weston featured a number of dance pictures in a single-artist exhibition held at the State Normal School. Among them were portraits of St. Denis and Shawn that were singled out for praise by the *Los Angeles Times* reviewer, Antony Anderson, who marveled that they "fell into the intent of the artist with a grace and abandon impossible to the ordinary mortal."[19]

One of these early dance photographs is a very soft-focus portrait of the dancer Ted Shawn as an androgynous leaping faun, rising up on one leg with his back arched, head thrown back, and arms outflung (pl. 44). Many who saw it felt that Shawn must have required some sort of physical support to maintain such a gravity-defying pose, but the image was nevertheless greatly admired by the sculptor Cyrus Dallin. Dallin wrote to Weston on receipt of a print of this photograph: "I think the 'dancing nude' almost the most beautiful photo of a dancing figure I ever saw and it has appealed to me so much from its plastic beauty that I have been tempted to make it in sculpture. It is truly quite a wonder from a sculptor's standpoint."[20] The print reproduced here was owned by the photographer Arthur F. Kales, a fellow member of the Camera Pictorialists club, whose wife belonged to the Denishawn dance company. Kales and Louis Fleckenstein were making their own dramatic images of dancers during this period, but unlike Weston's theirs were heavily manipulated prints that often featured movie-set backdrops or exotic props.

Another connection to the world of dance and theater was forged through Weston and Mather's friendship with George Hopkins, a Hollywood costume and set designer, whom Weston had photographed on at least two occasions in the 1910s. Hopkins also employed Weston to document a number of the Denishawn dancers wearing costumes of his own design. One of the most extravagant of the images Weston made is one of Yvonne Verlaine dressed in a goldfish-inspired dress with an iridescent hooded mask and long, shimmering train (pl. 45). Shot in low light, with flame-like shapes behind the sinuous figure, the impression is of a strange underwater creature rather than a human being. A much more understated picture, of an unknown dancer, may also have been part of this commission. It was photographed outdoors in natural light, possibly in Hopkins's Pasadena garden (pl. 46). A young female dancer with long, flowing hair poses under a tree whose anthropomorphic trunk and branches seem to respond to the turn of her head and the gesture of her outstretched arm.

Weston himself loved to dance and continued to seek out professional dancers as models well into the 1930s, because they understood the dynamics of movement in space and were less inhibited in their poses. A group of

Detail, plate 46

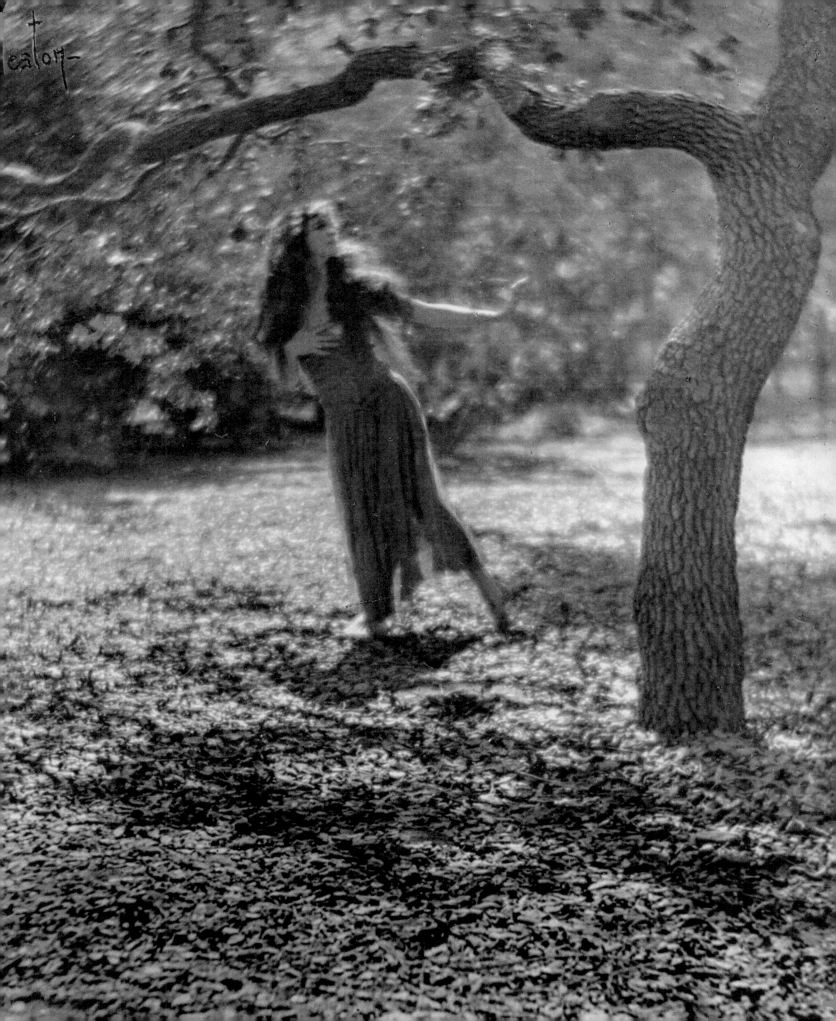

his photographs of the New York–based Marion Morgan Dancers was reproduced in the rotogravure section of the *Los Angeles Times* on December 26, 1920; these may have been the first female nudes to appear in its pages.[21] The seven images of the female interpretive dance troupe that were included in the newspaper spread are credited to both Mather and Weston. During 1920 and 1921 the two photographers were working in such close partnership that they co-signed a number of prints. The Marion Morgan Dancers appear on the grounds of Anoakia, a Renaissance Revival estate north of Los Angles, which featured elaborate colonnaded gardens, fountains, and pools that offered an appropriate setting for dancers known for their classically themed tableaux and dances (pl. 47).[22] Here the two nude figures are framed by soft shadows that conceal their faces, preserving their anonymity and focusing attention on their elegant, languid poses on a sunlit marble bench.

A somewhat earlier invitation in 1919 to photograph outside the confines of his studio — from a friend and distant cousin, Sarah Bixby Smith — led Weston to make two of his most understated and meticulously composed nude studies. These portraits of Bixby Smith's young sons are from a series of at least four images taken of the brothers posed along the edge of an indoor swimming pool at the family's Claremont home, which had once been a private boys' school (pls. 48, 49). Both pictures capture a swath of light from an unseen window that slants against the rear wall of the large room and is reflected in the gentle ripples of the water. The insouciant boys are visually anchored by the angle of the light, the geometric rim of the pool, and their own soft reflections on the water's surface.

A handful of strikingly abstract pictures from the early 1920s seem to relate to Weston's interest in the milieu of dance, drama, and music. In both *Scene Shifter*, of 1921, and his portrait of the avant-garde pianist Ruth Deardorff Shaw, made the following year, Weston employed strong, directional lighting and very simple props with which his sitters interact in shallow, stage-like spaces. Illumination from the lower right of the scene casts an exaggerated dark shadow of the anonymous man in *Scene Shifter* as he poses between the legs of a wooden ladder, his legs spread and his face turned away from the viewer (pl. 50). This rather baffling image relates to the depiction of Ruth Shaw, with her distinctive sharply angled bangs and slender figure, as she leans out awkwardly from a row of what could be theatrical backdrops (pl. 51). Weston's somewhat less than flattering treatment of Shaw may be explained, at least in part, by his response to her notoriously prickly personality. Her challenging modernist piano recitals were said to have left Los Angeles audiences confused and unsettled.[23]

A definite shift of emphasis toward dramatic contrasts of light and shadow emerges in Weston's studio portraiture beginning about 1918–19. At the time when he made his groundbreaking artificially lit photograph of Mather entitled *Epilogue* (see pl. 35), he also embarked on a group of pictures of close friends that present them posed in the strong natural light that flooded into his Tropico studio. These include *Enrique*, an image of his studio assistant at the time, Enrica Jackson, whom he had first met while working at Mojonier's studio almost a decade earlier (pl. 52). Weston's portrait of her, standing in raking window light and wearing a lace mantilla, was shot using an 8 x 10-inch camera fitted with a soft-focus lens. It was widely celebrated when it was shown at the Scottish National Photographic Salon in Glasgow in 1920, as well as in Boston and New York. An editor at *American Photography* described the image, which had won an honorable mention in the magazine's first annual competition, as "a study in strong contrast, in queer shapes and various tones, cunningly contrasted one against the other" and "the result of . . . long and arduous practice in posing and lighting."[24]

The same could have been said for a portrait of Weston's fellow photographer Johan Hagemeyer, which Weston inscribed on the verso: "Mynheer, J.H." (pl. 53). The Netherlands-born artist, who was living in southern California at the time and had recently become one of Weston's closest confidants, would have certainly seen the humor in his use of the Dutch equivalent of "mister" or "sir." Hagemeyer seems to have been willing to pose for his friend's camera on numerous occasions — here, possibly during the two months in 1918 that he apprenticed in Weston's studio — patiently waiting until the reflected light on the wall and the deep shadows of his own silhouette might be captured on film. Imogen Cunningham singled out Weston's likeness of George Hopkins entitled *Sun Mask* for its similar characteristics (pl. 54). This remarkable image — one of a handful that survive from a single, very successful sitting — records the exact moment in which a bright circle of sunlight falls across Hopkins's face and is repeated in his round dark-rimmed glasses. Cunningham was quick to point out: "While it might appear a stunt to most people [it] is so wonderfully carried out as to be so much more."[25]

Even as late as 1920, the majority of Weston's professional camera work would still have revolved around taking portraits for paying customers, mostly everyday people, on special occasions such as weddings and birthdays. In a letter sent to his friend Hagemeyer in October of that year, Weston described himself as already "busy with holiday work — Margrethe helping — raised prices to [$]15."[26] Weston's studio also became a magnet for the many Hollywood and

other celebrities drawn to southern California. Among those who sat for pictures was the Hungarian-born artist Franz Geritz, framed by two large panels in the studio (perhaps those in the image of Ruth Shaw), in a dapper costume complete with hat and cane, and holding a printer's block in his hand (pl. 55). The friendship that developed from this sitting eventually resulted in Geritz's producing a series of woodblock portraits of Mather and Weston that were loosely based on their photographs of each other.

Another celebrated figure who found his way to Weston's studio was the poet Alfred Kreymborg, an early member of the Stieglitz circle in New York who was soon to become editor of *Broom: An International Magazine of the Arts*. Weston's surprisingly stagy and playful portrait of Kreymborg, sometimes titled *Balloon Fantasy*, was made during the writer's speaking tour through California in the spring and summer of 1921 (pl. 56). Kreymborg had recently lectured at the Friday Morning Club of Los Angeles, the largest women's club in California at the time, which had been the first institution to offer Weston a solo exhibition of his work, in 1914. A regular on the poetry circuit, Kreymborg was noted for his recitations, which he accompanied on the hybrid stringed instrument known as a mandolute, shown in Weston's portrait. Years later, the photographer's youngest son, Cole, recalled being asked to string up the balloons for this photo session; they were meant to allude to the opening lines of one of Kreymborg's best-known poems, "In a Dream": "Oh, what delirious fun this is, / the juggling of crazy balloons!"[27]

During these same years, Weston produced a series of photographs he referred to as the "attic prints," which marked a major turning point in his career. As was often the case with Weston, a romantic liaison was the apparent instigation for several of these pictures. In the fall of 1920, Edward began a brief but passionate affair with Betty Katz, a Romanian émigré from New York City who suffered from tuberculosis. She had come to Los Angeles to recuperate from her disease, and was sometimes forced to spend long stretches of time living in the desert whenever her condition worsened. The dark-haired, exotic-looking Katz was a longtime friend of Mather's and had been photographed by her as well. So, in the hope of keeping their affair a secret, Edward and Betty met in a borrowed attic apartment under the eaves of an old Victorian house in downtown Los Angeles. There Weston made a number of intriguing images of Katz. In at least one of them she is nearly nude, but several depict her wearing the same long dark dress, seated on the floor smoking a cigarette or standing and leaning into the steeply angled walls of the nearly vacant space. Edward also recorded her lounging on the house's ornate, Moorish-style balcony with

Fig. 11
Souvenir, 1920

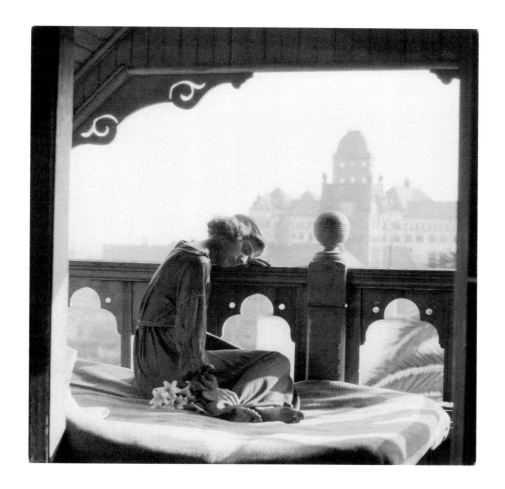

a view of the city in the distance (fig. 11); in a letter to her, he wrote: "Think of having missed those moments on your balcony!—to have never known that starlit hour of ecstasy."[28]

The photograph he titled *Betty in Her Attic* and made public only after their relationship had ended was not universally appreciated by the critics, who were confused by the ungainliness of Katz's pose, the abstract geometry of the composition, and its large expanse of empty space (pl. 57). One writer in *Photograms of the Year* went so far as to say, "Queerness for its own sake must have obsessed Edward Weston . . . [and] the position of the girl!—is there not a touch of pure cussedness in that?"[29] Edward appears not to have been particularly affected by critiques like these; if anything, they may have simply confirmed for him that he no longer needed the affirmation of the salon prizes and magazine competitions that had seemed so important in previous years. From this point on, Weston gradually submitted fewer and fewer prints to competitions. When Weston complained that one of his attic pictures had been passed over for a Wanamaker Prize—whose panel of judges included Alfred

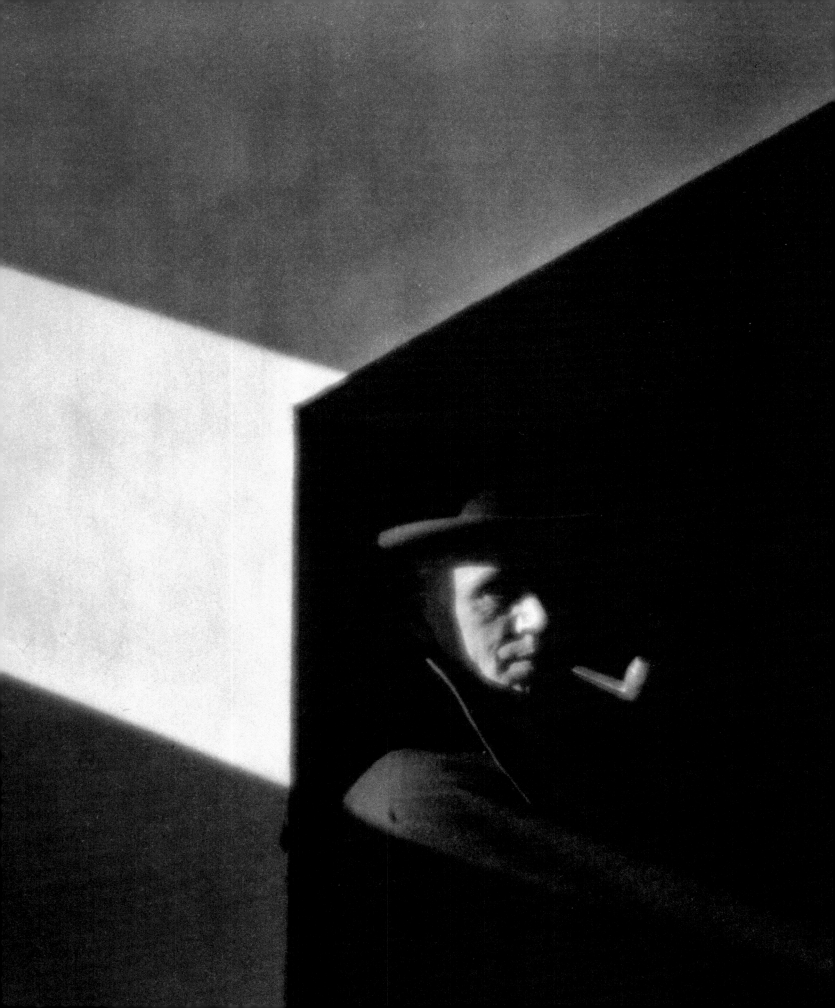

Stieglitz—he was heartened by the response of J. Nilsen Laurvik, director of the San Francisco Palace of Fine Arts, who said: "Pay no attention to Stieglitz, he is afraid of them; they are too original."[30]

The attic photographs of Katz were not Weston's first experiments with portraiture and architectural abstraction. In a letter written in July 1920, Imogen Cunningham effusively praised another of Edward's experimental attic pictures taken earlier that summer—in this case, a picture of Weston's friend Ramiel McGehee in a garret-like space in Redondo Beach (pl. 58). Cunningham wrote, "If that doesn't make old near-sighted Stieglitz sit up and look around . . . I don't know what could. It has Paul Strand's eccentric efforts . . . put entirely to shame, because it is more than eccentric. It has all the cubisticly inclined photographers laid low. It is a most pleasing thing for the mind to dwell on. . . . It is literal in a most beautiful and intellectual way."[31] Weston and his fellow West Coast photographers would certainly have been aware of Alfred Stieglitz's very vocal criticism of soft-focus pictorialism and his praise for Strand's much more abstract, cubist-inspired photographs, to which Stieglitz had devoted the final issue of *Camera Work* in 1917. So it is not surprising that Weston had begun to tackle some of these same concerns in his own work. More than the portrait that its title suggests, *Ramiel in His Attic* became a study in camera "vision": an investigation into how the camera transformed a sunlit dormered room and figure into a series of geometric shapes, reducing them from three dimensions to two, and how printing in palladium turned the composition into an arrangement of tones from black to white and all the shades of gray in between.

Weston received a thoroughly positive response from reviewers to his photograph of Ramiel, with one writer describing it as "a gem of cleverness" and an image that would leave a "conventional portraitist . . . gasping."[32] He submitted it to at least five major exhibitions during 1921 and singled it out as one of the very few prints he showed to Stieglitz when the two finally met in New York in 1922. The success of the pictures of Ramiel and Betty may also have encouraged Weston to create two very austere portrait studies of the photographer Johan Hagemeyer and the pianist Ruth Shaw that employ some of the same compositional devices as the attic photographs, without the spatial context. The image of Hagemeyer, sometimes titled *Sunny Corner in an Attic*, portrays him framed by a sliver of bright light, seated in a shadowy niche under an eave with only part of his face and the end of his pipe visible (pl. 59). The more extreme close-up of Ruth Shaw captures her in sharp profile, her head dramatically cropped to align the angle of her modern haircut with the

Detail, plate 59

triangles created by a mounted print set against the dark surface behind her (pl. 60). The resulting portrait is no longer simply a likeness of a friend, but a study in abstract forms and contrasting planes of dark and light.

Another of Weston's portraits of elegant men from this period records the lanky figure of the etcher Ralph Pearson posed against a pocked and crumbling adobe facade (pl. 61). Pearson had trained at the Art Institute of Chicago, and was a member of the California Society of Etchers; he had recently opened a studio in northern New Mexico. In this beautifully tonal yet sharp-focused print Weston portrays Pearson standing at the far left of the composition, looking away from the camera, with his arms crossed and knee bent, outlined by the meandering pattern on the worn surface of the wall. This image was taken as part of a series that the photographer made at this site of a group of artists who were showing their work in Los Angeles in 1922. The subjects included Weston's friend Roi Partridge, also a member of the California Society of Etchers, who taught at Mills College and was married to Imogen Cunningham.

In March 1921 Weston and Mather made portraits of two of the most radical American thinkers and writers of the postwar period — the poet Carl Sandburg and the political activist Max Eastman — as they were passing through Los Angeles. Mather and Weston co-signed the prints, although Max Eastman later recalled that Weston had not even been present on the occasion of his portrait shoot. The outdoor settings of these pictures are particularly fitting to their subjects, who would have been less comfortable in the contained environment of the photography studio than in the natural world. For Carl Sandburg, the photographers used a location not far from Weston's work space, posing him leaning on the curved railing of a bridge that crossed the Los Angeles River and carried the electric commuter train that ran between downtown and Glendale (pl. 62). At the time, Sandburg was a film critic for the *Chicago Daily News*, which probably brought him to Los Angeles; he also was the brother-in-law of Edward Steichen and had a number of acquaintances in common with Weston and Mather who could have made the connection with them. In their likeness of the famously rough-hewn Midwest poet, Sandburg is shown looking off into the distance, his jaw set and his hat pulled low over his forehead, during a break in the clouds on what had been a gray, rainy day.

Max Eastman, an editor of the socialist journal *The Masses* and an activist for a variety of liberal causes and women's rights, was photographed later in the same month, by the seashore. One of the images depicts him seated on a long wooden fence that recedes into space in much the same way as the bridge railing curves into the distance in Sandburg's portrait (pl. 63). Weston

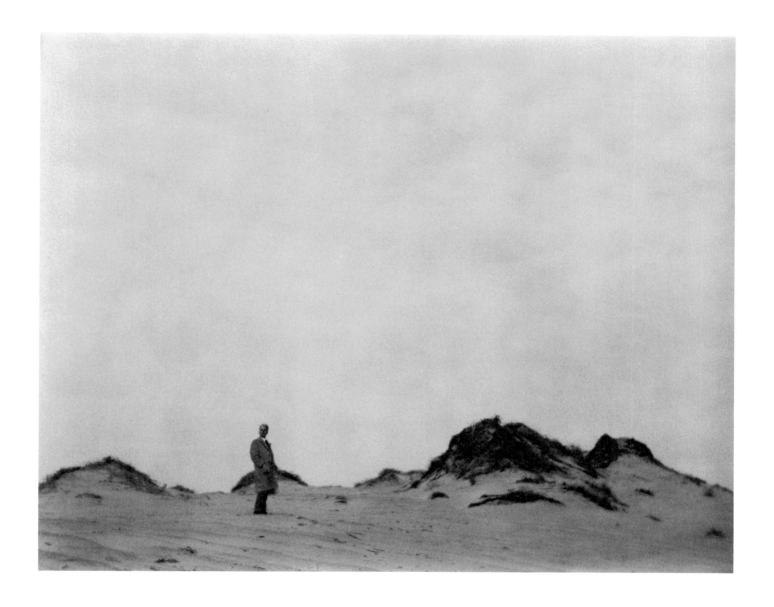

and Mather would later exhibit this print paired with the Sandburg image as pendant portraits on a number of occasions. Perhaps in recognition of the mutual admiration between the two men, Carl Sandburg chose one of the dune pictures of Eastman for his personal collection. In another image from the session, possibly shot by Mather, Eastman appears as a tiny dark form in the midst of low, windswept sand dunes set off against a blank expanse of sky (fig. 12). The nationally renowned subjects of these portraits indicate that Weston was now traveling in more elevated cultural circles, as he continued to move away from commercial and conventional photography and develop his own modernist aesthetic.

Fig. 12
Edward Weston and
Margrethe Mather,
*Figure in Landscape
(Max Eastman)*, 1921

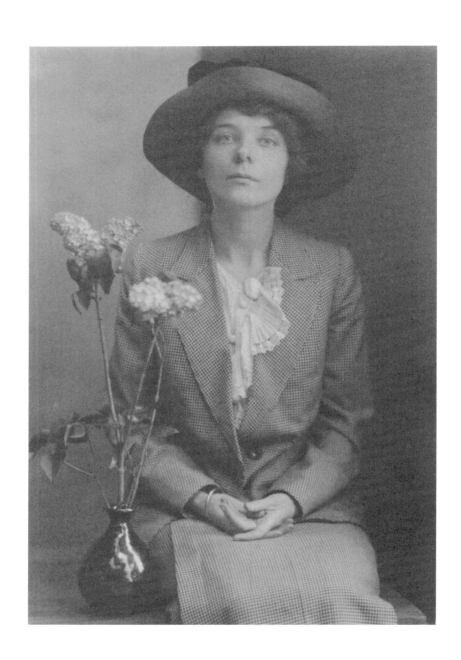

27 | MARGRETHE MATHER, ABOUT 1913

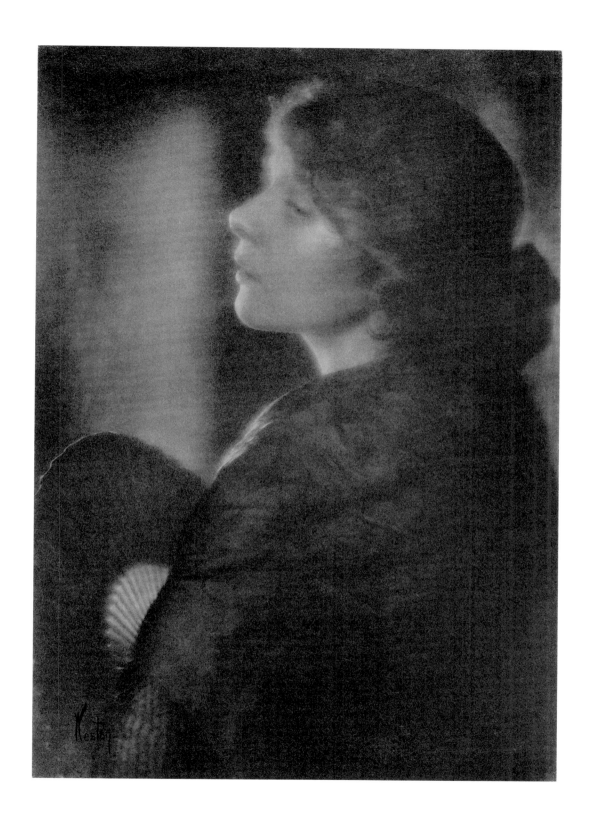

28 | CARLOTA, 1914

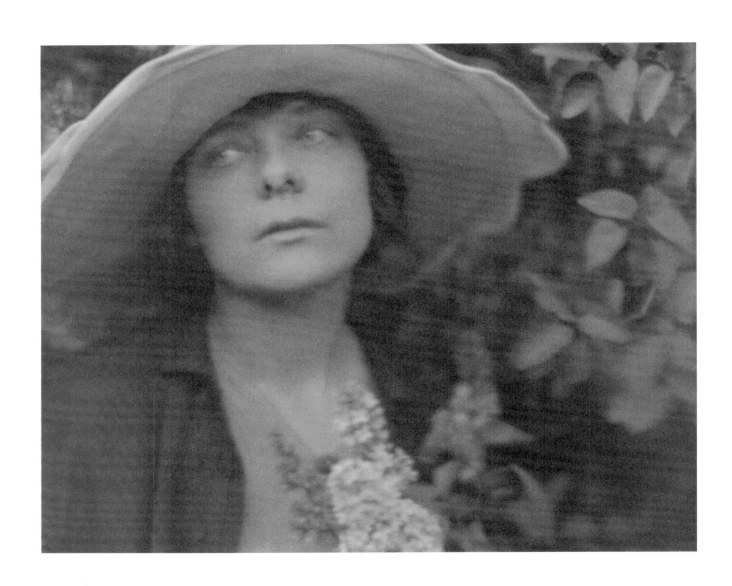

29 | MARGRETHE IN GARDEN, ABOUT 1918

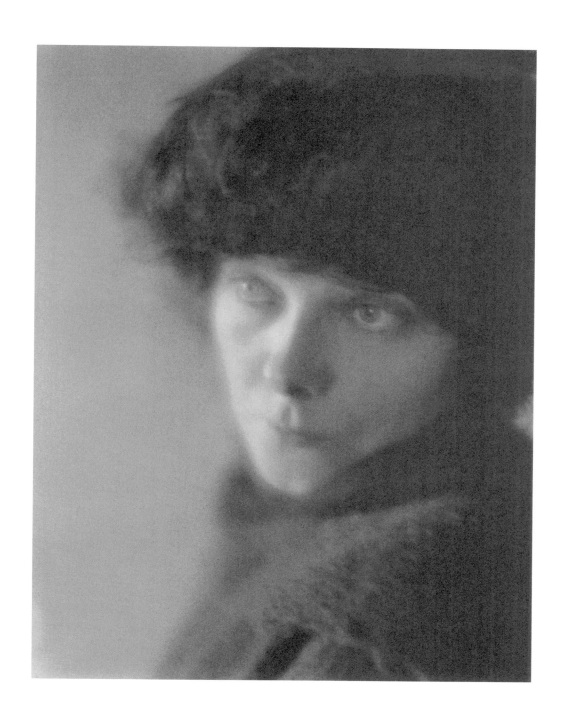

30 | MARGRETHE IN THE STUDIO, 1920

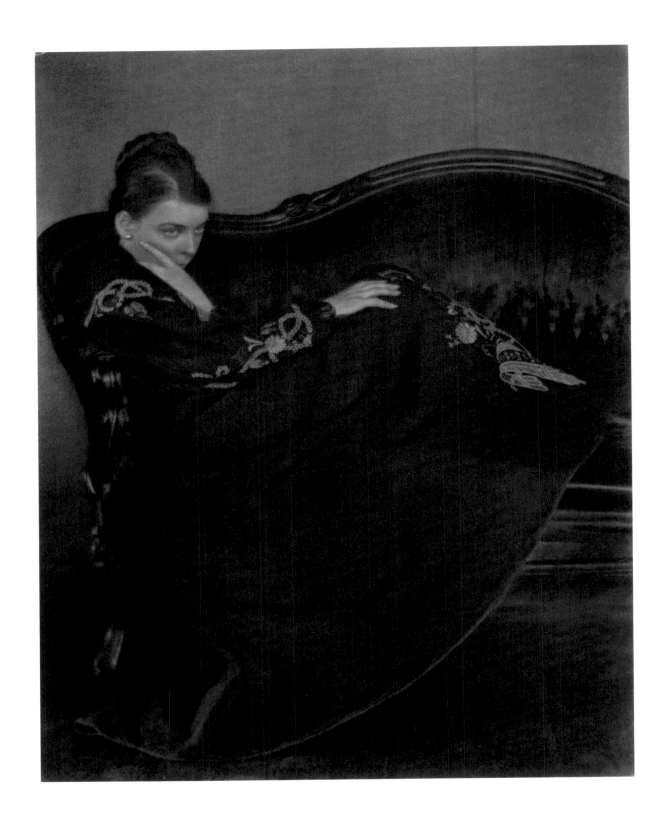

31 | MARGRETHE MATHER, 1921

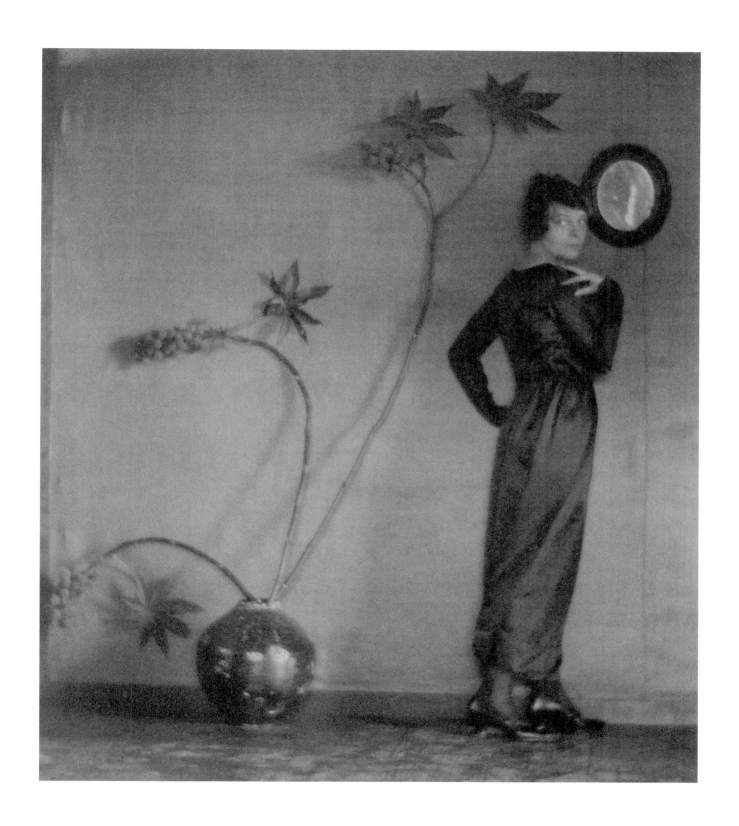

32 | MARGRETHE IN THE STUDIO, 1920

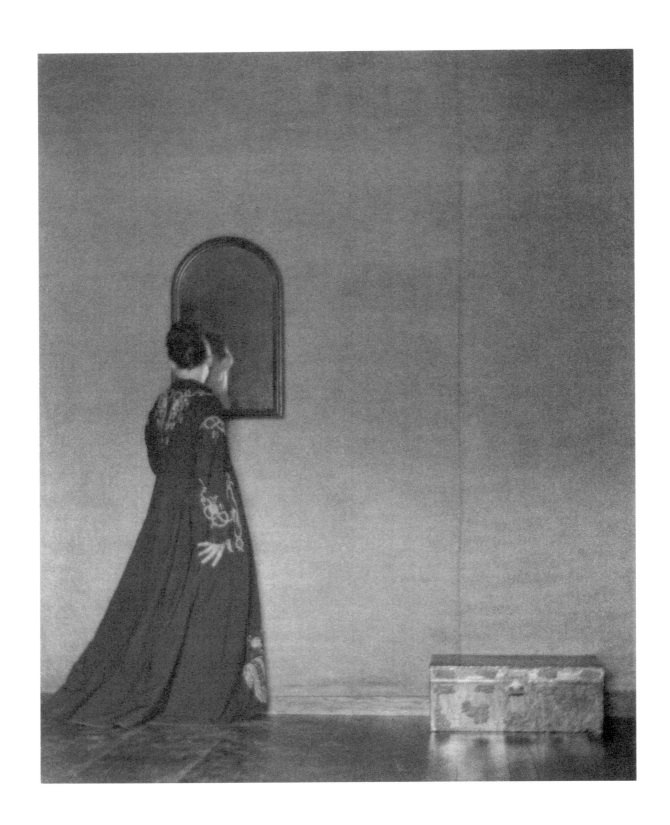

33 | MARGRETHE MATHER IN MY STUDIO, 1921

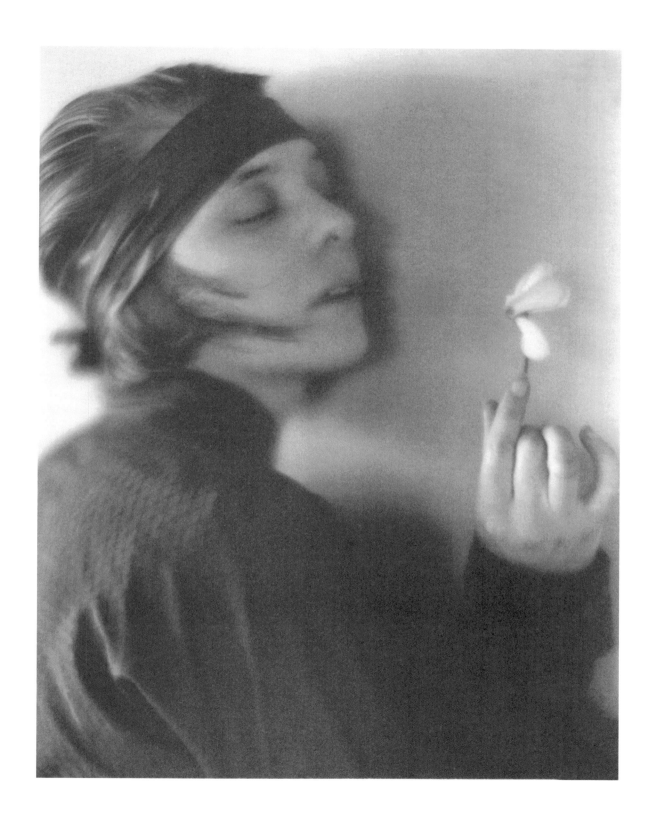

34 | UNTITLED (MARGRETHE MATHER), 1921

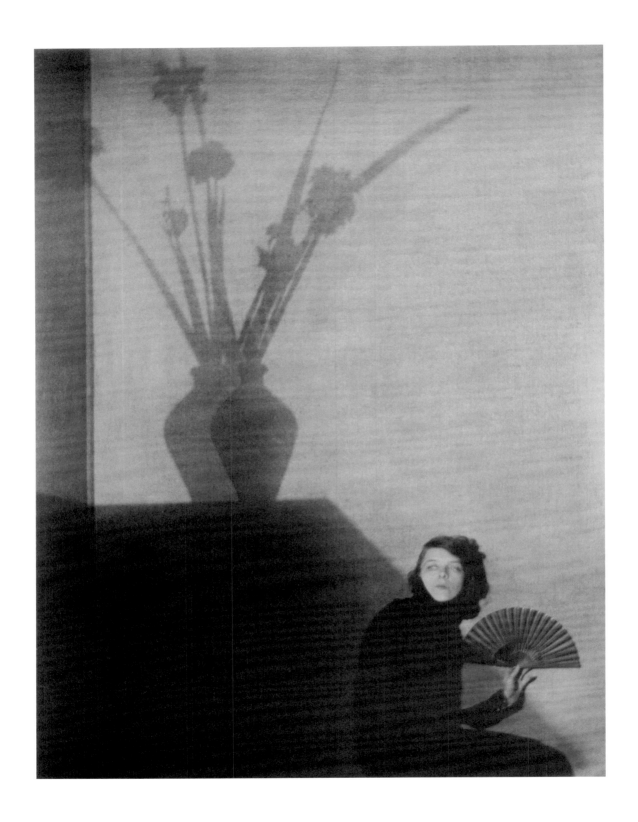

35 | EPILOGUE, 1919

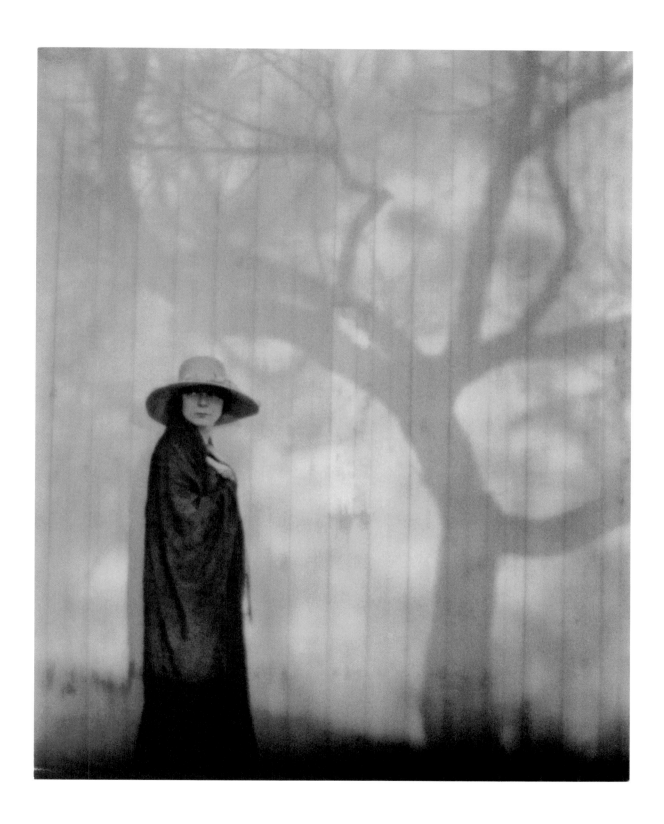

36 | PROLOGUE TO A SAD SPRING, 1920

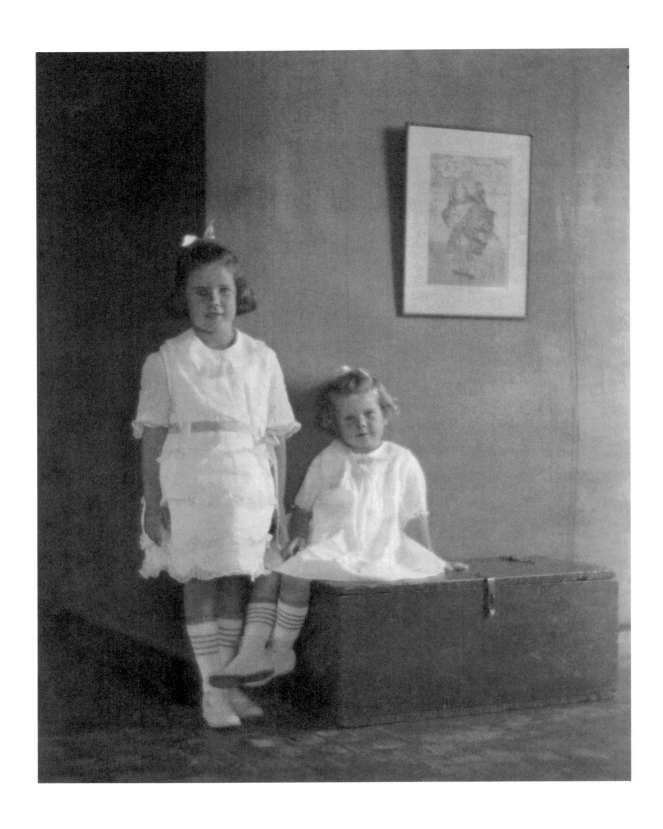

37 | UNTITLED (PORTRAIT OF TWO GIRLS), ABOUT 1919

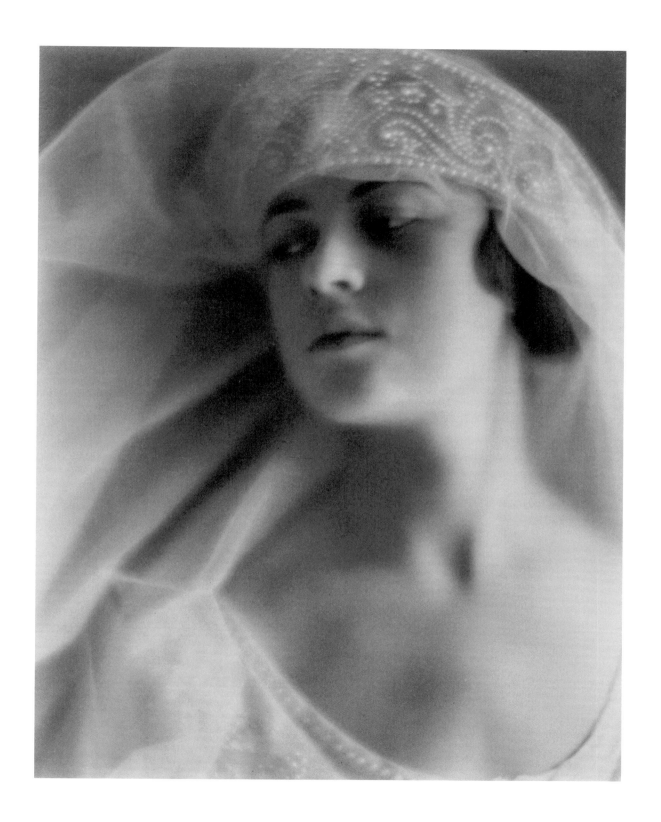

38 | PORTRAIT OF A BRIDE, ABOUT 1920

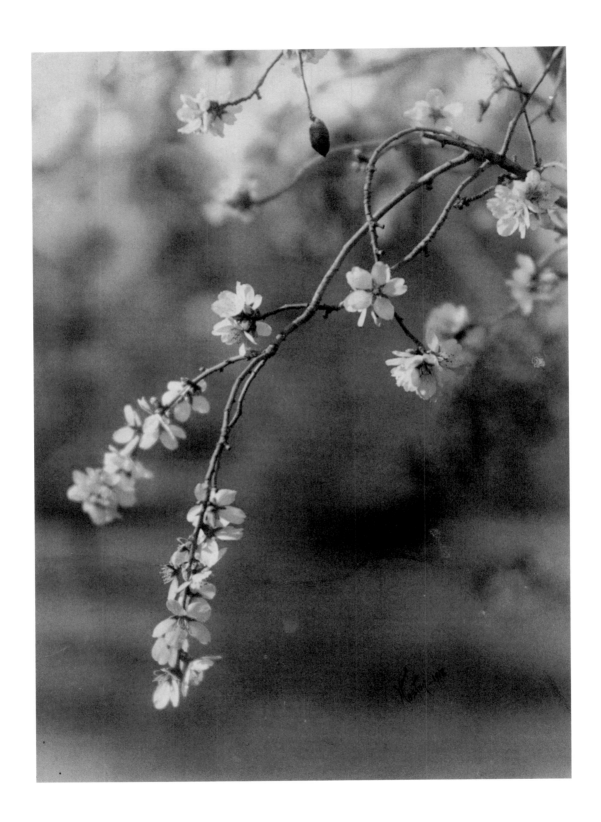

39 | ALMOND BLOSSOMS, 1912

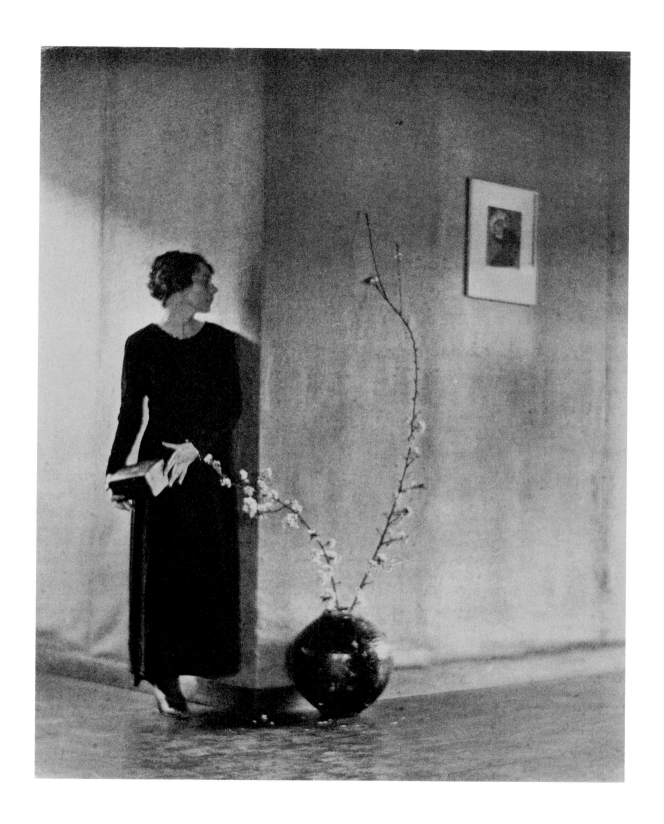

40 | MARGRETHE IN MY STUDIO, 1917

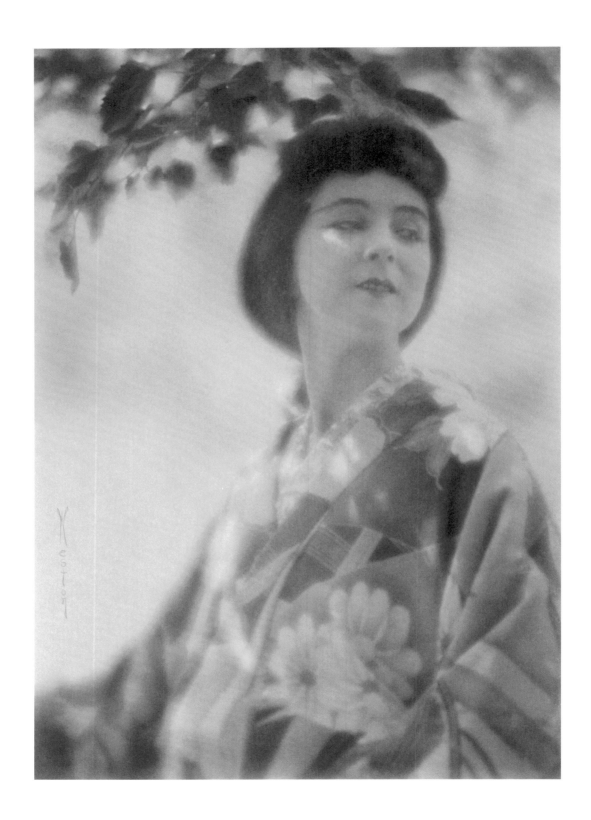

41 | RUTH ST. DENIS, ABOUT 1916

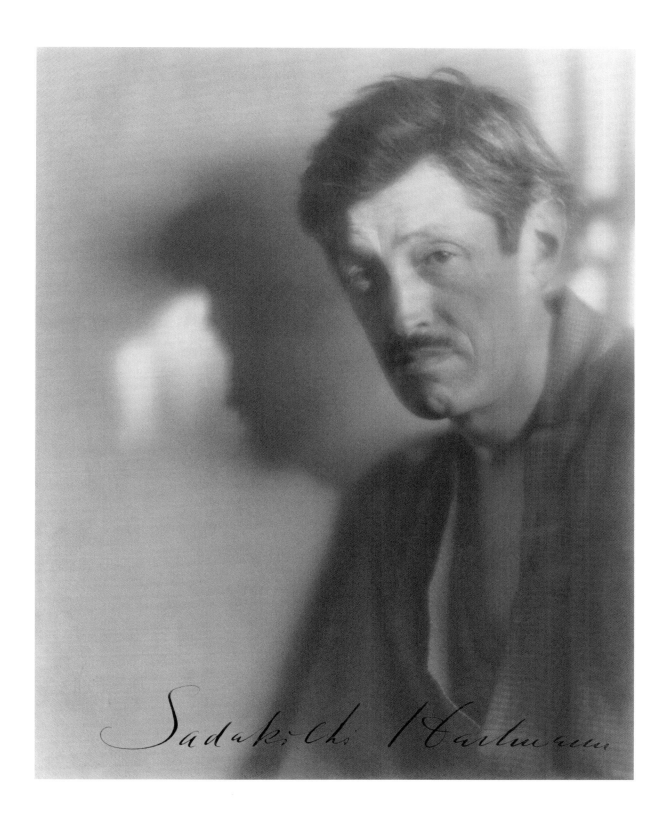

42 | SADAKICHI HARTMANN, 1917

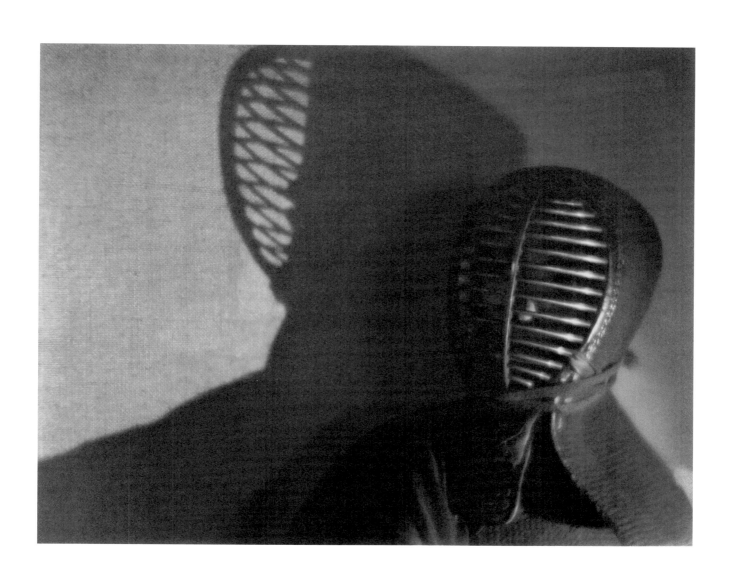

43 | JAPANESE FENCING MASK, 1921

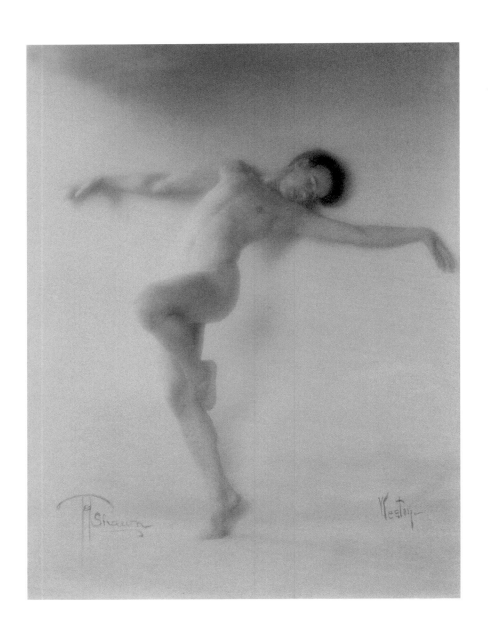

44 | TED SHAWN (DANCING NUDE), 1916

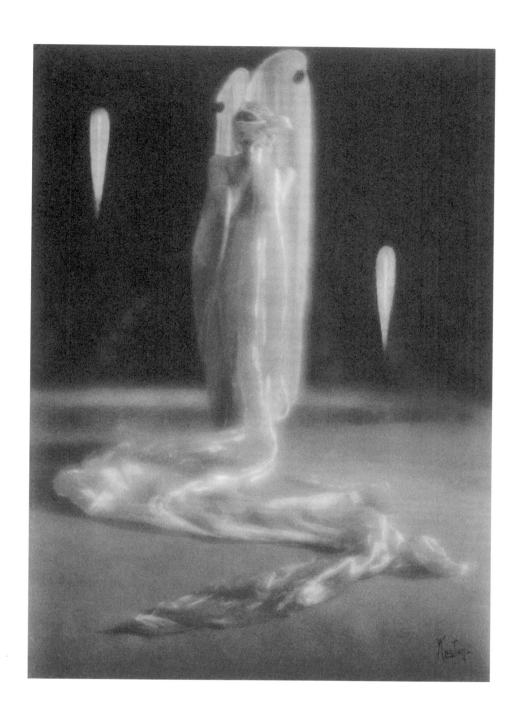

45 | COSTUME STUDY (THE GOLDFISH), ABOUT 1916–17

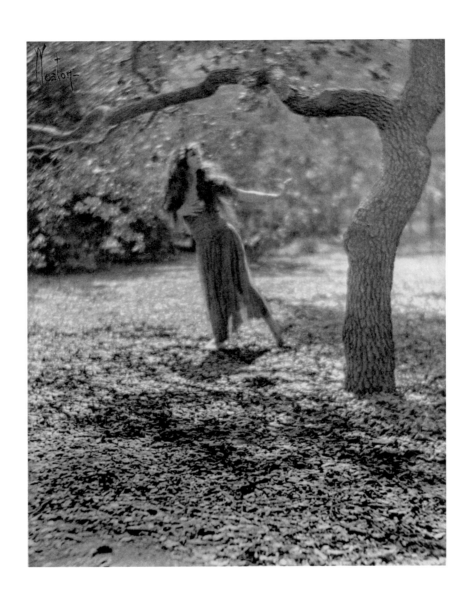

46 | DANCER, ABOUT 1916–17

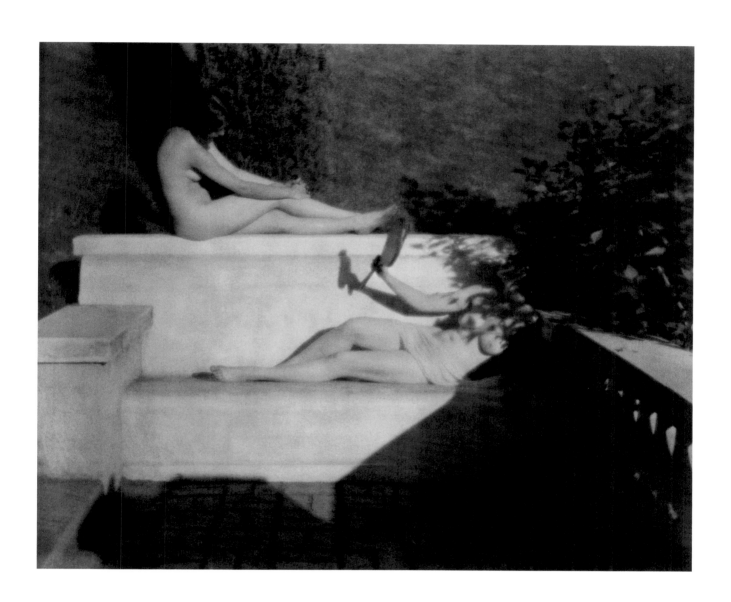

47 | EDWARD WESTON AND MARGRETHE MATHER | MARION MORGAN DANCERS, 1920

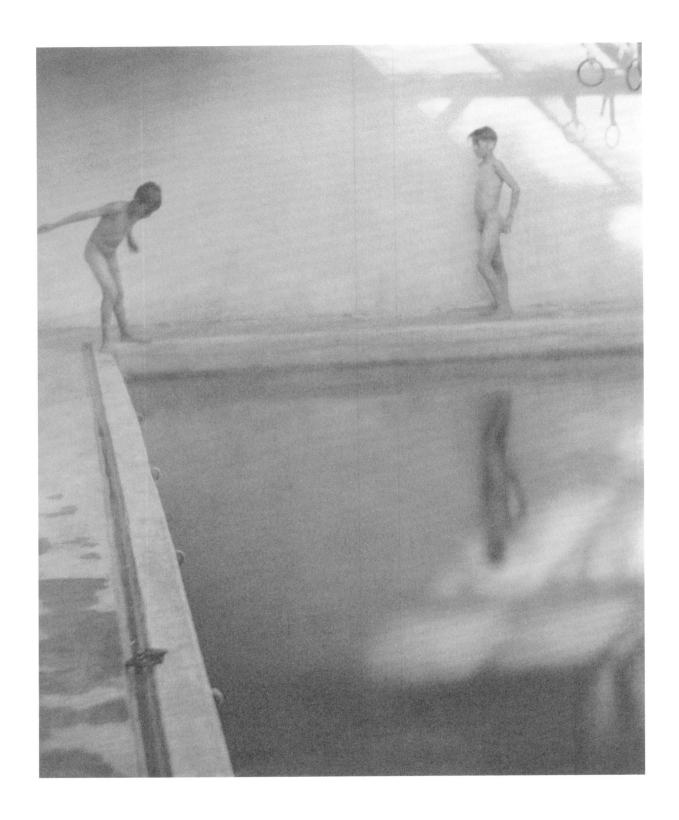

48 | BATHERS, 1919

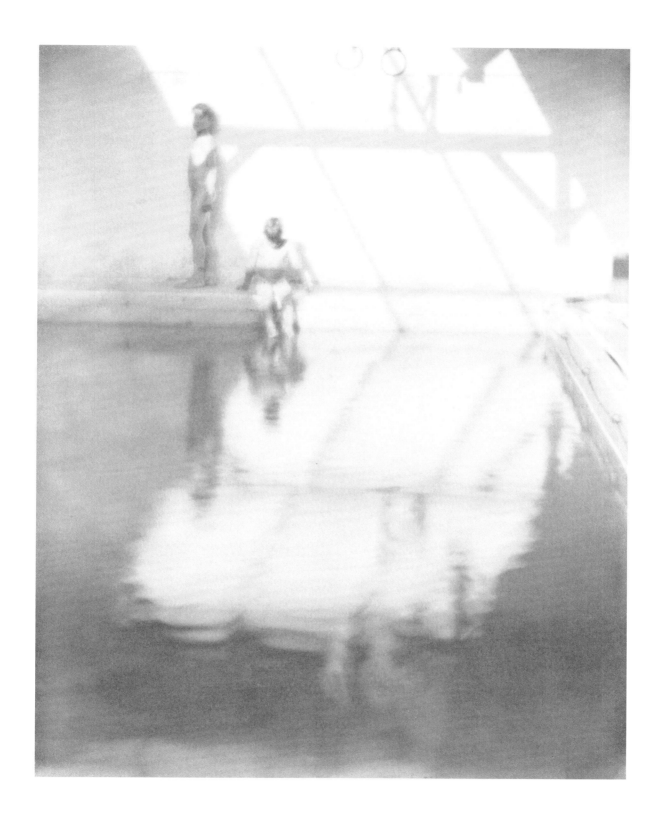

49 | BATHING POOL, 1919

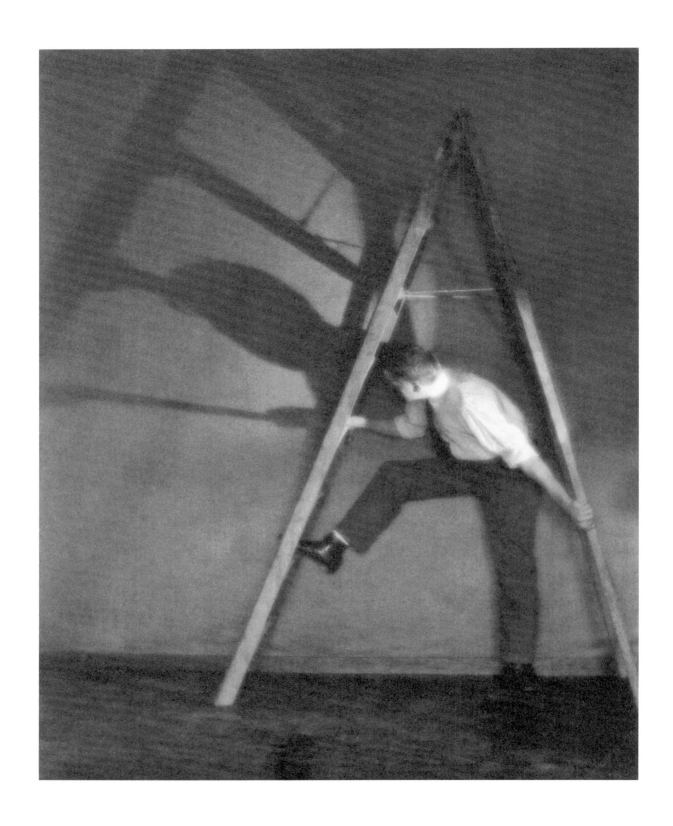

50 | SCENE SHIFTER, 1921

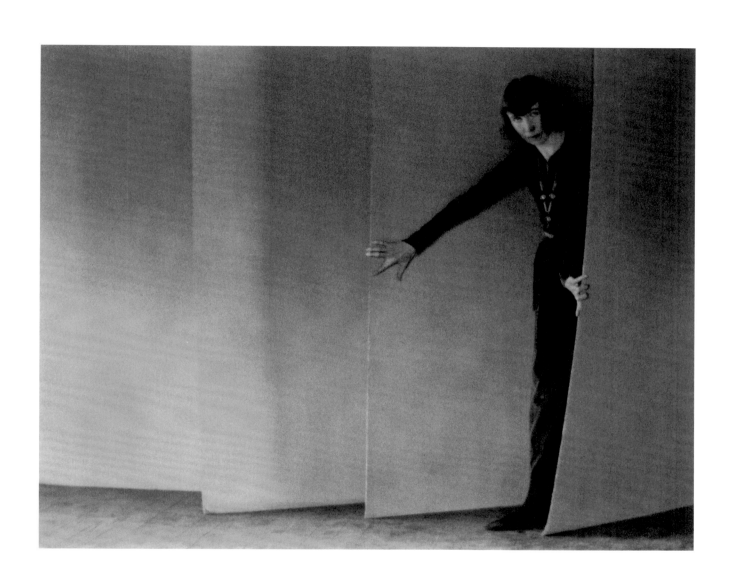

51 | RUTH DEARDORFF SHAW, 1922

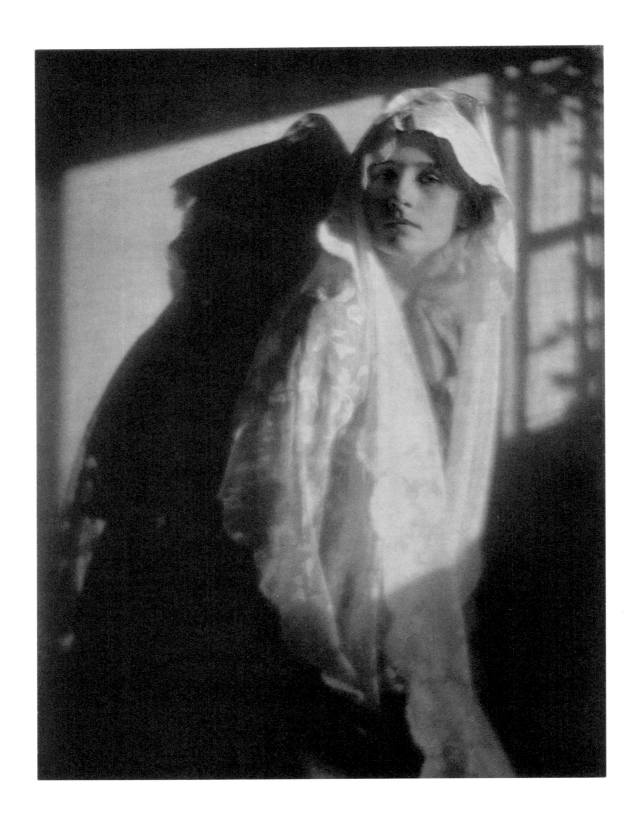

52 | ENRIQUE, 1919

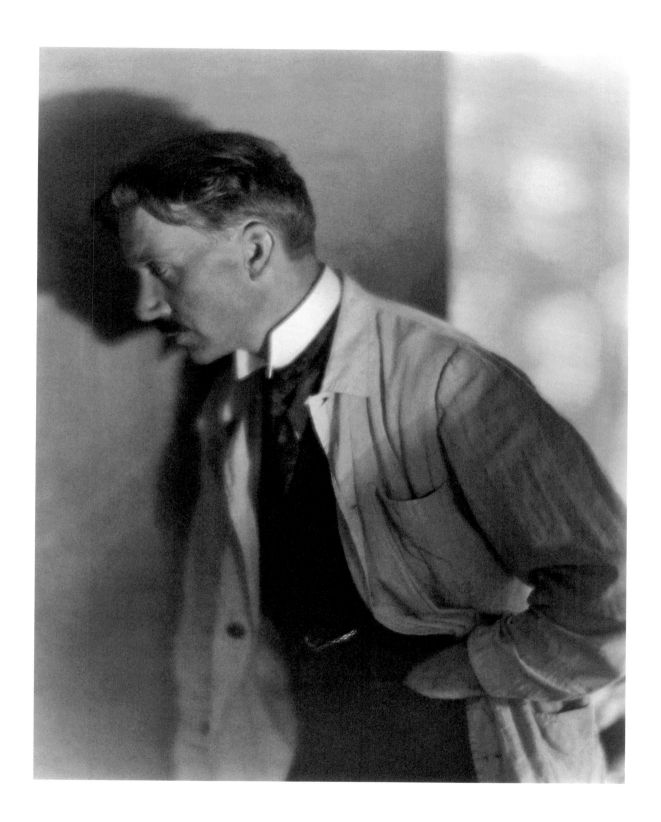

53 | MYNHEER, J.H., 1918

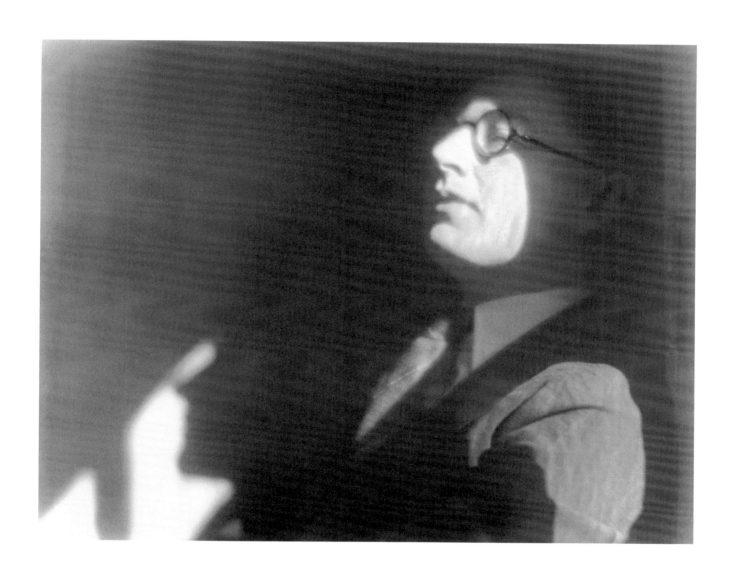

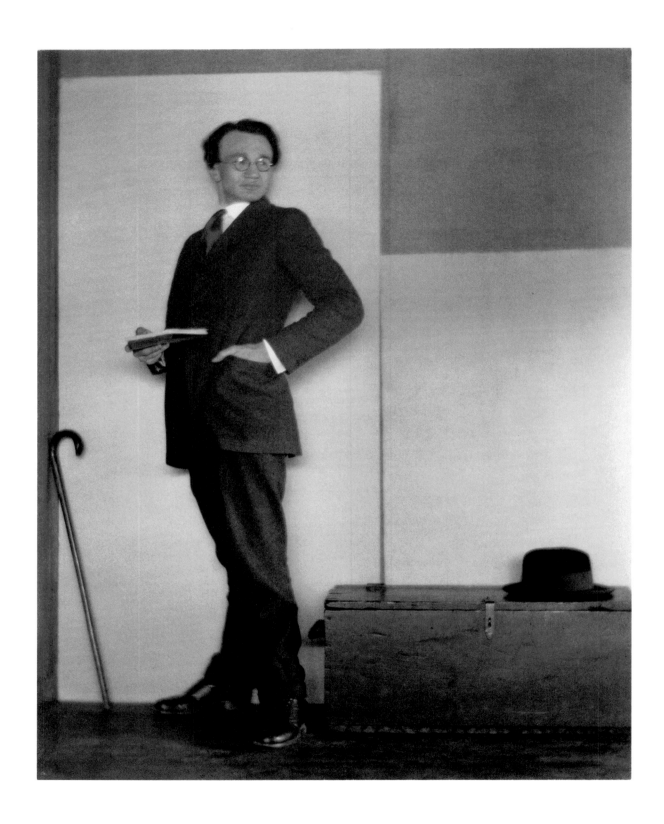

55 | FRANZ GERITZ, 1920

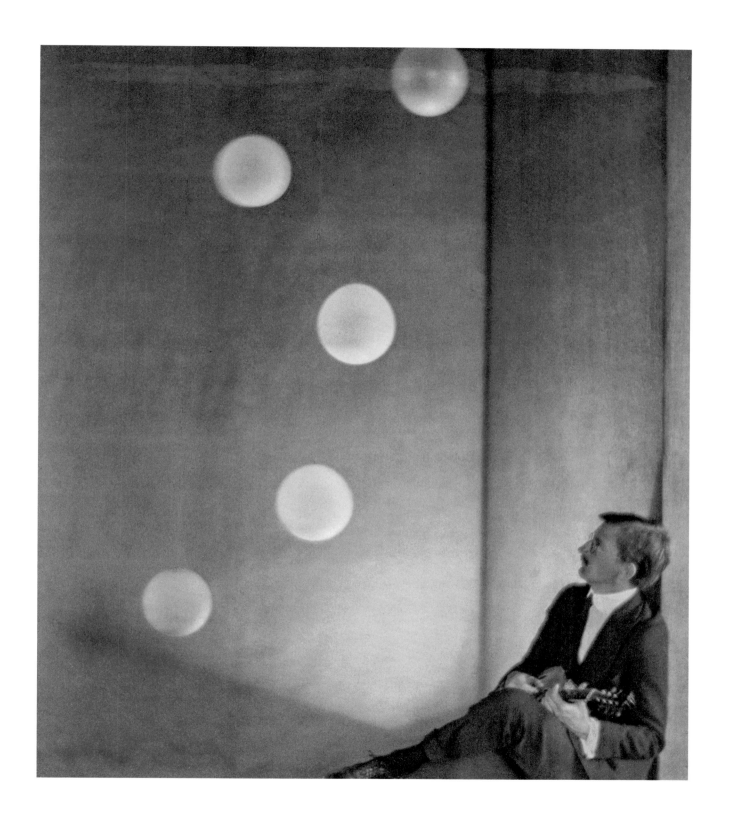

56 | ALFRED KREYMBORG (BALLOON FANTASY), 1921

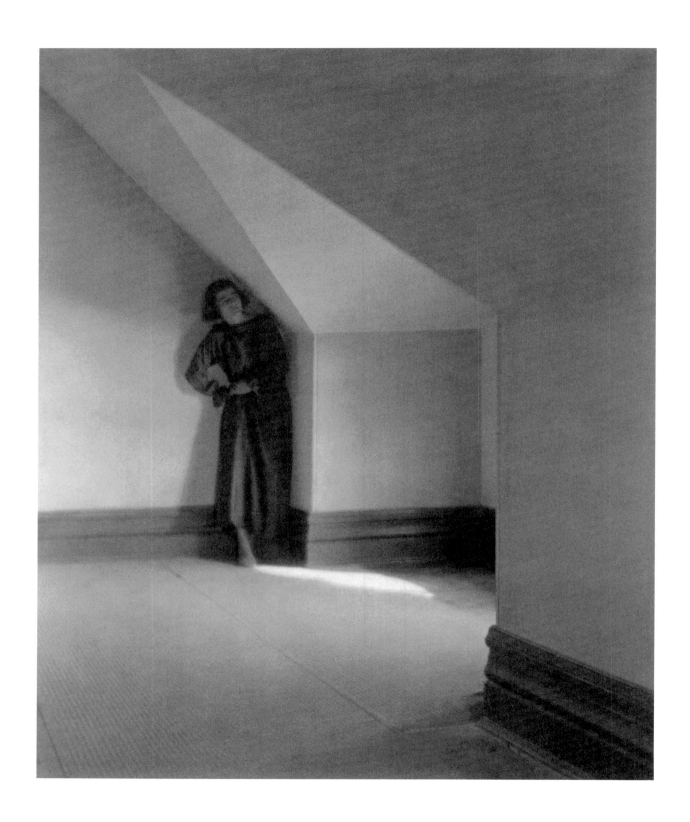

57 | BETTY IN HER ATTIC, 1920

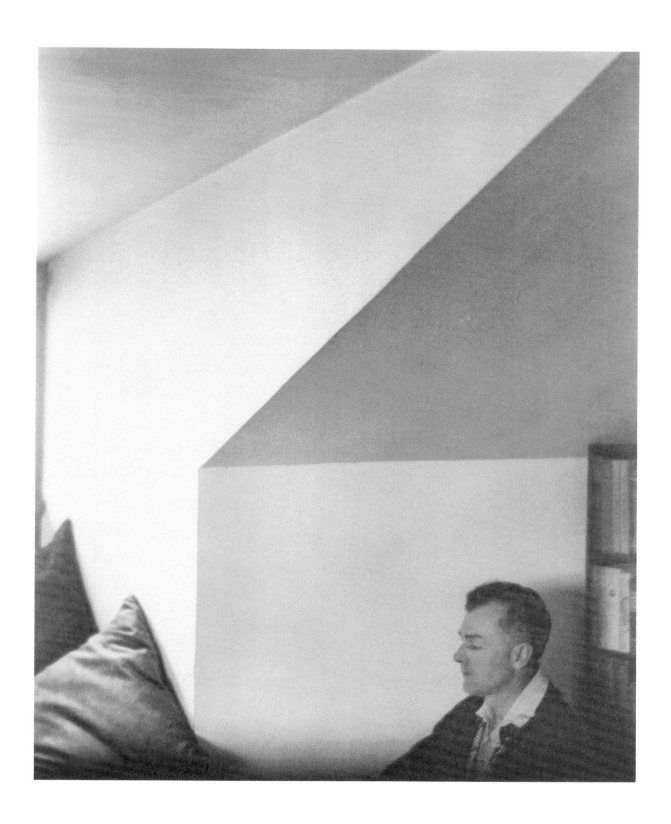

58 | RAMIEL IN HIS ATTIC, 1920

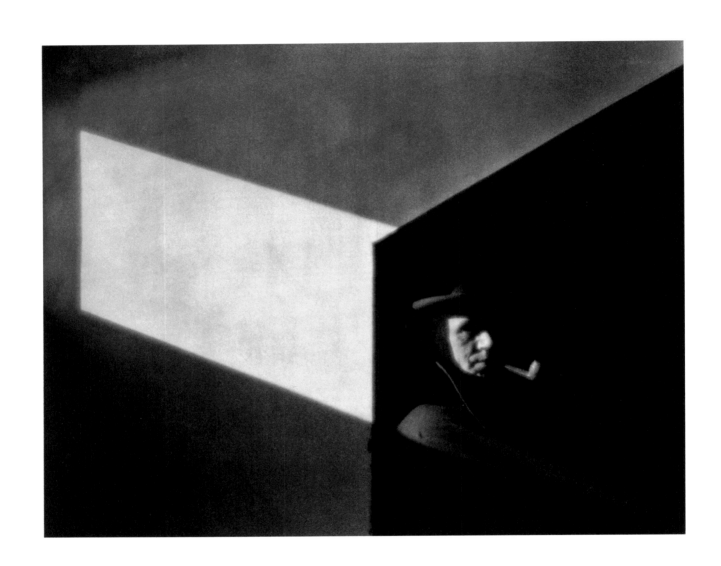

59 | JOHAN HAGEMEYER, 1920

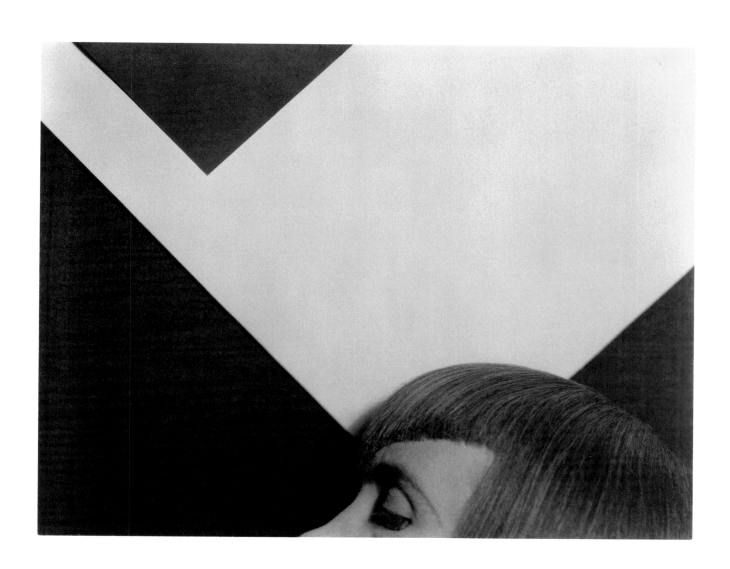

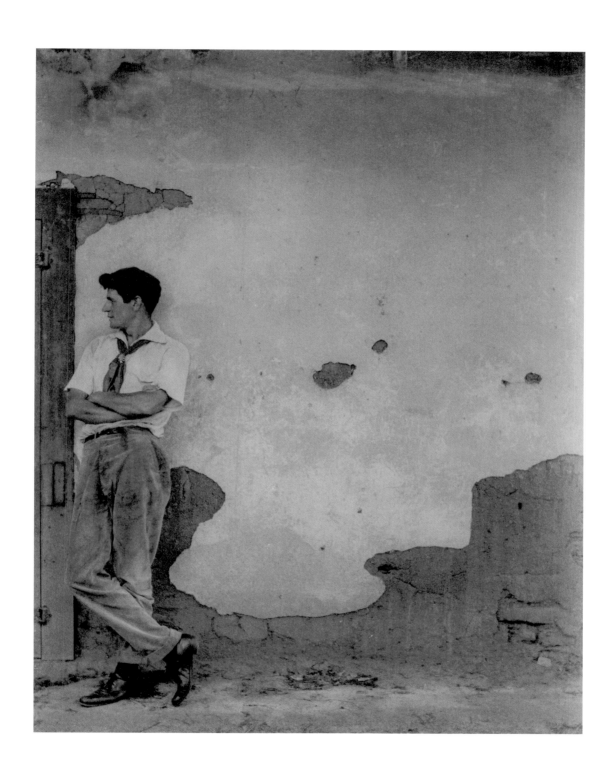

61 | RALPH PEARSON, 1922

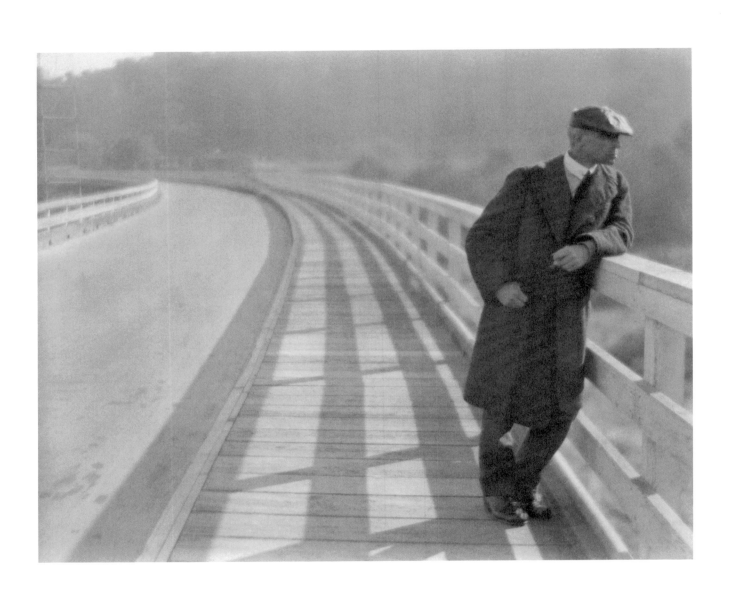

63 | EDWARD WESTON AND MARGRETHE MATHER | MAX EASTMAN, 1921

LIGHT AND SHADOW

THE NEXT ENCOUNTER to change Edward Weston's personal life and professional career came in early 1921, when he was introduced to the Italian-born actress Tina Modotti and her partner, an artist and writer who called himself Roubaix de l'Abrie Richey. Tina Modotti had emigrated from her native Udine to the United States, following her father and other family members to California—to San Francisco in 1913, and then to Los Angeles in 1918 with "Robo" de Richey, to pursue a career in silent films. Despite the rather grandiose title he bestowed on himself, Robo had been given the name Ruby Richey when he was born into a farm family in rural Oregon. Although he and Modotti claimed to have married, perhaps for the sake of her Italian Catholic family and her budding acting career, they seem never to have actually formalized their union. The couple apparently met Weston not long after the end of his brief liaison with Betty Katz, and soon thereafter Weston and Modotti embarked on a secretive and intense romantic relationship.

The start of Weston's passionate affair with Modotti coincided with a shift in his professional connection with Margrethe Mather that gave her nearly equal billing in the studio, at the same time that their personal relationship was threatened. The decision to share responsibilities for the portrait studio business and to co-sign some of their photographs was a step that Weston did not take with any other photographer. The arrangement, though it lasted less than a year, was capped off by joint exhibitions of Weston and Mather's work at the Friday Morning Club in February 1921 and the California Camera Club

in July. These shows garnered very positive reviews, for the work and for what one writer referred to as their unusual "art partnership."[1]

Weston's involvement with Modotti, an actress who was at ease before the camera, allowed him to explore the subject of the female nude, which was to play a major role in his oeuvre by the 1930s. By the time he met Modotti, he had already made nude studies of Flora, Margrethe, and his children; but as he gradually moved away from pictorialism and gained confidence in his own more modernist vision, nudes became more central to his work. Years later, as he attempted to document the creation of his earliest negatives, Weston listed a series of five images — all of the same unnamed female subject and made in about 1918 — as his first nudes. In this early logbook he assigned the number "N1" (for Nude 1) and the initials "R.W." to a beautifully lit and slightly soft-focus photograph of a dark-eyed *femme fatale* with tousled hair and a smoldering expression (pl. 64). The subject of this photograph is a sensual, self-aware woman, unlike the white-robed virginal goddesses who appear in so many pictorialist photographs. There is nothing casual about her hand resting on her hip or the way she clasps the fabric draped at her waist; her frontal pose and the triangle formed by her arm relate this image to one of Weston's rare male nudes, which is thought to have been taken at about the same time (pl. 65). This extraordinary image of an anonymous male torso is cropped so the sitter's face cannot be identified, but his unusually muscular arms and chest, accentuated by the strong raking light and rendered in relatively sharp focus, suggest that he was an athlete or dancer.

In 1921 and 1922 Weston made three groundbreaking photographs of female torsos and breasts. The earliest of these nude studies, often titled *The Source* (or sometimes simply *The Breast*), is the most graphic and dramatically lit (pl. 66). It dates from 1921 and is believed to be a close-up of Tina Modotti. The zebra-like stripes of shadow that spread across the curve of her breast may have been produced by light falling through the ribs of a Japanese paper lantern, like the one in another Weston portrait of Modotti made that same year (see pl. 78). Weston's use of interchangeable titles for this and the other torsos has caused confusion, although he wrote "The Source" on the mount of the print shown here, which he donated to the Smithsonian in 1923. The similarity to the title of a 1906 work by his friend and fellow California photographer Anne Brigman may also be a nod to her daring female nudes.

The two other photographs in the group were made the following year. They are both thought to record the same sitter, although in very different styles. According to Weston, he was approached at the time by a woman he did

not know, who asked him to make some nude photographs of her; he claimed never to have learned her name. One of these images, titled *Refracted Sunlight on Torso*, portrays a figure standing next to a studio window bathed in a soft, watery light (pl. 67). The other, more close-up view, taken next to the same window, is more sharply focused and reduced to a few simple shapes, including a distinct halo of light that circles the unknown sitter's breast (pl. 68). The latter view was especially admired by a local writer, who declared, "I do not hesitate to say that it is the most perfect photograph I have ever seen and one of the most successful examples of sane expressionism to be found in any medium."[2]

During his New York trip in 1922, Weston apparently showed these works to Stieglitz, who by this time had begun taking nude photographs of the artist Georgia O'Keeffe that often focused on parts of her body rather than the whole figure. According to the younger man's notes on their meeting, Stieglitz told Weston that if he were still publishing his journal *Camera Work*, he would definitely ask to reproduce all three, but that *The Source*, to his eyes, was "the most complete."[3] Weston's feelings about *The Source* seem to have changed over time: he eventually came to the conclusion that it was "full of striving for effect" and later claimed to have destroyed the negative.[4] Weston ultimately considered the two torsos the more successful images, including them in his MoMA retrospective and the Project Prints.

Weston's fascination with Modotti resulted in two of his most powerful early nude portraits. Rather than depicting anonymous torsos, these romantic pictures of Tina are full of shadowy low light and capture her face with her eyes closed in a dream-like reverie. The two poses are similar and may result from a single sitting. The picture simply titled *Head of an Italian Girl* is the more modest of the two (pl. 69). The second image includes a glimpse of Modotti's breast and introduces a delicate white iris blossom, which is set off against the darkness of the background at the left, her raven hair against a lighter background, and the softly lit contours of her neck and shoulders (pl. 70). Tina seems to have taken Margrethe's place not only in Edward's heart, but also as his favorite photographic subject. He wrote of his new love to his friend Johan Hagemeyer: "Life has been very full for me — perhaps too full for my good — I not only have done some of the best things yet — but also have had an exquisite affair . . . [with] a lovely Italian girl."[5] Another sensuous image of Tina, taken not long after the two first met, shows her fully clothed, with her serious gaze leveled directly at Edward and one hand clasping the collar of her heavy coat (pl. 71).

Weston's portraits of Modotti mark the beginning of an innovative group of monumental close-ups of other friends and acquaintances made during the early 1920s. In contrast to the more distanced approach of his previous portrait studies, the photographer gradually began to move the camera physically closer to his sitters and create more individual likenesses. With these monumental head shots he seems to have hit his artistic stride. They indicate a new ease in collaborating with their subjects, who were not his usual studio clients, and often display a newfound elegance and polish. An example is the writer and bibliophile Paul Jordan-Smith, who was married to Weston's cousin Sarah Bixby-Smith. Weston photographed him on several occasions, including in 1922, perhaps at Erewhon, the Smiths' home in Claremont, California (pl. 72). With its subject viewed from slightly above, smoking a cigarette and seemingly deep in thought, the careful composition of this image is complemented by Weston's consummate skills in the darkroom. Also taken that year was a glamorous profile shot of the Denishawn dancer Ruth Wilton, who may be the mysterious *femme fatale* he tagged with the initials R.W. in his logbook of negatives (pl. 73).

Weston also created a pair of evocative portraits of two women photographers among his extended circle of artist friends, Dorothea Lange and Imogen Cunningham, both of whom were based in the Bay Area of California (pls. 74, 75). When the likeness of Lange was taken in 1920, she was married to the painter Maynard Dixon, running her own portrait studio in San Francisco, and not yet making the social documentary photographs for which she would become known during the Depression. Here Lange appears relaxed and unpretentious, with her hair tousled, wearing a shy smile, and surrounded by softly focused foliage. Although she never became the close friend to Weston that Cunningham did, many years later Lange advised Weston on his successful application for a Guggenheim Fellowship.

The portrait of Cunningham was made when she and her husband, the artist Roi Partridge, were staying with the Westons for several days during the summer of 1922. The photographer renders Cunningham's features in a soft, watery daylight, not unlike the illumination he employed in his torso study taken that same year (see pl. 67). Cunningham is portrayed in shadowy profile, with her red hair braided into a thick coil at the side of her head, her eyes closed, and her left hand hovering at her throat. During her short time in Glendale, Cunningham in turn invited Weston and Mather to collaborate with her on a number of pictures featuring the two of them. The prolonged sitting resulted in more than a dozen poignant photographs: in one, they posed with

Detail, plate 73

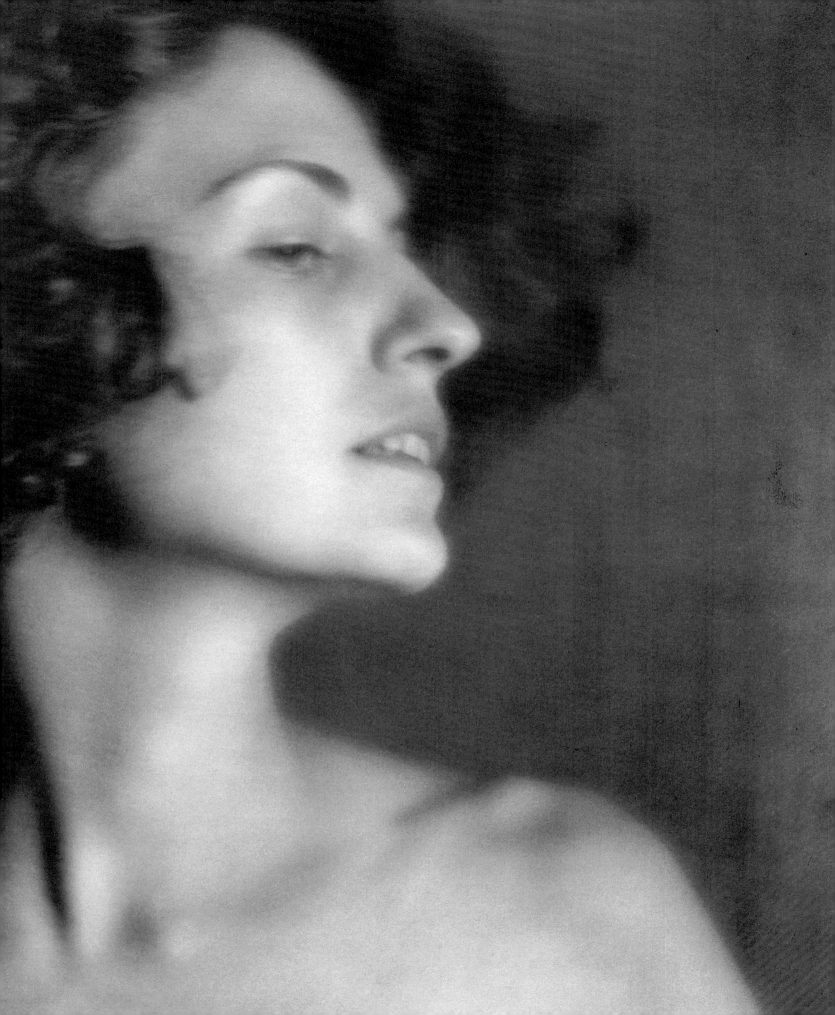

Margrethe's head leaning against Edward's shoulder; in a second, their heads are close together but they gaze in opposite directions, perhaps suggesting the waning of their romantic relationship. Another of Cunningham's memorable pictures of the pair captures them leaning companionably against the studio wall in well-worn aprons, holding tubes of their favorite Willis and Clements Palladiotype paper (see fig. 6).

One of Weston's most powerful portraits made around this time was a close-up of his good friend and fellow photographer Johan Hagemeyer, wearing a soft white shirt (pl. 76). His introspective expression is very unlike the stern, mask-like representation in Weston's earlier attic portrait of him (see pl. 59). Weston wrote to him about this new profile view in April 1922, "Am sending also four prints of you—taken the day I was drunk—perhaps both of us were!"[6] Perhaps Hagemeyer's world-weary gaze can be explained by too much bootleg alcohol rather than by his chronic neurasthenia. Weston also chose this print to show to Alfred Stieglitz and Georgia O'Keeffe when he traveled to New York later that year, and he recalled O'Keeffe commenting on this particular image, "He must be very close to you—it is one of the most revealing portraits you have shown me."[7]

A picture of a young girl, made in California in 1922, is unlike any of Weston's other portraits of children, including his own (pl. 77). The unidentified child appears to be unclothed, and her expression is more wise and adult than her years would suggest. Startling in its strict symmetry and the direct intensity of the girl's gaze, this image calls to mind Weston's comment in his early essay about photographing children, that their portraits should "run the whole gamut of expressions—don't have them all laughing."[8] This image is an extreme example of that philosophy, but it also relates to an assertion he voiced in a lecture delivered to the Southern California Camera Club in 1922: "It is in portraiture and figure studies that photography's opportunity lies. . . . Only the photographer can register what lies between himself and the object before his lens at a given moment of time, catch fleeting facial expressions, sudden twitching smiles, momentary flashes of anger and pain."[9]

Among the connections to other art forms that Tina Modotti brought into Weston's life was her involvement with textile arts. Before Tina's film acting career took off, she had worked as a seamstress in San Francisco to help support her family. Her sewing skills also came into play after she and Robo moved to Los Angeles in 1918. There she began to design and create dresses out of the batik fabrics that Robo produced in a workshop behind his mother's house, where the couple lived when they couldn't afford to pay rent. Batik—a

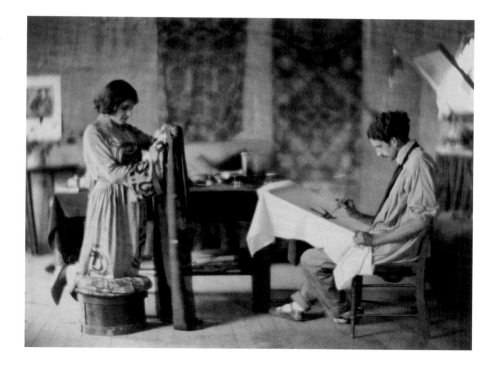

traditional Javanese method of hand-printing fabrics that involves wax resist and natural dyes — had become popular across the United States during the Arts and Crafts movement, and Robo gained a reputation for his skill in creating these intricately patterned and brilliantly colored textiles. The local celebrity photographer Walter Frederick Seely documented Robo and Tina at work in their studio in 1921 for a piece in *California Southland* magazine on the revival of interest in the craft (fig. 13).[10] Modotti kneels on a stool to sew one of her own dress designs, embellished with bold Celtic-inspired decorations, while Robo sits opposite her, drawing with hot wax on a piece of fabric stretched across a frame.

That same year, Weston made two portraits of Modotti dressed in an elaborate flowing gown of silk batik, very much like one she wore in her starring role in the 1920 film *The Tiger's Coat*. Photographed in Weston's studio, Modotti in her long, shimmering dress with bell-shaped sleeves stands out like an exotic apparition against the plain muslin-covered walls. In *Girl in Canton Chair* Tina is seated in a woven chair flanked by a large Chinese paper lantern and three small tables, one holding a vase of flowers, strategically placed within the shallow space of the studio (pl. 78). In the second image, entitled *The Batik Gown*, she appears in the same dress, adopting a trance-like pose as if sleepwalking, with her right arm outstretched below one of Robo's distinctive batik wall hangings, accompanied by an Asian-style trunk on the floor behind her (pl. 79).

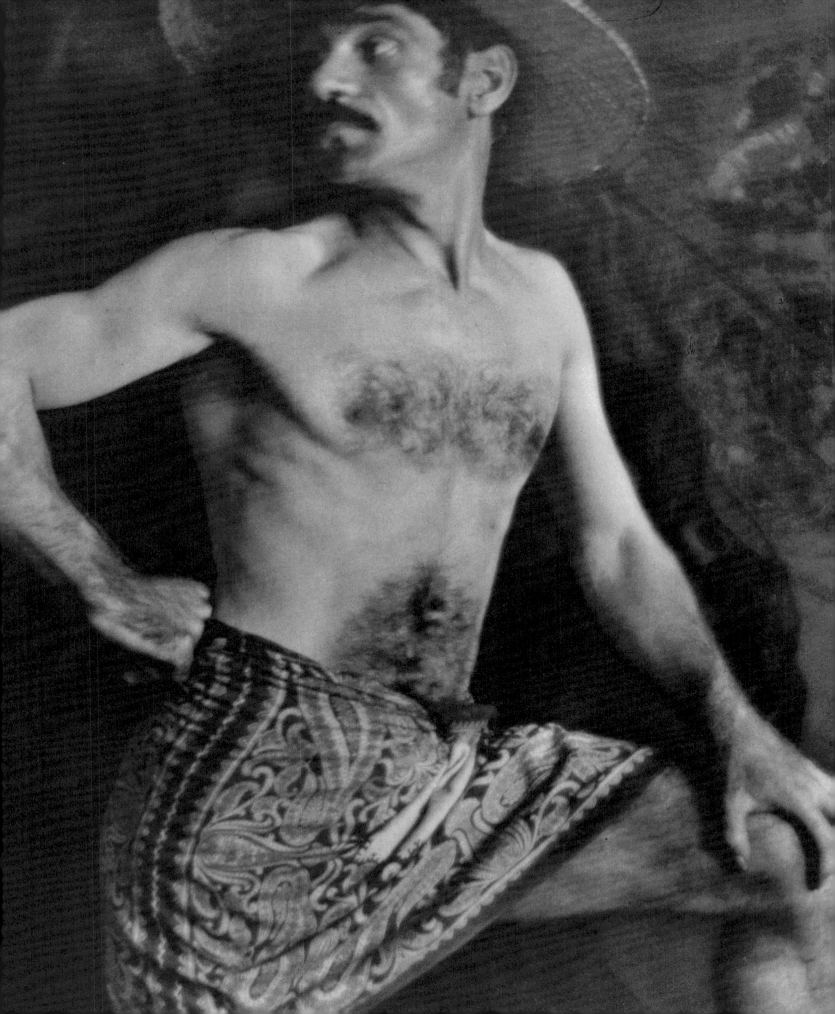

Weston recorded another member of his bohemian circle during this period, the French-born painter and sculptor Gjura (or George) Stojana (who sometimes went by the name George Stanson), proudly baring his chest and wearing only a batik sarong and broad-brimmed hat (pl. 80). Stojana, who had recently returned from a stint in Hawaii, cultivated an air of mystery within the Los Angeles artistic community, and this wonderfully quirky image of him would have only enhanced that reputation. Also living in Los Angeles at the time was Ricardo Gómez Robelo, an exiled Mexican writer and poet, who was to return to his home country in 1921 to head up the Department of Fine Arts under the new Minister of Public Education, Jose Vasconcelos. Before Gómez Robelo left California, however, Weston made several photographs of him. *Poesque* depicts him standing in front of one of Robo de Richey's batik wall hangings, titled "The Witch," including a stylized black cat that appears to perch on his shoulder—a fittingly spooky companion for Gómez Robelo, who so revered the American writer of horror and suspense Edgar Allan Poe that he had undertaken a comprehensive translation of Poe's work into Spanish (pl. 81).[11] On probably the same day, Weston made what he later described as "one of my best portraits," of the poet seen very close-up and in profile, his coat collar drawn up to his chin and his strong features highlighted against the dark shadow he casts on the wall behind him (pl. 82).[12]

Weston photographed Robo de Richey in the Glendale studio in 1921 as well (pl. 83). Stretched out on a low daybed, the tall, slender Robo looks every bit the dandy. From his wavy dark hair and moustache all the way down to the elegant spats that cover his shoes, Weston managed to capture his friend and romantic rival's distinctive persona in this elegant portrait. Not long after this likeness was made, planning for a joint exhibition of Robo's batik designs and Weston's photographs in Mexico City took Robo across the border into Mexico, where he contracted smallpox and died in February 1922.

Following this sudden loss, Tina and Edward's relationship faltered. Nevertheless, Weston continued to move forward with plans to relocate to Mexico City, along with Tina and his eldest son, Chandler, to open a portrait studio there that Modotti had agreed to help him run. Although Edward had finally moved out of the family home permanently, and his fourteen-year marriage to Flora was officially over, it would still be more than a year before he and Tina and Chandler would depart for Mexico.

In the meantime, in the fall of 1922, Weston wrote to his friend Hagemeyer in San Francisco, "Wish me luck dear Johan for I am out for blood—to conquer the East!"[13] Edward's sister May had surprised him by sending money so

that he could travel to the Midwest for a visit with family in Chicago and Middletown, Ohio, before leaving for Mexico City. He spent his three-week-long interlude in Middletown with May and her husband taking leisurely drives through the surrounding countryside, and it was on one of those excursions that they encountered the American Rolling Mill Company, known as Armco Steel. At this massive industrial site, unlike any that existed on the West Coast at the time, Weston recognized the photographic potential in its utilitarian structure and long row of towering smokestacks. Over the course of a single day, he shot several views of the steel plant, in their sharp-focus approach and industrial subject matter very different from his earlier work (plates 84–87). Some were taken from a distance and capture the broad sweep of the surrounding landscape and low factory buildings broken only by smokestacks and telephone poles, while others focus on details of architectural forms, such as the plant's enormous conveyors and coal chutes.

One of the most austere and iconic photographs in the group is a steeply raking view of the factory's stacks, seen from below and set off against an expanse of overcast sky (pl. 85). Later in his career, Weston exhibited and published this particular image simply as *Steel*. The title has caused some confusion, as he also used *Smoke-Stacks* and *Armco Steel* interchangeably for this and for another picture of the same stacks framed by the dark forms of curved pipes (pl. 86). His satisfaction with these pictures made him more determined to show his work to Alfred Stieglitz; fortunately, his sister and her husband offered him the funds to continue his cross-country trip to New York. As he recounted in his daybooks, "The Middletown visit was something to remember. . . . But most of all in importance was my photographing of 'Armco,' the great plant and giant stacks of the American Rolling Mill Co. That day I made great photographs, even Stieglitz thought they were important: And I only showed him unmounted proofs" (fig. 14).[14]

During his several weeks in New York, Weston also managed to show his work to a number of other photographers he had long admired, some of whom, such as Clarence H. White and Gertrude Kasebier, continued to work in the soft-focus pictorialist style that Weston had gradually begun to disavow. Apart from his visits with Stieglitz and O'Keeffe, the most meaningful encounter with another photographer seems to have been with Charles Sheeler. In 1920 Sheeler had collaborated with Paul Strand on the groundbreaking silent film *Manhatta* and on a subsequent series of related New York City skyscraper views that Weston described as "the finest architectural photographs I have seen."[15] Sheeler and Weston developed a lasting friendship based on this first

Fig. 14
Armco Steel, 1922

contact, and seeing Weston's Armco Steel pictures very likely made an impression on Sheeler, whose own iconic modernist photographs of the Ford Motor Company plant in Dearborn, Michigan, were still five years in the future. The Hungarian-born artist and Bauhaus teacher László Moholy-Nagy recognized the striking parallels between Weston's and Sheeler's industrial subjects; he paired an Armco Steel image with Sheeler's *Criss-Crossed Conveyors* in one of his celebrated Bauhaus Books, published soon after *Criss-Crossed Conveyors* appeared in Film und Foto, a major international exhibition in Stuttgart in 1929 (fig. 15).[16]

Although Weston's time in New York was pivotally important to him, and his conversations with Stieglitz were worth the long wait once he arrived, the trip also marked an important turning point in his development as a

abb. 202 abzugsschlote einer fabrik in ohio foto: weltspiegel

230

abb. 203 fordfabrik in detroit (u.s.a.)

231

photographer. He initially wrote to his friend Hagemeyer: "Steiglitz [*sic*] has not changed me only intensified me," and then, a few weeks later, "[Stieglitz's] attitude towards life presented no revolutionary premise to distress me — though it was all fascinating conversation — but my work he irrefutably laid open to attack. And I am happy! I saw print after print go into the discard — prints I loved — yet I am happy! For I have gained a new foothold — a new strength — a new vision — I knew when I went there something would happen to me — I was already changing — yes changed — I had lugged these pictures of mine around New York and been showered with praise — all the time knowing them to be part of my past. . . . I seemed to sense just what Stieglitz would say about each print — So instead of destroying or disillusioning me — he has given me more confidence and sureness — and finer aesthetic understanding of my medium."[17]

The confidence Weston gained from his visit to New York, and the encouragement he received from Stieglitz and others, seem to have further strengthened his resolve to leave Los Angeles and make a new start in Mexico City. That city had become a powerful magnet for foreign artists and intellectuals following the Constitution of 1917, which marked the end of years of revolution and civil unrest. Edward hoped that he and Tina could afford to live more

simply and cheaply there, freeing him to do more of his own personal work and not focus solely on running a portrait studio. By January 1923, as he wrote Hagemeyer, he had begun to "burn his bridges" in southern California.[18]

One commitment Weston fulfilled before he left was to the Smithsonian Institution's Photographic Section, whose head, A. J. Olmstead, had requested a selection of Edward's prints for the National Museum's collection. He donated nine of his own pieces and five of Mather's, including *Ramiel in His Attic*, *Epilogue*, *Girl in a Canton Chair*, *Robo de Richey*, *Head of an Italian Girl*, and *Prologue to a Sad Spring*—marking one of the earliest examples of an American museum's acquiring photographs as works of fine art. Weston also took the opportunity to write to Stieglitz, thanking him for his encouragement and support: "You have intensified me in my own direction—given me more sureness and confidence—and finer aesthetic understanding of my medium. . . . Well the future will tell—I leave for Mexico City in late March to start life anew—why—I hardly know myself—but I go."[19]

His March departure date turned out to be optimistic, but the delay was fruitful from a photographic standpoint. In a letter to Hagemeyer in early April, Weston wrote that he was about to go off on a "little adventure," which he cryptically described as a "kind of farewell."[20] This seems to have been one final assignation with Margrethe Mather. She had apparently tried to discourage him from abandoning his family and studio and moving to Mexico, to no avail. However, she did agree to his making a final series of portraits of her that are some of Weston's most sensuous from this period. First came a group of nudes of Mather in the studio, which portray her with her hair newly bobbed and in a variety of languid poses in front of a silver-paneled folding screen, accompanied once again by a few simple studio props—a wooden chair, a fan, a lacquered trunk, or a vase with pine boughs or flowers (pls. 88, 89). These softly lit, glimmering nude studies are reminiscent of other images Edward made about this time, for example, those of his young son Neil (see pls. 23, 24).

Somehow Weston and Mather also managed to take time away from the studio later that spring and go to Redondo Beach, where they stayed at the home of their friend Ramiel McGehee. There, over the course of several days, Edward shot a series of daring, sharp-focused photographs of Margrethe in brilliant sunlight, with her nude figure stretched out on the sand and partially shaded by a Japanese paper parasol (pl. 90). At least two of these startlingly modernist images were taken at very close range, with Margrethe's head cropped out of the photograph and the soft curves of her torso starkly

Fig. 16
Nude (Charis), 1936

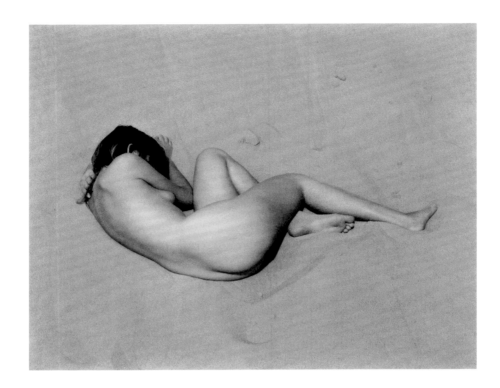

juxtaposed against the dark ribs of the parasol (pl. 91). Others capture her
from a slightly greater distance, with her face hidden and her body nestled into
the crystalline sand — prefiguring Weston's portraits of Charis Wilson, who
was to become his second wife, in the dunes at Oceano some thirteen years
later (fig. 16).

One final image made on that occasion records an enigmatic scene fea-
turing the nude Margrethe reclining between the seated and clothed figure
of Ramiel on one side of her, and Weston's large-format camera and tripod
draped with a dark cloth on the other (fig. 17). Like a contemporary take on
Manet's painting *Le déjeuner sur l'herbe*, this picture, which survives only as a
contact print, stands as a last tribute to two of the most significant people in
Weston's early years, from whom he would soon be parted.[21] The abandoned
camera stands idly by, as a kind of surrogate or stand-in for the absent pho-
tographer, and while Mather covers her eyes against the sun and turns away,
McGehee looks back at his friend from beneath his umbrella, as if imploring
him not to go.

Weston and Modotti finally sailed to Mexico in late July of that year. The
following day, Margrethe commemorated Edward's departure with a note
that simply read, "The studio misses you — And I do."[22] Less than two years
later, she was evicted from the space that they had worked in together as part-
ners for so long, and Edward copied her bittersweet letter into his daybook:

Fig. 17
*Ramiel and Margrethe
with Camera*, 1923

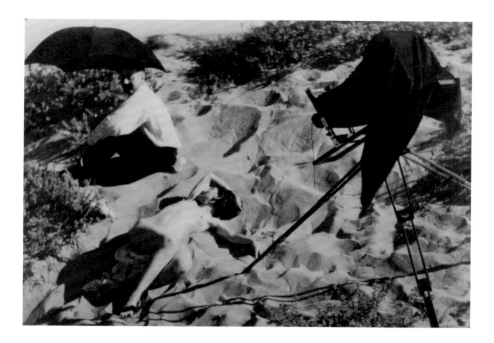

"Today — my last Sunday in the Studio — raining softly — like tears — for you and for me . . . a terrific nostalgia envelops me."[23]

During the years in Mexico City, Weston went on to fully develop his modernist style and to concentrate on the still lifes, nudes, and landscape subjects for which he ultimately became so well known. But for all the importance of this period as a turning point in Weston's professional life, the major strides that he took in Mexico were made possible by the solid foundation laid by his first two decades of photography. This often groundbreaking and experimental early work, which at first he was so eager to erase from his daybooks and negative files, he later came to recognize as a significant piece of his personal narrative. Revisiting these seminal photographs and the circumstances in which they were created greatly expands our understanding of Weston's aesthetic development and allows us to see him not as a lone heroic figure, but as a photographer who actively engaged in the lively mix of art and commerce of his day and ultimately discovered in that formative experience the seeds of his own artistic identity.

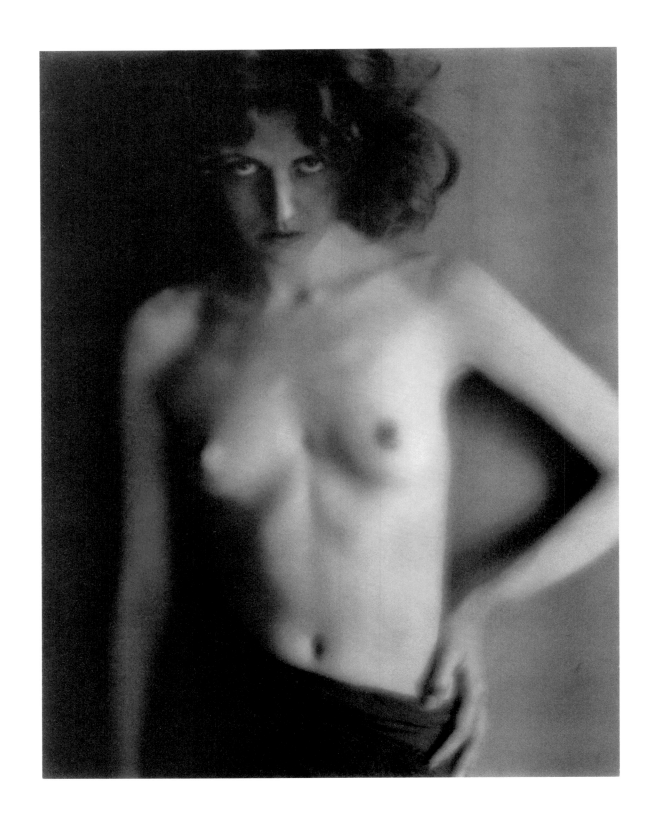

64 | NUDE, ABOUT 1918

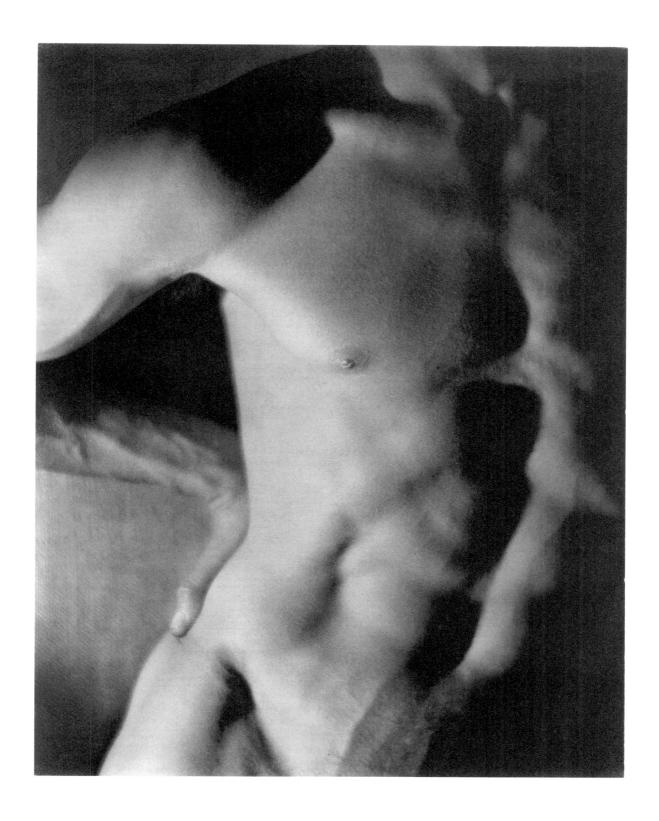

65 | *TORSO, ABOUT 1918*

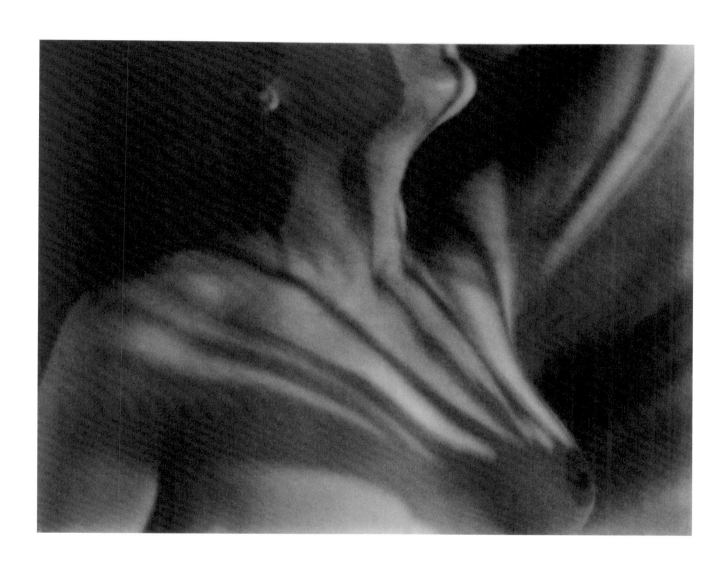

66 | THE SOURCE, 1921

67 | REFRACTED SUNLIGHT ON TORSO, 1922

68 | BREAST, 1922

69 | HEAD OF AN ITALIAN GIRL, 1921

70 | THE WHITE IRIS, 1921

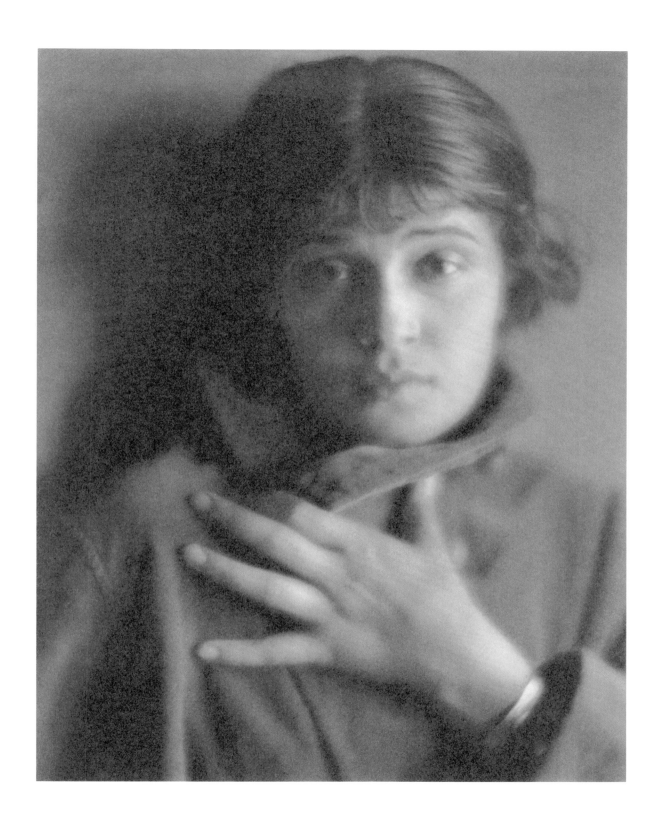

71 | TINA MODOTTI, 1921

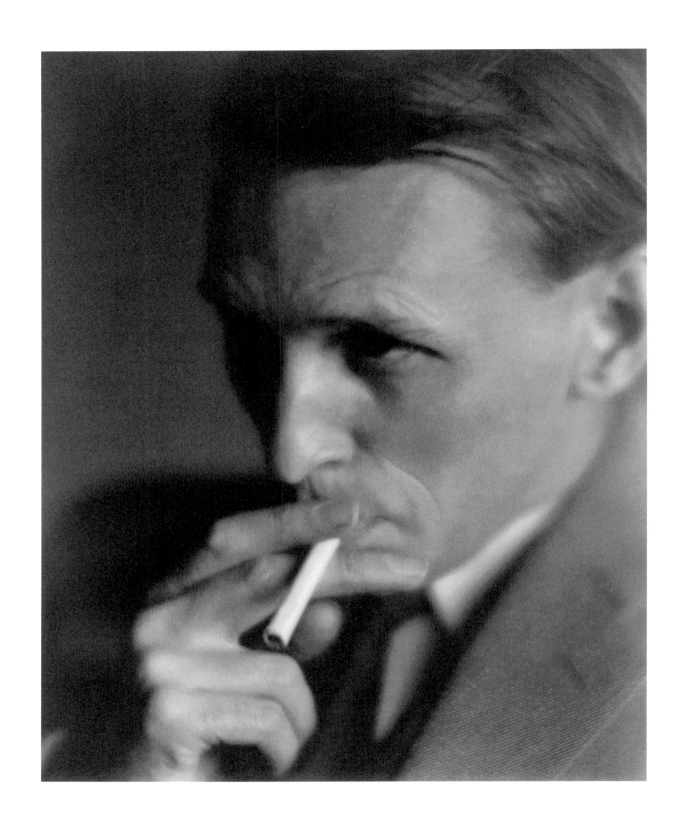

72 | PAUL JORDAN-SMITH, 1922

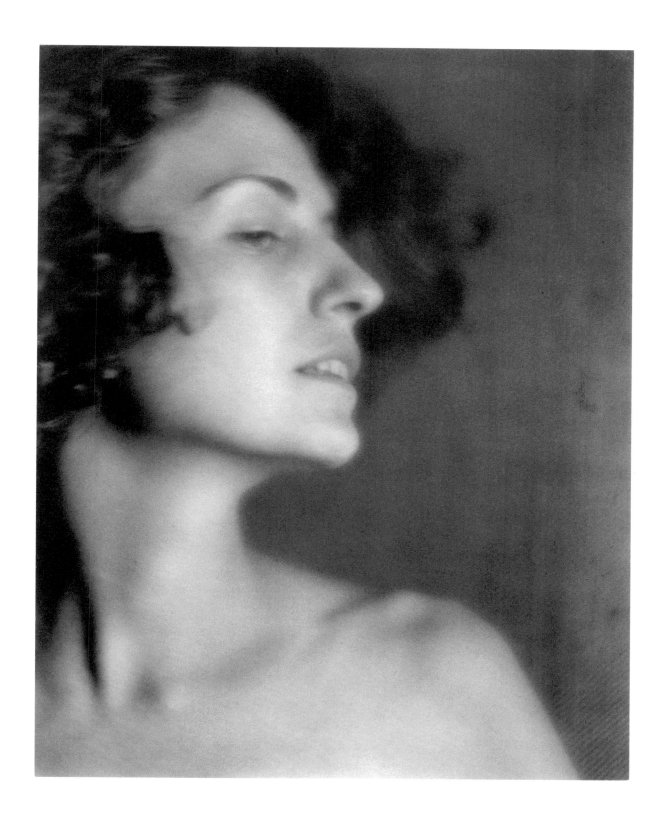

73 | RUTH, 1922

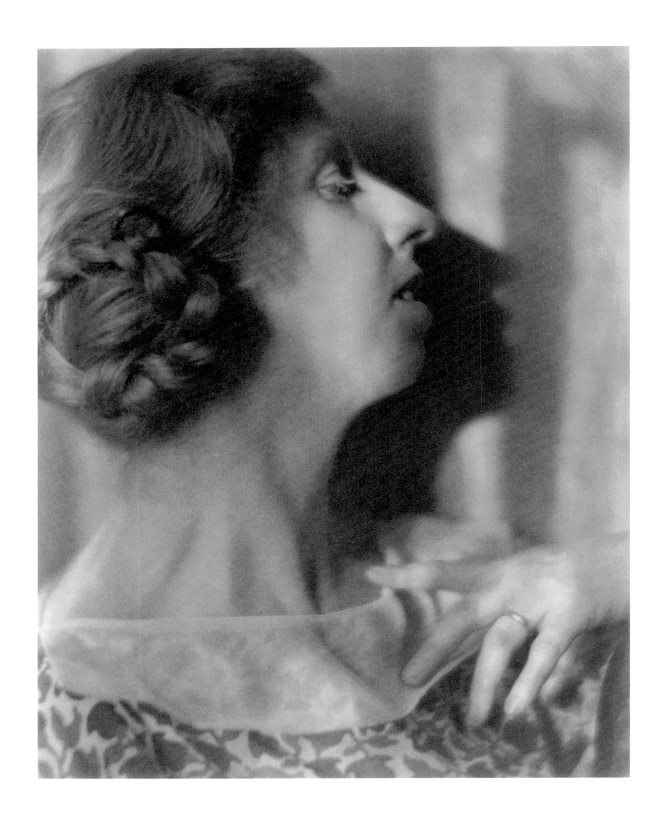

74 | IMOGEN CUNNINGHAM, 1922

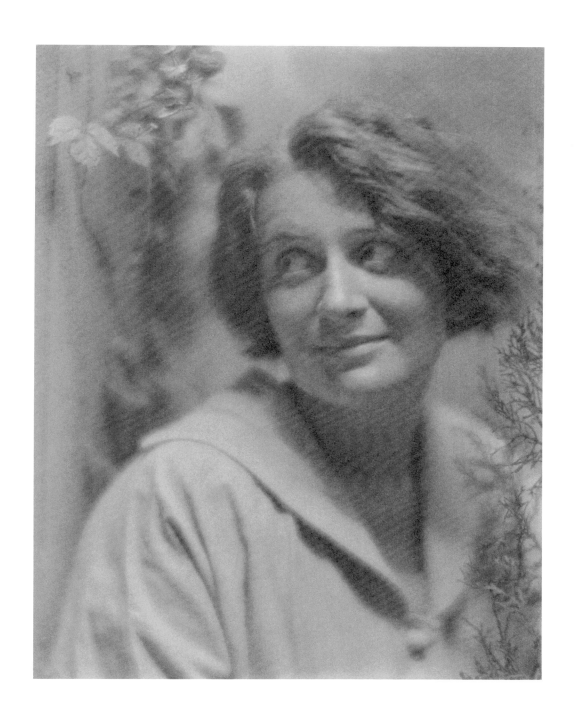

75 | DOROTHEA LANGE, 1920

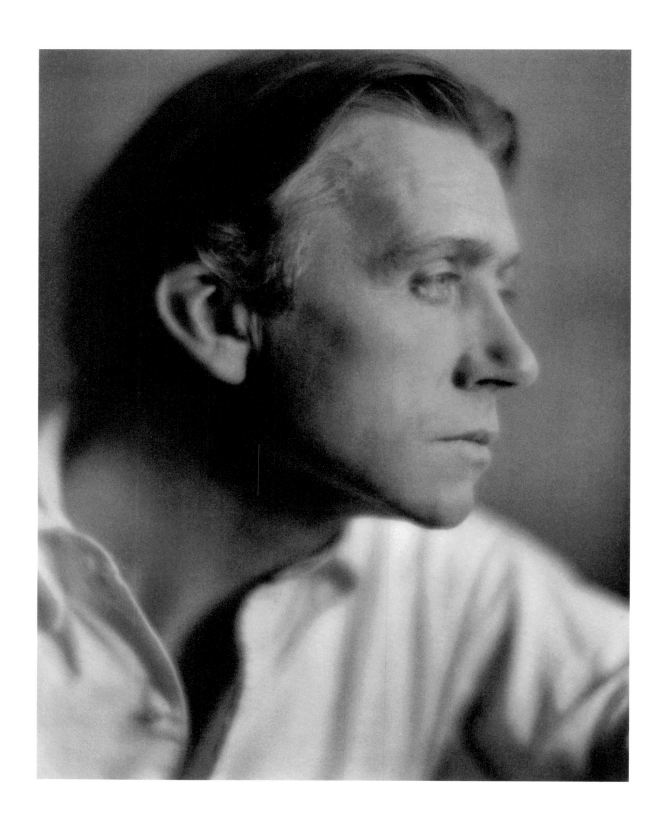

76 | JOHAN HAGEMEYER, 1921

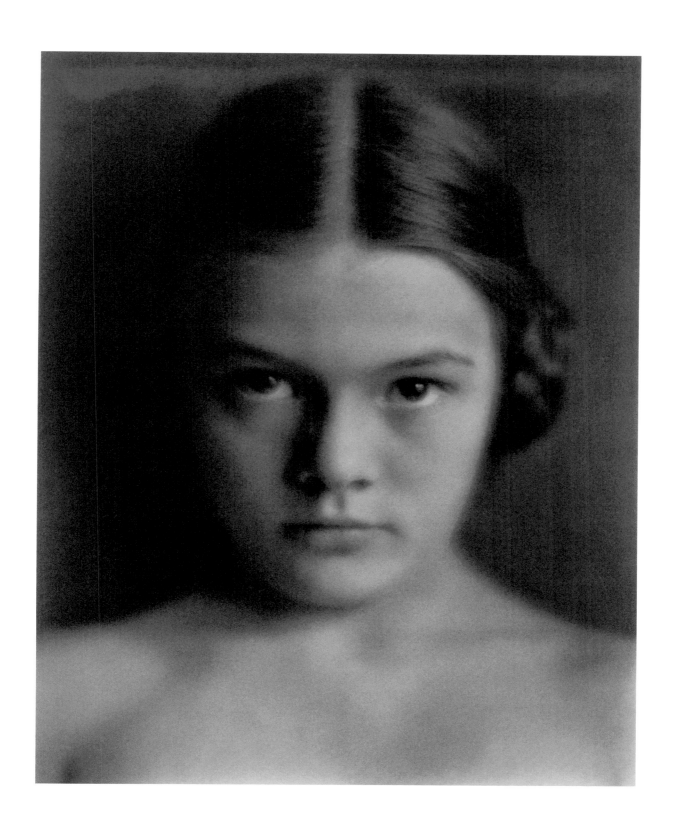

77 | PORTRAIT OF A GIRL, 1922

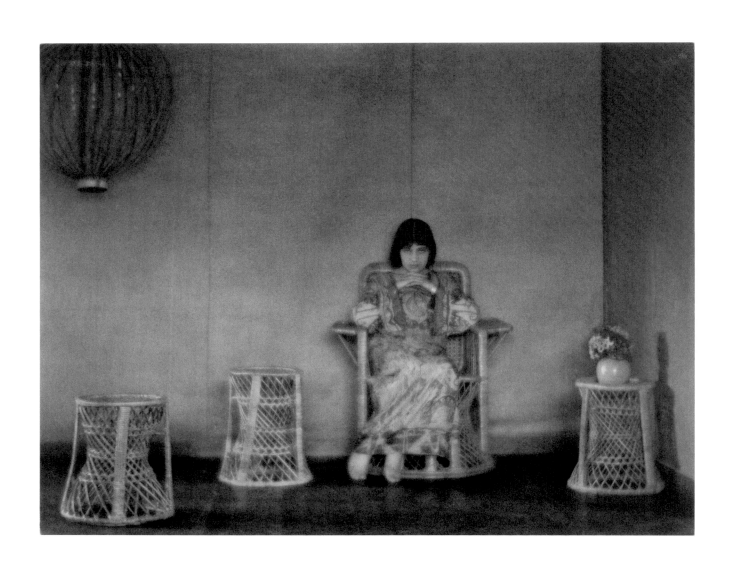

78 | GIRL IN CANTON CHAIR, 1921

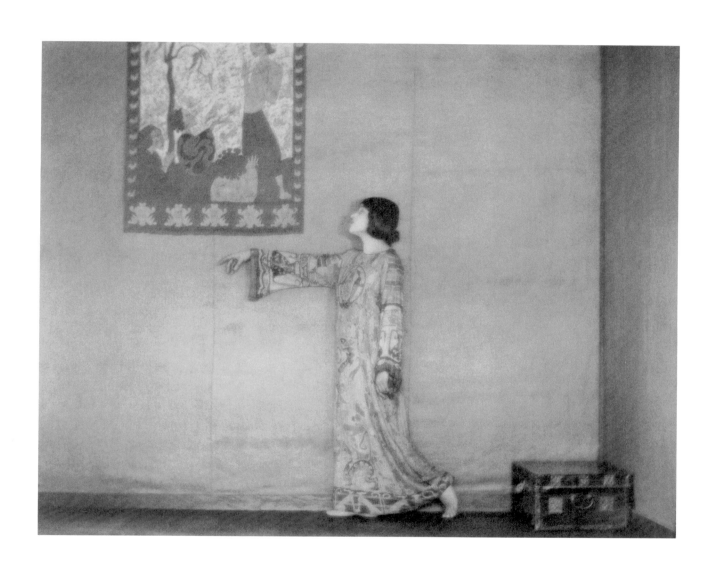

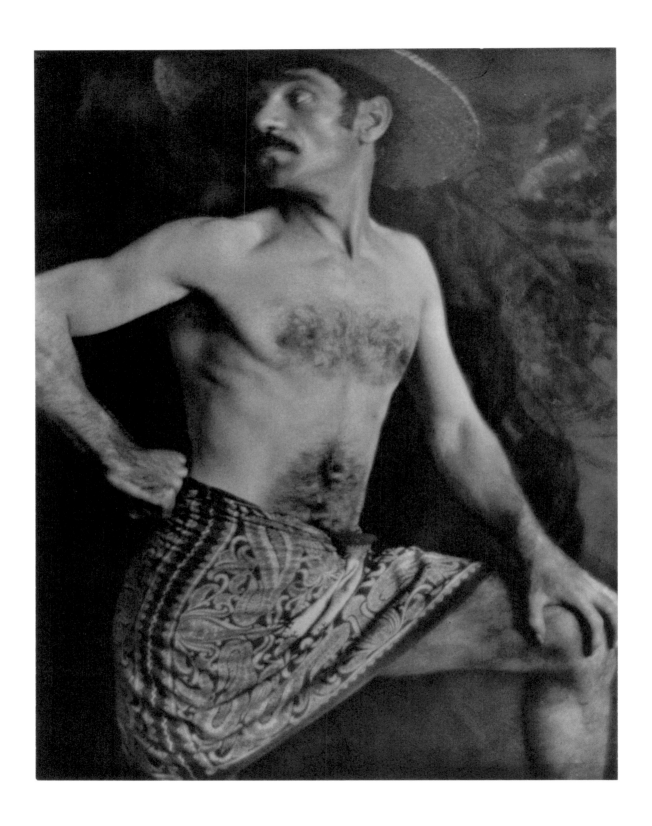

80 | GEORGE STOJANA, 1921

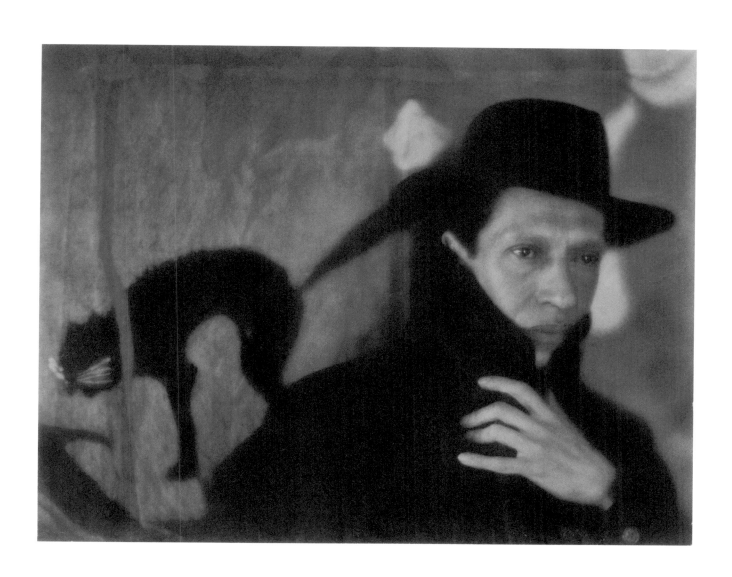

81 | ROBELO (POESQUE), 1921

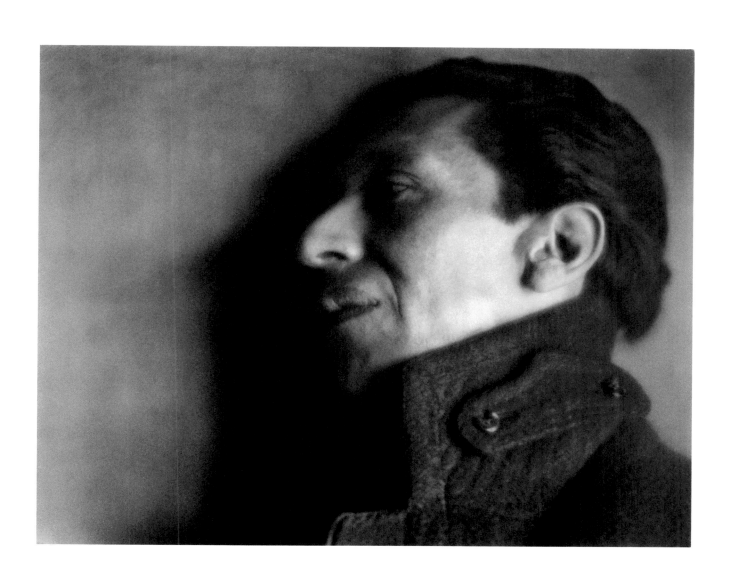

82 | RICARDO GÓMEZ ROBELO, 1921

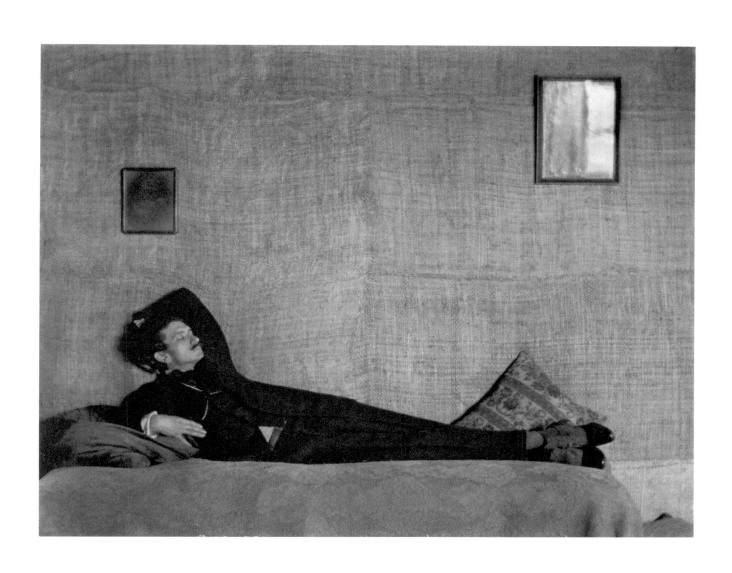

83 | ROBO DE RICHEY, 1921

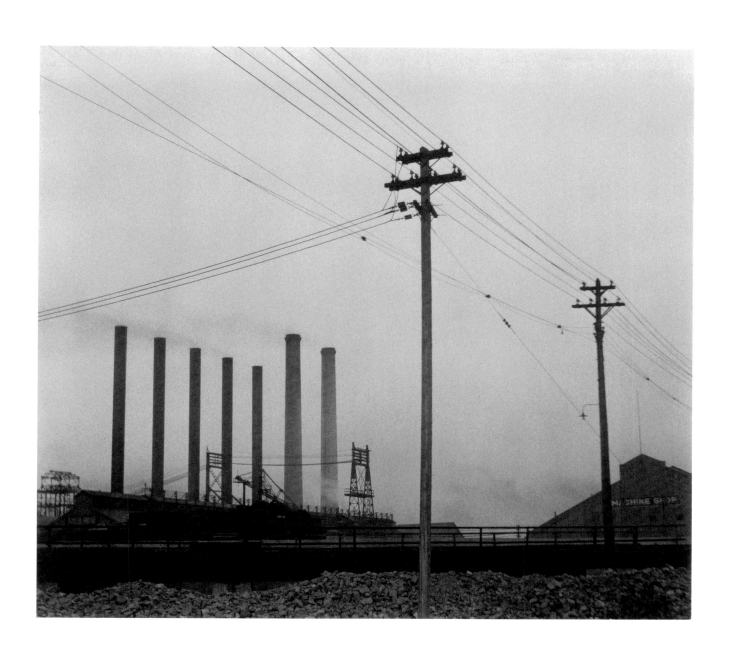

84 | ARMCO STEEL, STACKS AND TELEPHONE POLES, 1922

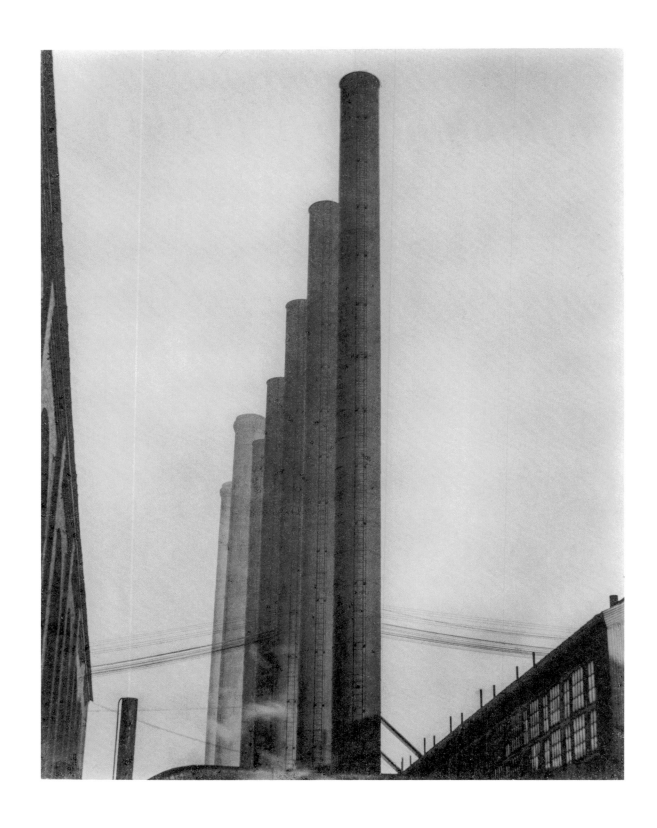

85 | ARMCO STEEL, SMOKESTACKS, 1922

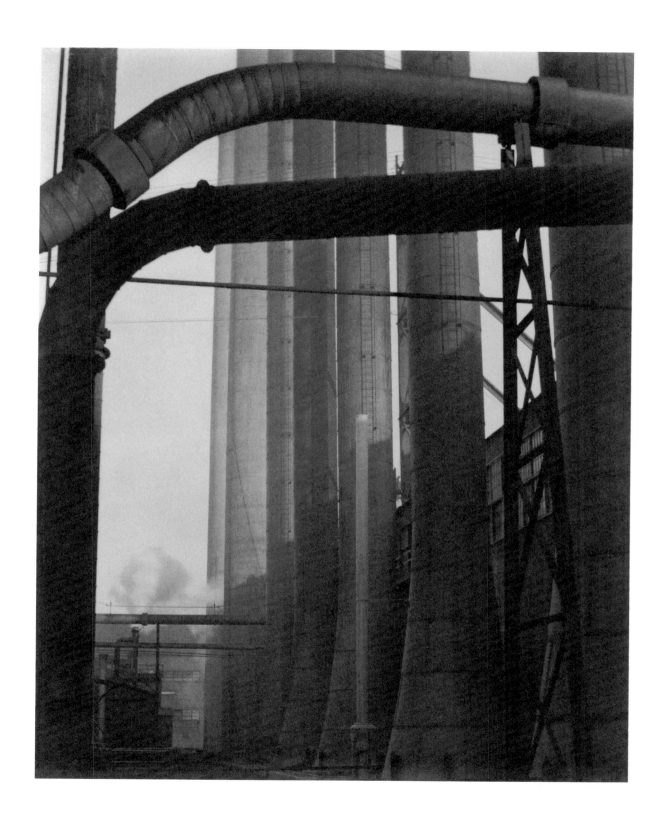

86 | ARMCO STEEL, PIPES AND STACKS, 1922

87 | ARMCO STEEL, VERTICAL COAL CHUTE, 1922

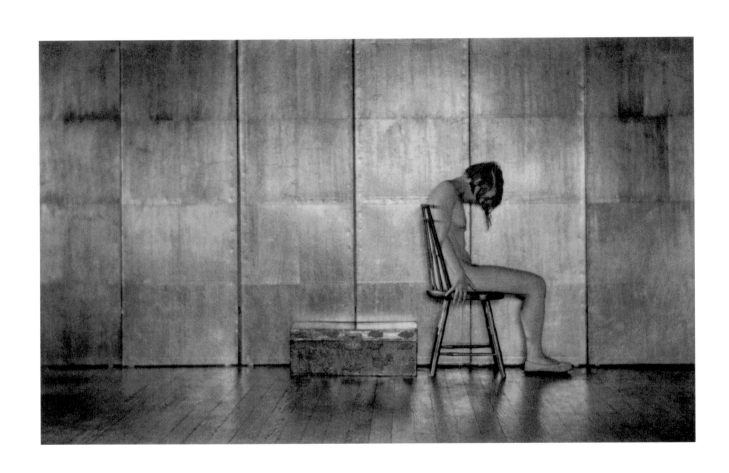

88 | IN MY GLENDALE STUDIO, 1923

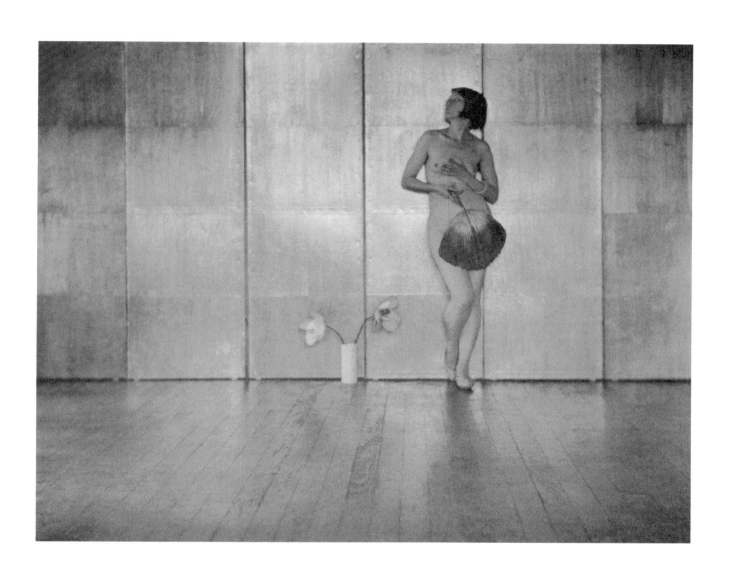

89 | MARGRETHE, 1923

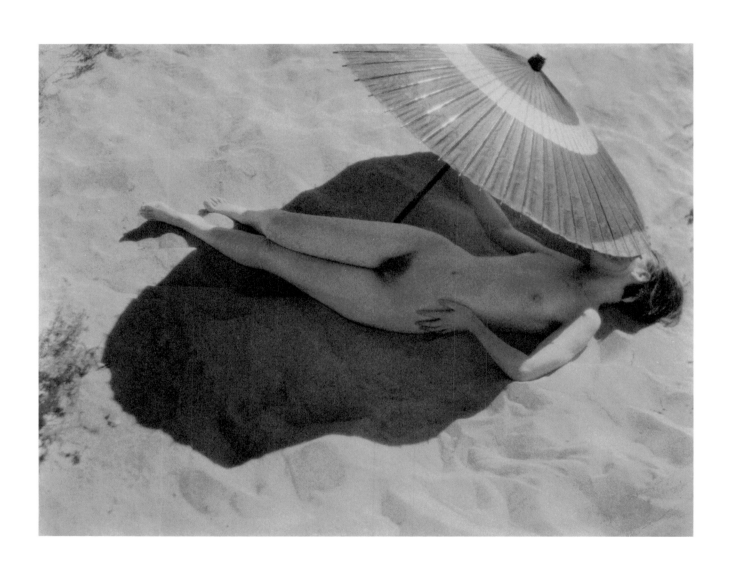

90 | MARGRETHE MATHER, REDONDO BEACH, 1923

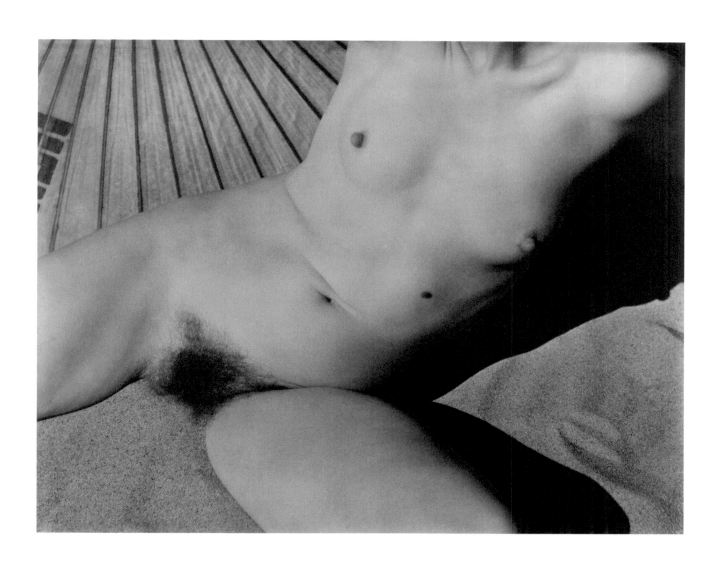

91 | NUDE (MARGRETHE), 1923

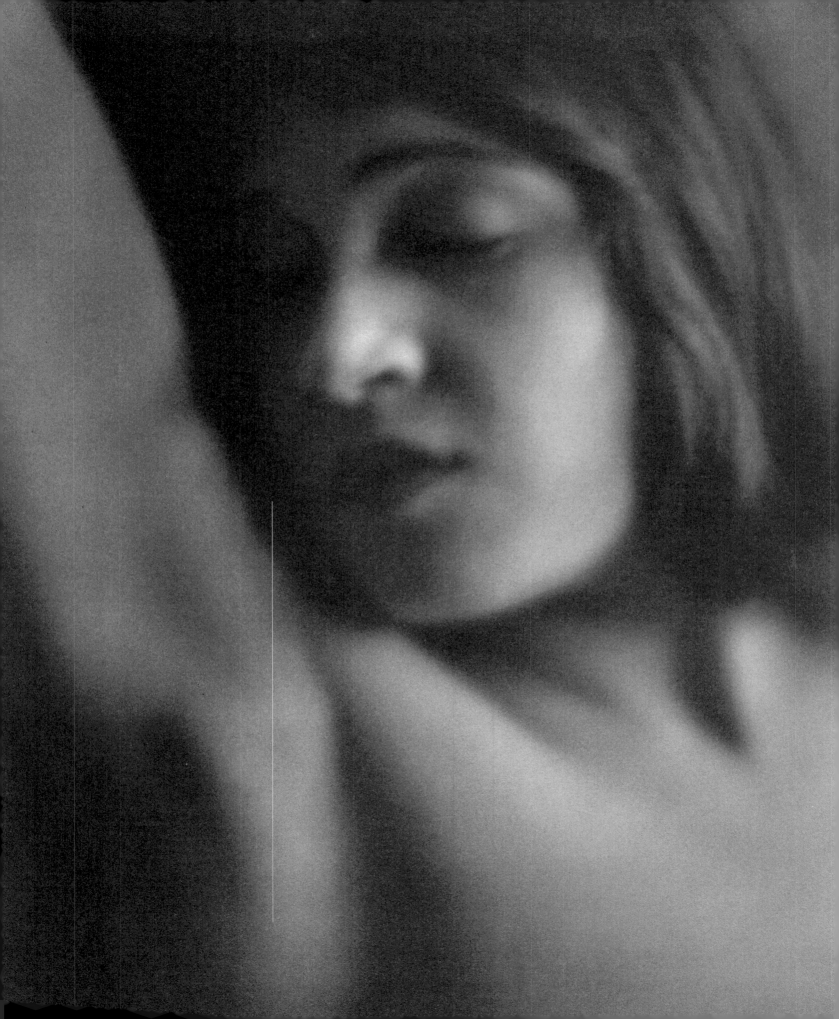

MATERIALS AND TECHNIQUES

Margaret Wessling

EDWARD WESTON consistently documented his shooting and printing sessions throughout his career, leaving behind ample evidence for understanding his methods. During most of his working life he used the same formula for developing film, and a limited number of photographic papers for making prints. Weston was a creature of habit — good habits — in the darkroom, and his mature work is meticulously executed. Yet for numerous reasons studies of his technique have glossed over his developmental years before 1923. Some information about this period can be found in contemporary photography journals and salon catalogs, but the most important resource is the photographs themselves. Close examination and instrumental analysis of these objects enable the clearest insight into Weston's technical development. What quickly becomes apparent is the variety of materials he tried out during this period of experimentation and learning, which guided him to his streamlined mature practice.

Weston became a photographer during a historic shift in the medium. The nineteenth century had seen the invention of the photographic process in France and in England, followed by the propagation of chemical methods and materials around the world. Although photography brought picture-making into the hands of everyday people, its expensive materials and equipment remained accessible primarily to those with disposable money and time. The turn of the twentieth century ushered in the era of mass-produced photographic materials, led by the manufacturing titan Eastman Kodak Company. Their famous advertising line "You press the button, we do the rest" marked

photography's transition to an everyday tool. During the 1880s and 1890s, photographic equipment and papers proliferated, along with journals and periodicals designed to instruct the amateur photographer. When Weston picked up his first camera, a Kodak Bull's-Eye #2, in 1902, he was stepping into a rapidly changing marketplace.

Weston's earliest experiments were made with the Bull's-Eye camera, which he quickly upgraded to a 5 x 7-inch view camera, bought for eleven dollars.[1] At this time, the size of a camera could be equated to its function, with smaller portable cameras being better for quick shooting, and larger cameras preferred for studio portraiture and artistic composition. Weston's progression to larger cameras indicates his developing skill at handling the equipment, as well as an interest in making larger and more thoughtfully composed photographs.

To make prints from his very first negatives, Weston chose the popular gaslight papers that were available from Kodak and other suppliers. These papers were designed to be exposed by the light of a gas lamp, allowing photographers to work indoors. Previously, photographic printing papers were sensitive only to strong daylight and had to be printed in a frame with the negative. This process is termed contact printing because the negative and paper are touching inside the frame. A major limitation of this method is that a print can be made only at the size of the original negative. In the late nineteenth century, an increased understanding of the chemistry of photographic materials led to the development of papers that could be printed using sources of light other than daylight. These higher-sensitivity papers allowed photographers to enlarge their images by shining light through a negative and projecting the image onto paper placed at a distance. Although Weston used gaslight papers, we know from his writings that he preferred the higher fidelity of contact printing to the convenience of enlargement throughout his career.

Weston set up his first darkroom in the attic of his father's house in Chicago.[2] There is no evidence that he owned an enlarging device, which would have been an expensive piece of equipment. Therefore, he most likely printed the first three plates in this book by contact with negatives of equal or greater dimensions. If these prints are from negatives taken with the 5 x 7 camera, Weston would have cropped out roughly a third of the image area when he made the prints. Such a process reveals that Weston was still learning how to compose a scene and capture his vision in the camera.

Around the time Weston moved to California in 1906, he purchased a third camera, a 3 ¼ x 5 ½-inch Kodak postcard camera, a hybrid between the Bull's-Eye and the 5 x 7-inch view camera.[3] Two postcards that he made with

this camera and printed on Kodak Velox postcard paper in 1907 illustrate his use of the format (see figs. 2 and 3). Postcard cameras and papers, which like the Bull's-Eye were marketed to amateurs, were more affordable than professional materials. Weston likely used the postcard format as a way to distribute his work and help make a name for himself as a photographer. By the next year he had decided to commit fully to a career as a photographer, and to jumpstart his training he enrolled at the Illinois College of Photography. The more common route to a professional career at the time was through apprenticeship, so Weston's decision to pay for training is a sign of his determination to achieve success.

The coursework at the Illinois College of Photography was designed to accommodate students with varying levels of commitment. All incoming students were placed in a "D" level course overseen by one of the college's teachers, where they were given instruction in subjects including lighting, posing, and composition; negative making; retouching; etching; carbon and platinotype printing; and finishing and proofing. After completing the assignments for the D-level course satisfactorily, students progressed through levels C, B, and A. This coursework was designed to last one month, three months, six months, or nine months, which likely corresponded to the four levels.[4] Weston spent six months studying at the Illinois College of Photography, at which point he had completed the requirements for the A-level course. However, as he had not paid for nine months of study, the college refused to award him the nine-month certificate, and he returned to California without a diploma.[5]

Although he didn't receive the credential, Weston undoubtedly learned critical skills for operating a portrait studio while studying in Illinois. When he returned to California at the end of 1908 he began working in established portrait studios doing printing and retouching, and recalled later that he learned how to work quickly and efficiently to meet the demands of studio output: "I spent two years in the darkroom and came out knowing how to print D.O.P. (and do it in a hurry, or work all night)."[6] "D.O.P." here refers to developing-out papers, which were papers like the gaslight and Velox products he already knew how to use. An image of the studio of A. Louis Mojonier in downtown Los Angeles shows Weston seated at a retouching booth with six other men and women, all at work adjusting negatives or prints (see fig. 5). A studio of this size had a tremendous output and employed people to perform specific tasks. As a retoucher, Weston was at the bottom of the studio hierarchy. His lack of influence in the output of the studio may have contributed to his decision to strike out on his own.

In 1911 Weston built and opened his own studio, which he dubbed "The Little Studio," in the outlying Los Angeles suburb of Tropico (later Glendale).[7] The studio was a small bungalow roughly twenty by fifteen feet, facing on a town street, with a yard in the back (see fig. 4). Weston cultivated plants and foliage to improve the appearance of the property and attract customers. The interior was divided into sections by walls and partitions to allow for a reception room, a studio, and a darkroom and storage space.[8] Natural light filled the space from three directions, including two sets of French doors and a long, low horizontal window. Additional light came in from dovecote skylights on both sides of the roof. Weston primarily used this natural light to compose his photographs in the studio, with occasional use of artificial light from a nitrogen lamp.[9] He may have learned methods of lighting at the Illinois College of Photography or the professional studios in Los Angeles; in any case, he was to earn early acclaim for the skill and ingenuity with which he manipulated light.[10]

Photographs made at the studio reveal a rotating set of props that Weston used to compose images around his sitters. Commonly recurring items include an upholstered sofa with a curved back, upholstered chairs, mirrors and framed objects, vases, and a decorative "oriental" trunk (see fig. 7).[11] The walls of the studio were covered with a rough, burlap-like fabric, and published descriptions and images suggest that some of the walls were movable.

In addition to opening and outfitting his studio, between 1911 and 1913 Weston added at least four more cameras to his arsenal, including an 11 x 14-inch Graf Variable, two medium-sized Senecas, and a smaller handheld Graflex. He also acquired a selection of larger lenses, many of them designed for soft-focused portraiture. Weston's favorite appears to have been an 18-inch Wollensak Verito, which he later described: "Some years before the war I had acquired a brass mounted Verito — possibly the first soft focus lens in professional use on this coast. At first I swallowed the idea with all the enthusiasm of one who saw retouching lessened if not eliminated, saw pleased patrons and increased sales."[12] The Verito was designed to create a soft image with a mild vignetting effect around the perimeter. An apparently unintended effect of this lens can be seen in close-up portraits Weston made against the fabric-covered walls of his studio. The linear weave of the burlap fabric backdrop, when captured through the vignetting aspect of the lens, causes faint patterns of diagonal parallel lines in the corners of some images (for example, see the lower right corner of pl. 73). Weston continued to use this lens throughout his years in Mexico, and made several references to it in his daybooks.

An article in *American Magazine* in August 1915 described a typical portrait photography session in Weston's studio:

> [The sitter] is engaged by Weston; and before the visitor is aware, he is sitting in the skylit room in a big chair, answering Weston's questions as to his likes and dislikes. He talks carelessly and entirely at ease, waiting, as he believes, for Weston to finish preparing the big camera, around which he hovers. When the sitter has begun to get nervous again, thinking that it is time to arrange his necktie and features once more, Weston quietly asks him to move his chair over a bit, into the ray of sunlight. He is not quite satisfied with the first six plates he has taken. Then the visitor realizes that, instead of hovering over the camera, Weston has been caressing it and coaxing from it the highest form of picture art.[13]

Owning his own studio and performing all aspects of the photographic process seem to have suited Weston both artistically and from a business perspective; in an article for *American Photography* in 1913 he already was stating that the proprietor of a one-man studio, "giving his precious time even to such details as spotting pinholes, should rightfully and consistently be able to ask a higher price than his competitor of equal artistic ability who employs a printer, a retoucher, and a five-dollar-a-week girl to spot and mount his prints."[14]

Although Weston was skilled at capturing the images he wanted from his sitters, he relied on post-processing techniques to get to the final product. One method he commonly used was manipulation of the negatives during processing. Early on Weston used a chemical known familiarly as "pyro" to develop his negatives, and he would process one negative at a time in a tray to afford him more control over the results.[15] Pyro, short for pyrogallic acid, is a slow developer that allows photographers to increase the dynamic range of an exposure. For example, pyro can be used to reveal details in a bright window while keeping the correct exposure for a darker interior. Sometime between 1916 and 1920 Weston switched to a different developer, metol hydroquinone, and began to process a dozen negatives at a time in a tank. Metol hydroquinone is a faster developer and better suited to film, so this switch may correlate to a shift in his preferred negative substrate.

Another technique that Weston used to manipulate his images was retouching. In an article written many years later he asserted, "I was a good retoucher, expert enough to flatter a sitter into actually believing he looked that way. I

Fig. 18
Vasia Anikeef, 1921
(detail of negative)

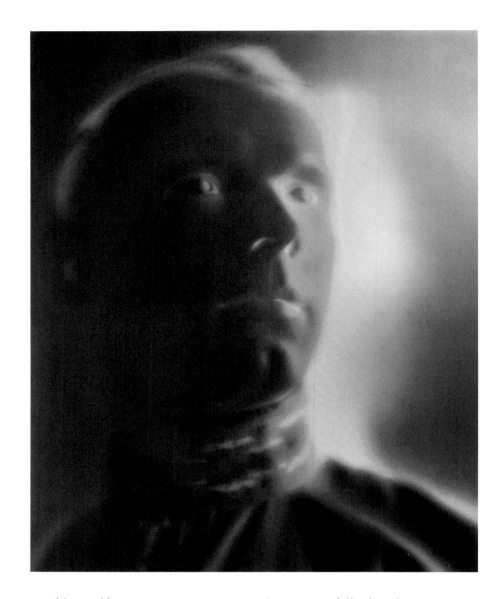

would spend hours on one negative, working so carefully that almost no trace of the pencil remained."[16] Retouching was another technique he studied at the Illinois College of Photography and would have perfected while working for the Mojonier studio in Los Angeles. It can be done on either the negative or the print (or both), and it may be additive or reductive. On the negative, the photographer would use a lead or graphite pencil to fill in areas that he wanted to appear lighter in the final print. He could also scrape away the emulsion of the negative with a sharp blade to allow an area to be darker in the final print. One of Weston's negatives reveals the extent of pencil retouching Weston applied to the sitter's face to smooth out wrinkles, cover freckles and spots, and make small adjustments to the profile (fig. 18). Pencil is an effective medium for retouching negatives, as it is not completely opaque.

Fig. 19
Nude, about 1918
(detail, plate 64)

Fig. 20
Detail of verso of
Nude, about 1918
(plate 64)

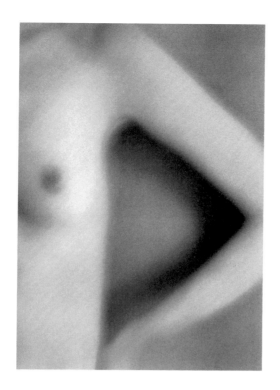

Weston seems to have less frequently used reductive retouching, such as scraping the negative to make the resulting area print darker; instead, he favored adding media to the final print. Many photographers are familiar with the process of "spotting," or adding media to remove light spots caused by dust trapped in the camera or on the negative. However, Weston would often use this technique to make compositional changes or shifts in areas of tone by applying fine strokes or larger passages of lightly applied media to tone down highlights. An example is a photograph in which he shaded down the figure's entire proper left arm with dry media, likely from a retouching pencil, applied directly with his fingers (fig. 19). On the verso of this print are tests of retouching pencils in three slightly different colors (fig. 20). The subtlety with which Weston applied his retouching reveals both his skill and his care for the final appearance of his photographs.

After finishing the retouching on a print, Weston would fastidiously trim, mount, and sign it. His prints are generally cropped to be slightly smaller than the nearest standard size, although some prints are cropped more aggressively. No two prints are exactly the same size, including multiple prints of the same image. The studio mounts Weston most commonly selected until about 1918 were made of thick brown paper with a textured surface. He would place a few dabs of glue on the verso of the finished print to adhere it to the mount paper. He usually signed his works in pencil or ink on the print, or used a blind stamp

on the mount that read "E. H. Weston / Tropico, Cal." (fig. 21). This tidy presentation was standard practice for portrait studios at the time.

Weston was simultaneously experimenting with shooting and printing techniques and developing his artistic vocabulary. For instance, he made a self-portrait that was an enlargement of part of another image (pls. 7 and 8). In *Let's Play Hookey*, Weston experimented with multiple negative printing, including an image of the sky from another negative (pl. 15). He does not seem to have pursued these techniques further. One practice that he did continue was to make enlargement negatives for contact printing. If Weston wanted to make a larger print from an image captured with one of his smaller cameras, he would rephotograph the negative with a larger camera to make an interpositive on film or glass, and then contact print the interpositive to make a new negative of the desired dimensions. This process seems an onerous alternative to making an enlargement from the original negative directly onto photographic paper. However, Weston remained committed to contact printing, preferring the image fidelity it provided.

Perhaps one factor in Weston's choice of contact printing was his preference for platinum papers. This kind of paper, sensitized with iron and platinum

salts, was considered to be the most permanent of photographic papers and was appreciated for the long tonal range it could reproduce and for its velvety matte surface. In the first decade of the twentieth century a dozen or so companies were making platinum papers, before Kodak began to buy out its competitors. The biggest holdout to Kodak, and the most well-known manufacturer of platinum papers, was the Britain-based Platinotype Company. It was owned and run by William Willis Jr. (who perfected the platinum process and held a patent on it) and Alfred Clements. Willis manufactured Platinotype papers and processing chemicals in Britain, and Clements distributed them in the United States from an office in Philadelphia. Great pictorialists of the late nineteenth and early twentieth centuries, such as Alfred Stieglitz and Clarence White, praised Platinotype paper for its especially fine quality. The product had such cachet that Imogen Cunningham photographed Weston and Margrethe Mather holding a cylindrical tin of Willis and Clements paper, indicating the paper's integral role in their artistic practice (see fig. 6).

Platinum prints look quite different from gaslight and other silver-based prints of the early twentieth century primarily because of the layer structure of the photographic paper. Silver-based papers, which use silver salts as the light-sensitive image-forming material, are coated-out in a gelatin emulsion over a baryta layer. Baryta is made by mixing the white, chalk-like substance barium sulfate with gelatin, and then spreading the mixture to a level finish on the paper. Baryta layers, like gesso layers under oil paintings, create a smooth and reflective surface. Gaslight and other silver-based papers generally produce neutral black images, with a finish that ranges from matte to glossy. In contrast, platinum papers have iron and platinum salts coated-out directly onto the paper without a preparatory layer or binder. As a result, the images take on the texture of the paper and appear matte and velvety. This finish was one of the most appreciated qualities of the platinum print, along with the range of warm to cool tones that could be achieved by altering the chemical processing.

Weston likely learned how to make platinum prints at the Illinois College of Photography; his earliest extant platinum prints date to 1908. Two years earlier, a critic writing about one of his photographs observed that his work had a natural affinity with this technique: "The print, which is on a rough developing paper, is very pleasing to the eye, but the quality of the negative seems better suited to platinum."[17] Weston may have delayed using platinum papers because they were significantly more expensive than silver-based papers. Around 1906, a dozen sheets of Kodak's 5 x 7-inch Velox gaslight paper sold for thirty-five cents, whereas a dozen sheets of Willis and Clements

Platinotype paper of the same size went for seventy cents.[18] When Weston did begin using platinum papers he bought his stock from Kodak, specifically that company's Etching Black Platinum or E.B. Platinum — a presensitized platinum paper that was processed in room-temperature potassium oxalate and fixed with hydrochloric acid. In 1916 Kodak discontinued production of platinum papers when the price of platinum skyrocketed due to World War I.[19] The high cost of platinum also affected Willis and Clements' Platinotype Company, which introduced palladium papers as an alternative. Palladium is a metal similar to platinum in its stability and in the behavior of its salts in the oxidation and reduction processes of photography. In late 1917 Willis and Clements started advertising Palladiotype paper, which they offered on paper stocks of buff and white colors, and in rough and smooth textures. In 1919 they began distinguishing between sepia and black Palladiotype papers, suggesting different chemical formulas that resulted respectively in warmer and cooler-toned prints. It appears that Weston used both kinds of Palladiotype papers, and generally preferred the buff-colored paper stock.[20]

X-ray fluorescence spectroscopy (XRF) performed on many of Weston's platinum and palladium prints included in this publication indicates that he began using palladium papers as early as 1918. He made his last platinum prints in 1920, and used only palladium papers after that. Some confusion persists in the terminology Weston used, as he continued to refer to making "platinum" and "platinotype" prints until he switched entirely to silver-based papers around 1927. Although Willis and Clements did continue to offer Platinotype products into the 1930s, analysis of Weston's photographs from 1920 to 1927 has revealed only palladium papers. These terms are employed interchangeably by photographers and historians, and the term "platinum" is commonly used to describe the entire category (which has been recently termed "siderotype," or chemistry relying on iron salts). Because it is not possible to tell by sight whether a print comprises platinum or palladium image material, XRF is required for identification. Media lines in this publication offer the correct identification of the image-forming metal in cases where analysis has been performed.

Weston understood that Palladiotype was a different product from Platinotype, and in fact he liked Palladiotype so much that he wrote to Alfred Clements in 1921, exclaiming about "its range of tones, ease of manipulation, surface beauty, its splendid blacks!"[21] Clements reproduced the quotation in an advertisement for Palladiotype paper in a 1922 exhibition catalog, also citing Margrethe Mather and Clarence White as proponents of the product. Indeed, Palladiotype was exceptional, capable of producing wider tonal ranges and

depth than most other papers available at the time. The variety of paper supports and image colors allowed photographers to print an image to their liking, with the surface beauty that Weston proclaimed and that was particular to Willis and Clements' products. Weston took advantage of these properties when printing his images, frequently overexposing the papers to achieve tonereversal in the darkest image areas. The density of palladium on the surface of the paper allows for details in the darkest areas to be enhanced in overexposure, whereby they begin to turn a browner, bronzed tone. This effect can be achieved with platinum papers, but happens more readily with palladium.

The transition to Palladiotype paper corresponds with a change in Weston's method for mounting and signing his prints, and both point to an increasing focus on his artistic output over his studio work. While Weston was still running his portrait studio, he was spending more time with Margrethe Mather and Johan Hagemeyer. The three worked collaboratively out of Weston's studio from 1917 to 1923, using the same materials and method of presentation. The mount they adopted was a buff-colored, textured heavyweight paper about 18 x 14 inches in size, to which they adhered the finished photograph by a bead of glue along its top edge. The print was placed above center on the mount, and signed and titled in graphite either below the photograph or along the bottom edge of the mount. Previously Weston had signed directly on his prints, in keeping with pictorialist tradition. His shift away from the older presentation method marks a departure from that aesthetic as well. Weston, Mather, and Hagemeyer all used the new presentation method, and in some instances Weston and Mather co-signed the same print. When Weston included a year after his signature on the mount, it sometimes represented the year the negative was made, and sometimes the year the print was made, which were not always the same. This inconsistency has created confusion around what date to assign some of his photographs; dates in this book reflect the year the image was taken, to the best of current knowledge.

A peculiar phenomenon related to Weston's mounting method was observed during an initial survey of the platinum and palladium photographs at the MFA. About 20 percent of the prints in the collection exhibit a neutral-toned band along their top edges that corresponds to the location of the adhesive Weston applied to the back. The most extreme example of this phenomenon in the collection at the MFA is a portrait of Margrethe Mather (fig. 22). Historical and analytical research was undertaken to ascertain the cause, and to determine whether the glue changed the color of the print, or the print changed around the glue. The answer provides important insight

Fig. 22
Margrethe Mather,
about 1919

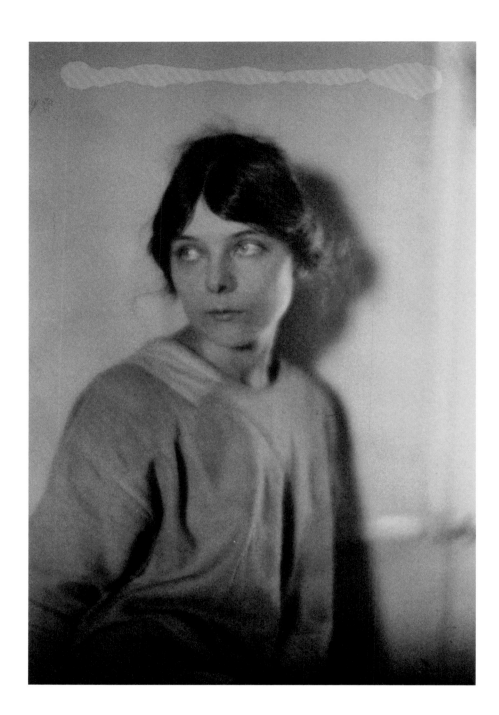

into the types of platinum and palladium papers Weston chose, as well as his preference for image tonality.

The neutral band associated with adhesive occurs only on Weston's platinum and palladium photographs, and on platinum and palladium prints by Mather and Hagemeyer. The problem appears unique to these artists, and it does not occur on any of their silver prints. It seems likely that these artists were using the same materials, and more specifically the same glue. The

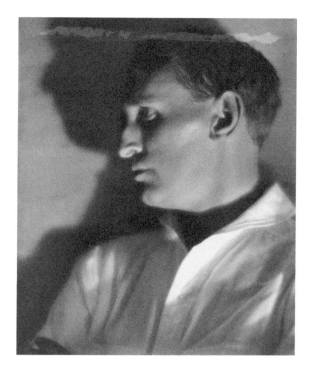
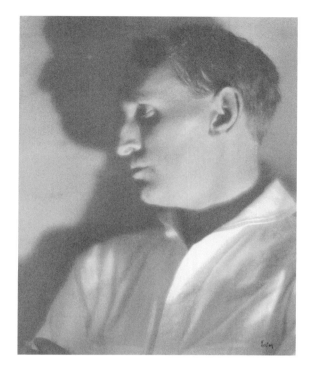

earliest example of the neutral band discovered so far is on Weston's 1915 photograph of his son Chandler, which is a platinum print (pl. 20). This defect stops appearing on prints made after Weston moved to Mexico; palladium prints made during the years 1923–26 instead exhibit a brown stain related to the location of the mounting adhesive.

XRF analysis of the neutral band phenomenon was performed on photographs in the collections of the MFA, the Center for Creative Photography (CCP), and private owners. There was no evidence that the neutral band phenomenon was associated with the image material, whether it was platinum, palladium, or mercury toner. Analysis did reveal a correlation between the area of the neutral band and elevated readings for calcium and zinc. Additives to early twentieth-century adhesives often contained forms of calcium and zinc, which changed the optical properties of the glue or acted as humectants. Protein analysis of samples of the mounting glue taken from photographs at the MFA indicate that the majority of Weston's adhesives were hide glue, including both those that caused neutral bands and those that did not.[22]

It appears that Weston did not always use the same adhesive when mounting multiples of the same image, as exemplified by his 1918 portrait of Paul Jordan-Smith. The version of this image from the MFA's collection (fig. 23) exhibits the neutral band along the top edge, while a version from the Center for Creative Photography (CCP) does not (fig. 24). The image material for

Fig. 23
Paul Jordan-Smith,
1918 (MFA)

Fig. 24
Paul Jordan-Smith,
1918 (CCP)

both prints comprises platinum toned with mercury, and the paper supports have the addition of barium. The presence of barium is most likely the result of the paper manufacturing process, where it would be added as a colorant. These shared attributes of image metals and paper colorant suggest the two portraits were printed on the same manufactured platinum paper. The presence of the neutral band on one print and its absence from the other suggests that Weston performed the mounting with different glues, perhaps on different days. XRF analysis of corresponding areas on the two photographs indicates the print in the MFA collection has elevated levels of calcium and zinc, while the unmarked CCP version does not. This comparison underscores the likelihood that the glue is changing the paper support, and that one particular glue causes the damage. This pair of prints also provides insight into Weston's working methods, indicating that he printed his images multiple times on the same stock of paper, but mounted duplicate prints at different times, perhaps for different purposes.

Research into the neutral band raises two more important questions: How quickly did the neutral band form, and did Weston see it during his lifetime? During the planning for Weston's retrospective at the Museum of Modern Art, in a 1942 letter to the curator, Nancy Newhall, he described the prints as "mostly if not all palladiotypes" and added, "I regret that the glue used for mounting stained quite a few of the prints. If I were sure which of two brands did the damage, I would expose it."[23] This shows that Weston observed a staining phenomenon related to his platinum and palladium prints as early as 1942, although it is not clear whether he is referring to the neutral band on the pre-1923 photographs or the brown stain that occurs on some of the 1923–26 photographs. He states that he used only (or primarily) two adhesives in these early years to mount his prints. The analysis suggests the two glues were relatively similar in composition, given their hide glue base, but that a crucial difference in their formulas caused one of them to create an unsightly band. Two versions of a portrait of Margrethe Mather show an effort to remedy this problem. The print from the MFA has a discolored band above Mather's head (fig. 25). The CCP print is a half-inch shorter at the top, and the print's verso reveals a small bit of adhesive residue along the top edge (fig. 26). The most likely reason for the reduced size is that the CCP print also had a neutral band along the top related to the adhesive, and someone—perhaps Weston himself—trimmed off the offending area.

The most likely cause of the phenomenon is a buffering effect by the calcium- and zinc-containing additives. Compounds with these elements are

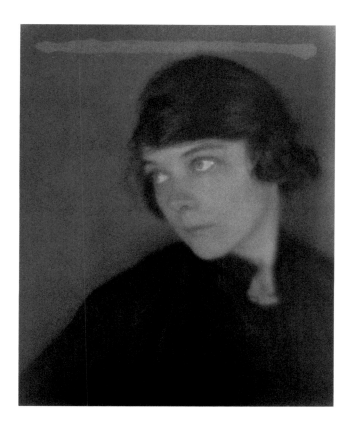 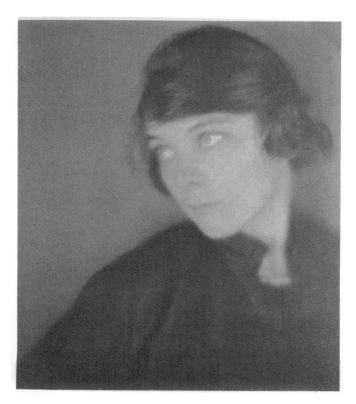

generally basic, having a higher pH, which can slow or prevent acidic degradation. Platinum and palladium photographs catalyze acidic degradation of their paper supports, which causes the paper to turn yellow-brown and the images to appear warmer in tone. It appears the glue prevented this process in the areas it came in contact with. This in turn suggests that the overall tone of Weston's platinum and palladium prints may have been significantly more neutral than the tone they display today.

Although Weston continued to print on palladium papers during his tenure in Mexico, he was already moving toward a transition to silver gelatin developing-out papers. In 1922 he made a series of images of the Armco steel mill in Ohio (pls. 84–87). During his subsequent visit to Alfred Stieglitz he shared proof prints of these negatives. The proofs were most likely printed on inexpensive silver gelatin developing-out papers, which would have been more accessible to Weston on his extended trip. An image of the mill's smokestacks may be one such proof print (fig. 14). The photograph is executed on a gelatin silver developing-out paper, and it reveals unusually extensive retouching. The lack of finish in the print indicates its function as a working image. Stieglitz responded enthusiastically to the Armco proofs, which may have begun to shift Weston's thinking about his photographic papers.

Fig. 25
Margrethe Mather, 1920
(MFA)

Fig. 26
Margrethe Mather, 1920
(CCP)

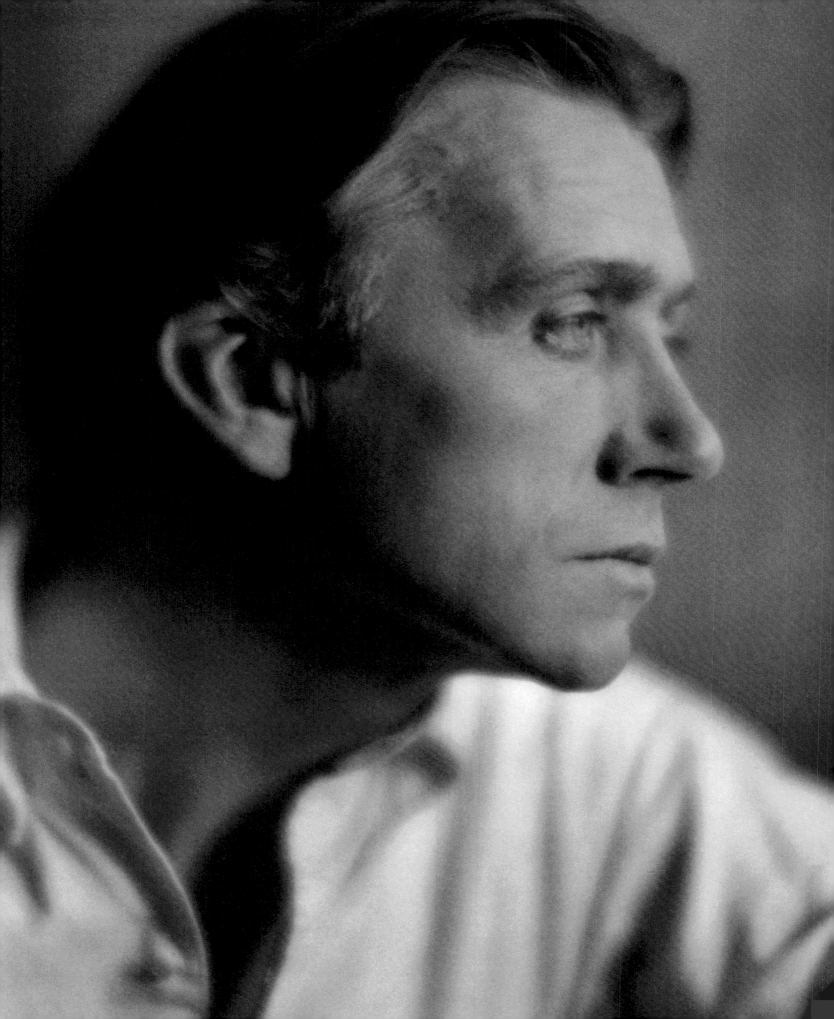

Initial findings about Weston's photographs made after his subsequent move to Mexico in 1923 indicate he continued to print his work on Willis and Clements Palladiotype paper.[24] While in Mexico he had trouble making ends meet, later recalling, "When I left Mexico I left my studio camera behind. And with that camera I also left behind platinum printing and negative enlarging. I was broke, and Palladiotype was expensive, did not keep well, and took five or six weeks to get since it had to be imported from England."[25] At this point, which was around 1926, Weston switched to using gelatin silver developing-out papers exclusively, and never made platinum or palladium prints again. Willis and Clements went out of business in 1937, and platinum and palladium printing generally fell out of popularity.

The occasion of Weston's 1946 retrospective afforded him the opportunity to reevaluate his earliest work. Out of 250 photographs in the show, seventeen were made before 1932. All of the photographs in the retrospective were available for sale, and Weston assigned a higher price to the early platinum and palladium prints. The silver gelatin prints made from the late 1920s onward had a price tag of twenty-five dollars, while the asking price for the platinum and palladium photographs was fifty dollars.[26] Weston knew it was impossible to create more platinum and palladium prints, but his reasons for including them and valuing them at twice the price go deeper. In the same 1942 letter to Nancy Newhall that describes the effects of glue on the prints, Weston also states that he selected his prints from viewpoints that were "historical, aesthetic and — I must confess — emotional. In other words, they all have a bearing on my life which makes me want to preserve them, for one reason or another."

Weston's urge to preserve his earliest photographs underscores the value of studying them closely to understand his materials and techniques. All of the experimentation Weston did in his early years with equipment and photographic papers created a deep knowledge base. He learned to visualize how the final print would look mounted and signed before he had even clicked the shutter. This kind of technical acumen has served the best photographers throughout the history of the medium, and Weston is an exceptional example of that disciplined training. Looking at Weston's early work, therefore, gives insight into his development and provides context for his mature work.

Detail, plate 76

LIST OF EQUIPMENT AND MATERIALS

CAMERAS

1902
Kodak Bull's-Eye #2
5 x 7 view camera, unknown make

1906
3 ¼ x 5 ½ Kodak

1911
11 x 14 Graf Variable

1912
3 ¼ x 4 ¼ Graflex
6 ½ x 8 ½ Seneca
5 x 7 Seneca
5 x 7 Graflex

1916
8 x 10 studio camera, unknown make

1920
8 x 10 Century Camera

LENSES

1910
Rapid Rectilinear

1911
Graf Variable

1912
Wollensak Vesta
Voigtlander Heliar

1916
Wollensak Verito

PAPERS

1906
Kodak Velox postcard paper

1910
Kodak Royal Bromide
 enlargement paper

1911
Cyko Buff Platinum paper
 (actually silver gelatin)
Kodak B Azo enlargement paper

1912
Artura Buff paper
Cyko Linen paper

1916
Kodak American Platinum
 Smooth paper
Kodak E.B. Platinum paper

1920
Willis and Clements Black
 Palladiotype paper

1921
Willis and Clements Palladiotype
 paper

Dates refer to the earliest published date of Weston's use. Camera formats are given in inches.

NOTES

PROLOGUE: BECOMING EDWARD WESTON

1. Notable exceptions include the writings of two scholars whose work is crucial for understanding Weston's early years, Amy Conger and Beth Gates Warren. See Amy Conger, "Edward Weston's Early Photographs, 1903–1926" (PhD diss., University of New Mexico, 1982); and Beth Gates Warren, *Margrethe Mather and Edward Weston: A Passionate Collaboration* (New York: W.W. Norton, 2001), and *Artful Lives: Edward Weston, Margrethe Mather, and the Bohemians of Los Angeles* (Los Angeles: J. Paul Getty Museum, 2011).

2. Edward Weston, letter to Don Prendergast, April 23, 1945, Susan Herzig and Paul Hertzmann Collection.

3. *The Daybooks of Edward Weston*, ed. Nancy Newhall, 2 vols. (New York: Aperture, 1973), hereafter cited as *Daybooks*. See *Daybooks* 1:xiii, where Newhall recounts that Weston described the daybooks as a kind of "safety valve" for him at a time "when pistols and poisons are taboo," but later was sorry, even with all the embarrassing "heartaches, headaches, [and] bellyaches" they contained, that he had destroyed them.

4. *Daybooks* 2:276–77.

5. J. C. Thomas, "A David Grayson Kind of Man," *American Magazine* (August 1915): 55–56.

BEGINNINGS

1. For a more detailed recounting of Weston's early family life, see Beth Gates Warren, *Artful Lives: Edward Weston, Margrethe Mather, and the Bohemians of Los Angeles* (Los Angeles: J. Paul Getty Museum, 2011), 1–5.

2. Edward Henry Weston to Edward Burbank Weston, August 20, 1902. Edward Weston Archive, Center for Creative Photography, University of Arizona, Tucson.

3. *Daybooks* 1:3.

4. *Daybooks* 1:3.

5. May Weston Seaman to Edward Weston, as quoted in Warren, *Artful Lives*, 5.

6. Weston had already had photographic work published by this time; of his 1903 landscape *Spring, Chicago*, one magazine's editors wrote, "We hope to see more of Mr. Weston's work." "Picture Criticism," *Camera and Darkroom* 9 (April 1906): 132–33.

7. Dennis Reed, *Making Waves: Japanese American Photography, 1920–1940* (Los Angeles: Japanese American National Museum, 2016), 45n73.

8. *Daybooks* 1:xvi, n. 2.

9. G. C. Henderson and Robert A. Oliver, *Tropico, the City Beautiful* (Tropico, Cal.: The Valley Press Publishers, 1915), online at http://content.cdlib.org/ark:/13030/c8z89bst.

10. Because 1911 was the year in which Weston produced the enlarged format, the original photograph has been erroneously dated to 1911 rather than 1909. See Amy Conger, "Edward Weston's Early Photographs, 1903–1926" (PhD diss., University of New Mexico, 1982), vol. 2, fig. 11/1, pp. 36–37. This image, which Conger describes as Weston's first enlargement, won first prize in the category of Outdoor Portraits, *Photo-Era* 29 (October 1912), 192. It was featured in Weston's studio brochure from late 1914 or early 1915; Weston Archive, CCP.

11. *Daybooks* 1:xviii.

12. "Our Competition," *American Photography* 2 (August 1908): 462, as quoted in Conger, "Weston's Early Photographs," vol. 2, fig. 8/1, p. 23; in this case, Conger mistakenly refers to the sitter as Edward's sister, May.

13. See, for example, Anne E. Havinga, "Pictorialism and Naturalism in New England Photography," in *Inspiring Reform: Boston's Arts and Crafts Movement*, ed. Marilee Boyd Meyer (Wellesley: Davis Museum and Cultural Center, 1997), 134–50; and Thomas Denenberg, *Wallace Nutting and the Invention of Old America* (New Haven: Yale University Press, 2003).

14. Sadakichi Hartmann, "Old Colonial Rooms," *Camera Work* (October 1910): 24–25.

15. E. H. Weston, "Artistic Interiors,"

Photo-Era 27 (December 1911): 298–300.

16. Although there is no record of this image's having been exhibited publicly, Weston did produce a large-scale platinum print of it. For a variant view, with Flora's head thrown back and arms outstretched, which was trimmed into a circular format, see Sarah M. Lowe, *Edward Weston: Life Work, Photographs from the Collection of Judith G. Hochberg and Michael P. Mattis* (Revere, Pa.: Lodima Press, 2003), pl. 3, p. 28.

17. *Daybooks*, 2:239.

18. The woman in this picture has long been thought to be Helen Cole; the J. Paul Getty Museum database identifies her as Nell Cole, a local school teacher and Tropico neighbor, for whom Weston's fourth son Cole was named: http://www.getty.edu/art/collection/objects/55000/edward-weston-edward-weston-and-eleanor-nell-cole-griffith-park-american-1909/.

19. "Monthly Competition," *Photo-Era* 25 (October 1910): 193, 206. The Kodak ad referred to in the inscription apparently never ran.

20. See *Daybooks* 2:235: "Schools, I only remember as dreary wastelands, I cannot believe that I learned anything of value in school, unless it be the will to rebel, to 'play hookey' which I have on numerous occasions since those first days with my camera in the snow-covered Chicago parks: 'play hookey' from my first job, from my own business, from my family life—not without some sense of responsibility, but never with after-regrets."

21. "Our Competition," *American Photography* 6 (November 1912): 643, 650.

22. "Competition Pictures—Genre Groups," *The Camera* (February 1911): 60, 63. Weston's response to the editor's comment in the February issue appeared in *The Camera* (May 1911): 226.

23. "Marine Studies," *The Camera* (November 1911): 480–82; and Conger, "Weston's Early Photographs," vol. 2, fig. 14/7, p. 106. This photograph was erroneously dated to about 1916 when it was lent by his former studio assistant, Rae Davis Knight, to the Weston retrospective at the Museum of Modern Art in 1975.

24. Thanks to Lesley Martin, Research Specialist at the Chicago History Museum, for help in locating the possible site of this image.

25. Thanks to the curatorial consultant and Weston specialist Paula B. Freedman, for identifying the reference to Lowell's poem.

26. "Pasadena Art Notes," *Pasadena News*, March 13, 1915, p. 8, as quoted in Conger, "Weston's Early Photographs," vol. 2, fig. 14/16, p. 105.

27. "Camera Portraits by Weston," advertisement in *Glendale, The Jewel City*, a 1912 promotional booklet, as quoted in Warren, *Artful Lives*, 11.

28. Edward Weston, "A One-Man Studio," *American Photography* (March 1913), 130–34, as quoted in Peter C. Bunnell, *Edward Weston: On Photography* (Salt Lake City: Peregrine Smith Books, 1983), 11–13.

29. See Conger, "Weston's Early Photographs," vol. 2, pp. 83–85; and Warren, *Artful Lives*, 356–57.

30. Warren, *Artful Lives*, 75.

31. Edward Weston, "Photography as a Means of Artistic Expression," lecture delivered to the College Women's Club, Los Angeles, October 18, 1916; reprinted in Bunnell, *Edward Weston: On Photography*, 18–21.

32. Edward Weston, "Photographing Children in the Studio," *American Photography* (February 1912): 83–88.

33. *Daybooks* 1:xvii.

34. Several Weston family albums are in the collection of the J. Paul Getty Museum, Los Angeles. See also Graham Howe and Beth Gates Warren, *Edward Weston: Portrait of the Young Man as an Artist* (London: Merrell, 2017).

35. Amy Conger, *Edward Weston: The Form of the Nude* (London: Phaidon, 2005), 13. Chandler's recollection was that his father directed him "to turn toward the branches of the nicotiana tree."

36. For a close variant of this image, see Lowe, *Edward Weston: Life Work*, pl. 4, p. 29.

37. Conger, "Weston's Early Photographs," vol. 2, pp. 116–17.

38. The same impulse may lie behind photographs he took of his sons in the 1940s, on the eve of their entering the military. See David Travis, *Edward Weston: The Last Years in Carmel* (Chicago: Art Institute of Chicago, 2001), "The War Years," 34–41.

39. "The Portraits at the London Salon of Photography," *British Journal of Photography* 64 (September 21, 1917): 484.

AN EXPANDING CIRCLE

1. *Daybooks* 1:145, December 29, 1925.

2. *Daybooks* 2:208-9, March 17, 1931; see also Beth Gates Warren, *Margrethe Mather and Edward Weston: A Passionate Collaboration* (New York: W.W. Norton, 2001), 10–15.

3. Imogen Cunningham to Phyllis Masser, 1970, as quoted in Lawrence Jasud, "Margrethe Mather: Questions of Influence," *Center for*

Creative Photography 11 (December 1979), 55.

4. *Daybooks* 2:209, March 17, 1931.

5. Bertram Park, "A Symposium: Which Is the Best Picture at the London Salon? The Honorary Secretary Pronounces for a Series by Edward H. Weston," *Amateur Photographer and Cinematographer*, September 29, 1914, as quoted in Beth Gates Warren, *Artful Lives: Edward Weston, Margrethe Mather, and the Bohemians of Los Angeles* (Los Angeles: J. Paul Getty Museum, 2011), 61n22.

6. Warren, *Artful Lives*, 55.

7. Warren, *Artful Lives*, 177n1.

8. Imogen Cunningham to Edward Weston, July 27, 1920, Weston Archive, CCP.

9. Wilfred A. French, "Our Illustrations," *Photo-Era* 45 (August 1920): 96.

10. Imogen Cunningham to Edward Weston, July 27, 1920, Weston Archive, CCP.

11. "Weston's Methods on Unconventional Portraiture," *Photo-Miniature* 14, no. 165 (September 1917): 354–56.

12. See Stacey McCarroll, *California Dreamin': Camera Clubs and the Pictorial Photography Tradition* (Boston: Boston University Art Gallery, 2004); and Michael Wilson and Dennis Reed, *Pictorialism in California: Photographs 1900–1940* (Los Angeles: J. Paul Getty Museum and Huntington Library and Art Gallery, 1994).

13. Arthur Wesley Dow, *Composition: A Series of Exercises in Art Structure for the Use of Students and Teachers* (New York: Baker and Taylor, 1899); Edward Weston, "Shall I Turn Professional?" in *American Photography* 6, no. 11(December 1912): 620–24.

14. A more direct connection to the Japanese-American photographic community in Los Angeles came in 1925, when the Shaku-do-sha club in Little Tokyo gave Weston a single-artist show, which resulted in a number of sales of prints; it was followed by another in the summer of 1927 and a final one in November 1931. See Dennis Reed, *Making Waves: Japanese American Photography, 1920–1940* (Los Angeles: Japanese American National Museum, 2016), 40–48.

15. Antony Anderson, "Of Art and Artists," *Los Angeles Times*, June 1, 1919, as quoted in Warren, *Artful Lives*, 159n29.

16. An accomplished self-promoter, St. Denis was also photographed by Adolf de Meyer and Arnold Genthe in her *Omika* costumes. The vaudeville version of the *Dance of the Flower Arrangement* was performed in 1916 and featured her husband, Ted Shawn, as well. See Rebecca A. T. Stevens, *The Kimono Inspiration: Art and Art-to-Wear in America* (Washington, D.C.: Textile Museum, 1996), 60.

17. Warren, *Artful Lives*, 107n113.

18. Sadakichi Hartmann to Edward Weston, October 18, 1915, Weston Archive, CCP.

19. Antony Anderson, "Art and Artists," *Los Angeles Times*, October 31, 1915, as quoted in Warren, *Artful Lives*, 79n48.

20. Ben Maddow, *Edward Weston: Fifty Years* (New York: Aperture, 1973), 82.

21. John Crosse, *Southern California Architectural History* blog, https://socalarchhistory.blogspot.com/: "EW, MM, and the Marion Morgan Dancers," July 9, 2014.

22. Warren, *Artful Lives*, 79.

23. Warren, *Artful Lives*, 253n34.

24. "Our Illustrations," *American Photography* 15 (November 1921): 625, 649, as quoted in Amy Conger, "Weston's Early Photographs, 1903–1926" (PhD diss., University of New Mexico, 1982), vol. 3, pp. 279–80, fig. 19/8.

25. Imogen Cunningham to Edward Weston, July 27, 1920, Weston Archive, CCP.

26. Edward Weston to Johan Hagemeyer, October 25, 1920, Weston Hagemeyer Collection, CCP.

27. See Conger, "Weston's Early Photographs," vol. 3, pp. 307–8, fig. 20/13; and Warren, *Artful Lives*, 192.

28. Edward Weston to Betty Katz, as quoted in Warren, *Artful Lives*, 203n96.

29. F. C. Tilney, "Pictorial Photography in 1921," *Photograms of the Year* (1921): 17.

30. Edward Weston, "Random Notes on Photography," lecture delivered to the Southern California Camera Club, Los Angeles, June 1922, as quoted in Peter C. Bunnell, *Edward Weston: On Photography* (Salt Lake City: Peregrine Smith Books, 1983), 26–32.

31. Imogen Cunningham to Edward Weston, July 27, 1920, Weston Archive, CCP.

32. John Paul Edwards, "The Eighth Pittsburgh Salon," *Photo-Era* 46 (May 1921): 228.

LIGHT AND SHADOW

1. Antony Anderson, "Of Art and Artists," *Los Angeles Times*, February 13, 1921, as quoted in Beth Gates Warren, *Artful Lives: Edward Weston, Margrethe Mather, and the Bohemians of Los Angeles* (Los Angeles: J. Paul Getty Museum, 2011), 208n3.

2. Elizabeth Bingham, "Art Exhibits

and Comment," *Saturday Night*, August 19, 1922, p. 9, as quoted in Amy Conger, "Weston's Early Photographs, 1903–1926" (PhD diss., University of New Mexico, 1982), vol. 3, fig. 22/5, pp. 380–6.

3. *Daybooks* 1:4.

4. *Daybooks* 1:6.

5. Edward Weston to Johan Hagemeyer, April 18, 1921, Weston Hagemeyer Collection, CCP.

6. Edward Weston to Johan Hagemeyer, April 29, 1922, Weston Hagemeyer Collection, CCP.

7. Quoted in *Daybooks* 1:6.

8. Edward Weston, "Photographing Children in the Studio," *American Photography* 6, no. 2 (February 1912): 83–88.

9. Edward Weston, "Random Notes on Photography," June 1922, as quoted in Peter C. Bunnell, *Edward Weston: On Photography* (Salt Lake City: Peregrine Smith Books, 1983), 26–32.

10. Reproduced in "Textiles and Interior Decoration Department: A Note on Batik," *California Southland* 23 (November 1921): 19.

11. Weston's friendship with Ricardo Gómez Robelo, and the fact that the latter had proposed an exhibition of Weston and Mather's work in Mexico City as early as 1921, was an important influence on Edward's eventual decision to move there with Modotti in 1923. Here Gómez Robelo appears in front of Robo's batik "The Witch," whose title and imagery seem to refer to one of Edgar Allan Poe's best-known short stories, "The Black Cat" (1843).

12. *Daybooks* 1:69.

13. Edward Weston, postcard to Johan Hagemeyer, October 7, 1922, Weston Hagemeyer Collection, CCP.

14. *Daybooks* 1:8; this is followed by:

"(Editorial comment: 20 years later they still look good—Edward Weston)."

15. *Daybooks* 1:6.

16. László Moholy-Nagy, *Von Material zu Architektur*, Bauhausbücher 14 (Munich: A. Langen Verlag, 1929), 230–31. Although Weston's Armco Steel image *Pipes and Stacks* was not among the twenty works he submitted to the Film und Foto exhibition in Stuttgart, it was reproduced on the cover of the Berlin newspaper *Der Weltspiegel* (a supplement of the *Berliner Tageblatt und Handelszeitung*) on November 21, 1926; see *Daybooks* 2:34–35.

17. Edward Weston to Johan Hagemeyer, November 18, 1922, Weston Hagemeyer Collection, CCP; and January 11, 1923, as quoted in Warren, *Artful Lives*, 266.

18. Edward Weston to Johan Hagemeyer, January 11, 1923, as quoted in Warren, *Artful Lives*, 266–67.

19. Edward Weston to Alfred Stieglitz, February 21, 1923, as quoted in Warren, *Artful Lives*, 275.

20. Edward Weston to Johan Hagemeyer, April 9, 1923, Weston Hagemeyer Collection, CCP.

21. See Warren, *Artful Lives*, 284.

22. Margrethe Mather to Edward Weston, July 29, 1923, Weston Archive, CCP.

23. *Daybooks* 1:116.

MATERIALS AND TECHNIQUES

1. *Daybooks* 1:3.

2. Beth Gates Warren and Graham Howe, *Portrait of the Artist as a Young Man* (New York: Merrell Publishers, 2017), 17.

3. Beth Gates Warren, *Artful Lives: Edward Weston, Margrethe Mather, and the Bohemians of Los Angeles*

(Los Angeles: J. Paul Getty Museum, 2011), 6.

4. Illinois College of Photography pamphlet, 1905–6, Collection of the Library of the University of Illinois at Urbana-Champaign.

5. Warren, *Artful Lives*, 9.

6. Edward Weston, "Thirty-Five Years of Portraiture," *Camera Craft* (September 1939): 399–408.

7. Edward Weston Studio brochure, 1914, Edward Weston Archive, Center for Creative Photography.

8. *Daybooks* 2:235.

9. Edward Weston, "Weston's Methods on Unconventional Portraiture," *Photo Miniature* 14, no. 165 (September 1917): 354.

10. "Our Illustrations," *Studio Light: A Magazine of Information for the Profession* 8, no. 5 (July 1916): 8.

11. This trunk is in the collection of the Center for Creative Photography.

12. Weston, "Thirty-Five Years of Portraiture."

13. "A David Grayson Kind of Man," *American Magazine* 80, no. 2 (August 1915): 55.

14. Edward Weston, "A One-Man Studio," *American Photography* 7 (1913): 130.

15. *Daybooks* 2:90.

16. *Daybooks* 2:90.

17. "Spring," *Camera and Darkroom* 9 (April 1906): 132–33.

18. Kodak supply catalog, 1905, p. 53. Willis and Clements Platinotype Handbook, 1906, p. 13.

19. Luis Nadeau, *History and Practice of Platinum Printing*, 3rd ed. (New Brunswick: Luis Nadeau, 1994), 35.

20. *Daybooks* 2:143.

21. Catalogue of the Ninth Annual Pittsburgh Salon of Photography, 1922, p. 24.

22. Protein analysis was completed by Matrix Assisted Laser Desorption/Ionization, performed by Dan Kirby

of Dan Kirby Analytical Services, Milton, Mass.

23. Edward Weston to Nancy Newhall, September 20, 1942. Museum of Modern Art Exhibition Records for *The Photographs of Edward Weston* (MoMA Exh. #311, February 11–March 31, 1946).

24. Analysis has been performed by XRF on a selection of prints made in Mexico at the MFA and at the J. Paul Getty Museum.

25. Weston, "Thirty-Five Years of Portraiture."

26. Letter of May 3, 1946, from Ann E. Armstrong, Photographic Department, MoMA, to Ichiro Misumi, San Francisco. Sotheby's Auction Catalog, October 3, 2012, Lot #73. See also internal memo dated January 21, 1946, Museum of Modern Art Exhibition Records for *The Photographs of Edward Weston*.

LIST OF ILLUSTRATIONS

Works are by Edward Weston unless otherwise noted. Dimensions, given as height x width, are print dimensions unless stated otherwise.

PLATES

1

Snow Scene, Jackson Park, Chicago, 1903
Gelatin silver developed-out print
8.3 x 11.1 cm (3¼ x 4⅜ in.)
Collection Center for Creative
Photography, 81.207.7
Copyright ©1981 Center for Creative
Photography, Arizona Board of Regents

2

Grand Mere, 1903
Gelatin silver developed-out print
6.5 x 11.7 cm (2⁹⁄₁₆ x 4⅝ in.)
The Lane Collection
Museum of Fine Arts, Boston, 2017.1610

3

Old Lake Michigan, about 1904
Gelatin silver developed-out print
9 x 11.8 cm (3⁹⁄₁₆ x 4⅝ in.)
The Lane Collection
Museum of Fine Arts, Boston, 2017.3814

4

Landscape with Skull, Mojave Desert, 1907
Gelatin silver developed-out print
11.6 x 16.9 cm (4⁹⁄₁₆ x 6⅝ in.)
Collection of Michael Mattis and Judith
Hochberg, New York
Copyright ©1981 Center for Creative
Photography, Arizona Board of Regents

5

Peaches, 1914
Gelatin silver developed-out print
11.9 x 20.3 cm (4¹¹⁄₁₆ x 8 in.)
The J. Paul Getty Museum, Los
Angeles, 86.XA.714.38
Copyright ©1981 Center for Creative
Photography, Arizona Board of Regents

6

Self-Portrait with Flora Chandler, 1907
Gelatin silver developed-out print
22.5 x 16.8 cm (8⅞ x 6⅝ in.)
The J. Paul Getty Museum,
Los Angeles, 86.XM.719.18
Copyright ©1981 Center for Creative
Photography, Arizona Board of Regents

7

Honeymoon Trip, 1909
Gelatin silver developed-out print
11.7 x 16.5 cm (4⅝ x 6½ in.)
The J. Paul Getty Museum, Los
Angeles, 86.XM.719.16
Copyright ©1981 Center for Creative
Photography, Arizona Board of Regents

8

Self-Portrait, 1909; printed 1911
Gelatin silver developed-out print
29.1 x 24.4 cm (11⁷⁄₁₆ x 9⅝ in.)
The Lane Collection
Museum of Fine Arts, Boston, 2017.3854

9

Priscilla, 1908
Gelatin silver developed-out print
13.2 x 7.4 cm (5³⁄₁₆ x 2¹⁵⁄₁₆ in.)
The Lane Collection
Museum of Fine Arts, Boston, 2017.3817

10

In Reverie, 1909
Gelatin silver developed-out print
16.3 x 11.4 cm (6⁷⁄₁₆ x 4½ in.)
The Lane Collection
Museum of Fine Arts, Boston, 2017.3827

11

Flora Chandler Weston, 1909
Gelatin silver developed-out print
15.2 x 9.4 cm (6 x 3¹¹⁄₁₆ in.)
The Lane Collection
Museum of Fine Arts, Boston, 2017.3828

12

Nude (Flora Chandler Weston), 1909
Platinum print
28.2 x 35.6 cm (11⅛ x 14 in.)
The J. Paul Getty Museum,
Los Angeles, 86.XM.719.13
Copyright ©1981 Center for Creative
Photography, Arizona Board of Regents

13

San Fernando Valley, Griffith Park, 1911
Gelatin silver developed-out print
18.8 x 15 cm (7⁷⁄₁₆ x 5¹⁵⁄₁₆ in.)
Collection of Michael Mattis and Judith
Hochberg, New York
Copyright ©1981 Center for Creative
Photography, Arizona Board of Regents

14

In Vacation Time, about 1910
Gelatin silver developed-out print
15.9 x 10.6 cm (6¼ x 4³⁄₁₆ in.)
The J. Paul Getty Museum,
Los Angeles, 86.XM.719.21
Copyright ©1981 Center for Creative
Photography, Arizona Board of Regents

15

Let's Play Hookey, 1910
Gelatin silver developed-out print
15.4 x 11.6 cm (6¹⁄₁₆ x 4⁹⁄₁₆ in.)
The Lane Collection
Museum of Fine Arts, Boston, 2017.3836

16

Chicago River Harbor, 1908
Gelatin silver developed-out print
15.8 x 23.5 cm (6³⁄₁₆ x 9¼ in.)
Collection of Michael Mattis and Judith
Hochberg, New York
Copyright ©1981 Center for Creative
Photography, Arizona Board of Regents

17

Valley of the Long Winds, 1913
Platinum print
29.4 x 41.3 cm (11⁹⁄₁₆ x 16¼ in.)
Courtesy of Susan Herzig &
Paul Hertzmann, Paul M. Hertzmann,
Inc., San Francisco
Copyright ©1981 Center for Creative
Photography, Arizona Board of Regents

18

Summer Sunshine (Rae Davis), 1914
Platinum print
47.6 x 33 cm (18¾ x 13 in.)
Jack and Beverly Waltman Collection,
1912–2014
The Huntington Library, San Marino,
California, PhotCL 553(88)
Copyright ©1981 Center for Creative
Photography, Arizona Board of Regents

19

I Do Believe in Fairies, 1913
Platinum print, mercury toned
33.2 x 26.7 cm (13¹⁄₁₆ x 10½ in.)
The Lane Collection
Museum of Fine Arts, Boston, 2017.1619

20

Portrait of My Son, 1915
Platinum print
32.9 x 23 cm (12¹⁵⁄₁₆ x 9¹⁄₁₆ in.)
The J. Paul Getty Museum,
Los Angeles, 86.XM.609
Copyright ©1981 Center for Creative
Photography, Arizona Board of Regents

21

Bust of Brett, about 1919
Platinum print
24.3 x 19.2 cm (9⁹⁄₁₆ x 7⁹⁄₁₆ in.)
The J. Paul Getty Museum,
Los Angeles, 86.XA.712.8
Copyright ©1981 Center for Creative
Photography, Arizona Board of Regents

22

Chandler in His Shop, 1920
Palladium print
Image: 23.7 x 19.1 cm (9⁵⁄₁₆ x 7½ in.)
The J. Paul Getty Museum,
Los Angeles, 86.XM.710.12
Copyright ©1981 Center for Creative
Photography, Arizona Board of Regents

23

Neil, 1922
Palladium print
23.5 x 17.5 cm (9¼ x 6⅞ in.)
George Eastman Museum,
1974.0061.0003
Image courtesy George Eastman
Museum
Copyright ©1981 Center for Creative
Photography, Arizona Board of Regents

24

Neil, 1922
Platinum or palladium print
23 x 18.4 cm (9 x 7¼ in.)
The New Orleans Museum of Art,
Women's Volunteer Committee Fund
and Dr. Ralph Fabacher, 73.139
Copyright ©1981 Center for Creative
Photography, Arizona Board of Regents

25

Two Boys, 1922
Palladium print
20.3 x 18.1 cm (8 x 7⅛ in.)
The Lane Collection
Museum of Fine Arts, Boston, 2017.1651

26

Portrait of My Father, 1917
Platinum print
19.2 x 24.3 cm (7⁹⁄₁₆ x 9⁹⁄₁₆ in.)
The Lane Collection
Museum of Fine Arts, Boston, 2017.1618

27

Margrethe Mather, about 1913
Gelatin silver developed-out print
16.3 x 10.9 cm (6⁷⁄₁₆ x 4⁵⁄₁₆ in.)
Collection Center for Creative
Photography, 78.151.1
Copyright ©1981 Center for Creative
Photography, Arizona Board of Regents

28

Carlota, 1914
Platinum print
23.3 x 16.2 cm (9³⁄₁₆ x 6⅜ in.)
The Lane Collection
Museum of Fine Arts, Boston, 2017.1616

29

Margrethe in Garden, about 1918
Platinum or palladium print
18.8 x 23.5 cm (7⅜ x 9¼ in.)
Collection Center for Creative
Photography, 81.207.21
Copyright ©1981 Center for Creative
Photography, Arizona Board of Regents

30
Margrethe in the Studio, 1920
Palladium print
24.1 x 18.5 cm (9½ x 7⁵⁄₁₆ in.)
Collection Center for Creative
Photography, 81.207.10
Copyright ©1981 Center for Creative
Photography, Arizona Board of Regents

31
Margrethe Mather, 1921
Palladium print
24.1 x 19.1 cm (9½ x 7½ in.)
The Lane Collection
Museum of Fine Arts, Boston, 2017.1642

32
Margrethe in the Studio, 1920
Palladium print, mercury toned
21.1 x 18.6 cm (8⁵⁄₁₆ x 7⁵⁄₁₆ in.)
The Lane Collection
Museum of Fine Arts, Boston, 2017.1626

33
Margrethe Mather in My Studio, 1921
Palladium print
24.1 x 18.9 cm (9½ x 7⁷⁄₁₆ in.)
The Lane Collection
Museum of Fine Arts, Boston, 2017.1628

34
Untitled (Margrethe Mather), 1921
Palladium print
23.4 x 18 cm (9³⁄₁₆ x 7¹⁄₁₆ in.)
Collection Center for Creative
Photography, 81.207.25
Copyright ©1981 Center for Creative
Photography, Arizona Board of Regents

35
Epilogue, 1919
Palladium print, mercury toned
24.3 x 18.6 cm (9⁹⁄₁₆ x 7⁵⁄₁₆ in.)
The Museum of Fine Arts, Houston,
Museum purchase funded by Target
Stores, 78.62
Copyright ©1981 Center for Creative
Photography, Arizona Board of Regents

36
Prologue to a Sad Spring, 1920
Palladium print
23.8 x 18.7 cm (9⅜ x 7⅜ in.)
The Lane Collection
Museum of Fine Arts, Boston, 2017.1641

37
Untitled (Portrait of Two Girls), about
1919
Platinum or palladium print
24.3 x 19.1 cm (9⁹⁄₁₆ x 7½ in.)
Collection Center for Creative
Photography, 81.281.2
Copyright ©1981 Center for Creative
Photography, Arizona Board of Regents

38
Portrait of a Bride, about 1920
Palladium print
24 x 18.7 cm (9⁹⁄₁₆ x 7⅜ in.)
Collection of Michael Mattis and Judith
Hochberg, New York
Copyright ©1981 Center for Creative
Photography, Arizona Board of Regents

39
Almond Blossoms, 1912
Gelatin silver developed-out print
20.5 x 15.2 cm (8¹⁄₁₆ x 6 in.)
The Lane Collection
Museum of Fine Arts, Boston, 2017.3844

40
Margrethe in My Studio, 1917
Platinum print
24.4 x 19.2 cm (9⅝ x 7⁹⁄₁₆ in.)
The Lane Collection
Museum of Fine Arts, Boston, 2017.1617

41
Ruth St. Denis, about 1916
Platinum print
41.3 x 29 cm (16¼ x 11⁷⁄₁₆ in.)
George Eastman Museum, Gift of Brett
Weston, 1974.0061.0050
Image courtesy George Eastman
Museum
Copyright ©1981 Center for Creative
Photography, Arizona Board of Regents

42
Sadakichi Hartmann, 1917
Gelatin silver developed-out print
24.1 x 19.2 cm (9½ x 7⁹⁄₁₆ in.)
The J. Paul Getty Museum,
Los Angeles, 85.XM.170.5
Copyright ©1981 Center for Creative
Photography, Arizona Board of Regents

43
Japanese Fencing Mask, 1921
Platinum or palladium print
19.1 x 24.4 cm (7½ x 9⅝ in.)
Wilson Centre for Photography
Copyright ©1981 Center for Creative
Photography, Arizona Board of Regents

44
Ted Shawn (Dancing Nude), 1916
Gelatin silver developed-out print
15.2 x 11.7 cm (6 x 4⅝ in.)
Collection of Dennis Reed and Amy
Reed, Los Angeles
Copyright ©1981 Center for Creative
Photography, Arizona Board of Regents

45
Costume Study (The Goldfish), about
1916–17
Platinum print
23.7 x 16.8 cm (9⁵⁄₁₆ x 6⅝ in.)
The J. Paul Getty Museum,
Los Angeles, 85.XM.170.1
Copyright ©1981 Center for Creative
Photography, Arizona Board of Regents

46

Dancer, about 1916–17
Gelatin silver developed-out print
15.2 x 11.6 cm (6 x 4%₁₆ in.)
The Lane Collection
Museum of Fine Arts, Boston, 2017.3848

47

Edward Weston and Margrethe Mather
(1886–1952)
Marion Morgan Dancers, 1920
Platinum or palladium print
18.8 x 22.5 (7⅜ x 8¹³⁄₁₆ in.)
Scripps College, Claremont, CA, Gift
of C. Jane Hurley Wilson '64 and
Michael G. Wilson, Wilson Centre for
Photography, 2008.4.26
Copyright ©1981 Center for Creative
Photography, Arizona Board of Regents

48

Bathers, 1919
Platinum print, mercury toned
24.1 x 19.2 cm (9½ x 7%₁₆ in.)
The J. Paul Getty Museum, Los
Angeles, 85.XM.257.1
Copyright ©1981 Center for Creative
Photography, Arizona Board of Regents

49

Bathing Pool, 1919
Platinum print, mercury toned
24.5 x 19.1 cm (9⅝ x 7½ in.)
Los Angeles County Museum of Art,
The Marjorie and Leonard Vernon
Collection, Gift of the Annenberg
Foundation and promised gift of
Carol Vernon and Robert Turbin,
M.2008.40.2381
Copyright ©1981 Center for Creative
Photography, Arizona Board of Regents

50

Scene Shifter, 1921
Platinum or palladium print
24 x 19.1 cm (9⁷⁄₁₆ x 7½ in.)
Collection Center for Creative
Photography, 76.5.15
Copyright ©1981 Center for Creative
Photography, Arizona Board of Regents

51

Ruth Deardorff Shaw, 1922
Platinum or palladium print
17.8 x 22.2 cm (7 x 8¾ in.)
Collection of Dennis and Annie Reed,
Los Angeles
Copyright ©1981 Center for Creative
Photography, Arizona Board of Regents

52

Enrique, 1919
Palladium print
24.4 x 18.4 cm (9⅝ x 7¼ in.)
The Lane Collection
Museum of Fine Arts, Boston, 2017.1615

53

Mynheer, J.H., 1918
Gelatin silver developed-out print
24 x 18.9 cm (9⁷⁄₁₆ x 7⁷⁄₁₆ in.)
Collection Center for Creative
Photography, 76.5.28
Copyright ©1981 Center for Creative
Photography, Arizona Board of Regents

54

Sun Mask, 1918
Gelatin silver developed-out print
19.3 x 24.3 cm (7⅝ x 9%₁₆ in.)
Collection Center for Creative
Photography, 76.5.32
Copyright ©1981 Center for Creative
Photography, Arizona Board of Regents

55

Franz Geritz, 1920
Palladium print
24.3 x 19.1 cm (9%₁₆ x 7½ in.)
The Lane Collection
Museum of Fine Arts, Boston, 2017.1627

56

Alfred Kreymborg (Balloon Fantasy),
1921
Palladium print
21.7 x 18.9 cm (8%₁₆ x 7⁷⁄₁₆ in.)
The Lane Collection
Museum of Fine Arts, Boston, 2017.1636

57

Betty in Her Attic, 1920
Palladium print
23.3 x 19 cm (9³⁄₁₆ x 7½ in.)
Collection Center for Creative
Photography, 81.207.3
Copyright ©1981 Center for Creative
Photography, Arizona Board of Regents

58

Ramiel in His Attic, 1920
Palladium print
23.6 x 18.7 cm (9%₁₆ x 7⅜ in.)
Collection Center for Creative
Photography, 76.5.22
Copyright ©1981 Center for Creative
Photography, Arizona Board of Regents

59

Johan Hagemeyer, 1920
Palladium print
19.2 x 23.5 cm (7%₁₆ x 9¼ in.)
The Lane Collection
Museum of Fine Arts, Boston, 2017.1643

60

Ruth Shaw, 1922
Palladium print
19.1 x 24.3 cm (7½ x 9%₁₆ in.)
The Lane Collection
Museum of Fine Arts, Boston, 2017.1652

61

Ralph Pearson, 1922
Palladium print
21.6 x 16.8 cm (8½ x 6⁹⁄₁₆ in.)
Collection of Michael Mattis and Judith
Hochberg, New York
Copyright ©1981 Center for Creative
Photography, Arizona Board of Regents

62

Edward Weston and Margrethe Mather
(1886–1952)
Carl Sandburg, 1921
Platinum or palladium print
18.8 x 23 cm (7⅜ x 9¹⁄₁₆ in.)
Collection Center for Creative
Photography, 80.138.2
Copyright ©1981 Center for Creative
Photography, Arizona Board of Regents

63

Edward Weston and Margrethe Mather
(1886–1952)
Max Eastman, 1921
Palladium print
19 x 23.7 cm (7½ x 9⅜ in.)
The Museum of Modern Art,
New York, Purchase, 574.1971
Copyright ©1981 Center for Creative
Photography, Arizona Board of Regents
Digital image © The Museum of
Modern Art/Licensed by SCALA/Art
Resource, NY

64

Nude, about 1918
Palladium print
24.3 cm 18.6 cm (9⁹⁄₁₆ x 7⁵⁄₁₆ in.)
The Lane Collection
Museum of Fine Arts, Boston, 2017.1621

65

Torso, about 1918
Palladium print
24.4 x 19.1 cm (9⅝ x 7½ in.)
The Lane Collection
Museum of Fine Arts, Boston, 2017.1620

66

The Source, 1921
Platinum or palladium print
18.9 x 24.1 cm (7½ x 9½ in.)
Photographic History Collection,
Smithsonian's National Museum of
American History, gift 2/8/23, cat. 3615
Copyright ©1981 Center for Creative
Photography, Arizona Board of Regents

67

Refracted Sunlight on Torso, 1922
Palladium print
22.4 x 19 cm (8¹³⁄₁₆ x 7½ in.)
Museum of Modern Art, New York,
Purchase, 487.1966
Copyright ©1981 Center for Creative
Photography, Arizona Board of Regents
Digital image © The Museum of
Modern Art/Licensed by SCALA/Art
Resource, NY

68

Breast, 1922
Palladium print
19 x 23.8 cm (7½ x 9⅜ in.)
Collection of Michael Mattis and Judith
Hochberg, New York
Copyright ©1981 Center for Creative
Photography, Arizona Board of Regents

69

Head of an Italian Girl, 1921
Palladium print
24.4 x 19.1 cm (9⅝ x 7½ in.)
The Lane Collection
Museum of Fine Arts, Boston, 2017.1623

70

The White Iris, 1921
Palladium print
24.2 x 19 cm (9½ x 7½ in.)
Collection Center for Creative
Photography, 76.5.27
Copyright ©1981 Center for Creative
Photography, Arizona Board of Regents

71

Tina Modotti, 1921
Palladium print
24.2 x 19 cm (9½ x 7½ in.)
The J. Paul Getty Museum,
Los Angeles, 85.XM.170.7
Copyright ©1981 Center for Creative
Photography, Arizona Board of Regents

72

Paul Jordan-Smith, 1922
Palladium print
24.3 x 19 cm (9⁹⁄₁₆ x 7½ in.)
The J. Paul Getty Museum,
Los Angeles, 84.XP.904.7
Copyright ©1981 Center for Creative
Photography, Arizona Board of Regents

73

Ruth, 1922
Palladium print
24.1 x 19.1 cm (9½ x 7½ in.)
The Lane Collection
Museum of Fine Arts, Boston, 2017.1644

74

Imogen Cunningham, 1922
Palladium print
24.3 x 19.1 cm (9⁹⁄₁₆ x 7½ in.)
The J. Paul Getty Museum,
Los Angeles, 84.XM.896.3
Copyright ©1981 Center for Creative
Photography, Arizona Board of Regents

75

Dorothea Lange, 1920
Palladium print
19.7 x 15.3 cm (7¾ x 6 in.)
Collection Center for Creative
Photography, 76.5.23
Copyright ©1981 Center for Creative
Photography, Arizona Board of Regents

76

Johan Hagemeyer, 1921
Palladium print
24.1 x 19.1 cm (9½ x 7½ in.)
The Lane Collection
Museum of Fine Arts, Boston, 2017.1634

77

Portrait of a Girl, 1922
Palladium print
24.1 x 19.1 cm (9½ x 7½ in.)
The Lane Collection
Museum of Fine Arts, Boston, 2017.1654

78

Girl in Canton Chair, 1921
Palladium print
19.1 x 24.4 cm (7½ x 9⅝ in.)
The Lane Collection
Museum of Fine Arts, Boston, 2017.1650

79

The Batik Gown, 1921
Palladium print
18.9 x 23.8 cm (7⁷⁄₁₆ x 9⅜ in.)
Collection Center for Creative
Photography, 81.207.4
Copyright ©1981 Center for Creative
Photography, Arizona Board of Regents

80

George Stojana, 1921
Palladium print
24.6 x 18.9 cm (9¹¹⁄₁₆ x 7⁷⁄₁₆ in.)
The Lane Collection
Museum of Fine Arts, Boston, 2017.1633

81

Robelo (Poesque), 1921
Palladium print
19.1 x 24.2 cm (7½ x 9½ in.)
The Lane Collection
Museum of Fine Arts, Boston, 2017.1640

82

Ricardo Gomez Robelo, 1921
Palladium print
19.4 x 24.4 cm (7⅝ x 9⅝ in.)
The Lane Collection
Museum of Fine Arts, Boston, 2017.1635

83

Robo de Richey, 1921
Palladium print
18.1 x 23.2 cm (7⅛ x 9⅛ in.)
The Lane Collection
Museum of Fine Arts, Boston, 2017.1638

84

Armco Steel, Stacks and Telephone Poles,
1922
Palladium print
18.6 x 21 cm (7⁵⁄₁₆ x 8¼ in.)
The Lane Collection
Museum of Fine Arts, Boston, 2017.1653

85

Armco Steel, Smokestacks, 1922
Palladium print
23.1 x 17.9 cm (9⅛ x 7¹⁄₁₆ in.)
Collection of Michael Mattis and Judith
Hochberg, New York
Copyright ©1981 Center for Creative
Photography, Arizona Board of Regents

86

Armco Steel, Pipes and Stacks, 1922
Palladium print
24.3 x 19.4 cm (9⁹⁄₁₆ x 7⅝ in.)
The Museum of Fine Arts, Houston,
Museum purchase funded by the estate
of Caroline Wiess Law, The Manfred
Heiting Collection, 2002.2635
Copyright ©1981 Center for Creative
Photography, Arizona Board of Regents

87

Armco Steel, Vertical Coal Chute, 1922
Palladium print
24 x 15.9 cm (9⁷⁄₁₆ x 6¼ in.)
The Lane Collection
Museum of Fine Arts, Boston, 2017.1648

88

In My Glendale Studio, 1923
Palladium print
15.7 x 24.2 cm (6⅛ x 9½ in.)
The Lane Collection
Museum of Fine Arts, Boston, 2017.1672

89

Margrethe, 1923
Platinum or palladium print
19 x 24.1 cm (7½ x 9½ in.)
Collection Center for Creative
Photography, 81.207.5
Copyright ©1981 Center for Creative
Photography, Arizona Board of Regents

90

Margrethe Mather, Redondo Beach, 1923
Platinum or palladium print
19 x 23.9 cm (7½ x 9⅜ in.)
Collection of Dennis and Annie Reed,
Los Angeles
Copyright ©1981 Center for Creative
Photography, Arizona Board of Regents

91

Nude (Margrethe), 1923 (printed later)
Gelatin silver developed-out print
19.1 x 24.1 cm (7½ x 9½ in.)
The Lane Collection
Museum of Fine Arts, Boston, 2017.1659

Fig. 16
Nude (Charis), 1936
Gelatin silver developed-out print
19.4 x 24.1 cm (7⅝ x 9½ in.)
The Lane Collection
Museum of Fine Arts, Boston, 2017.2324

Fig. 17
Ramiel and Margrethe with Camera, 1923
Gelatin silver developed-out print
7.3 x 9.9 cm (2⅞ x 3⅞ in.)
Edward Weston Archive, Center for
Creative Photography
Copyright ©1981 Center for Creative
Photography, Arizona Board of Regents

Fig. 18
Vasia Anikeef, 1921
Gelatin silver negative on film (detail)
25.4 x 20.3 cm (10 x 8 in.)
George Eastman Museum, Gift of
Richard L. Menschel, 1972.0166.0003
Image courtesy George Eastman
Museum
Copyright ©1981 Center for Creative
Photography, Arizona Board of Regents

Fig. 19
Nude, about 1918 (detail, plate 64)

Fig. 20
Detail of verso of *Nude*, about 1918
(plate 64)

Fig. 21
Detail of mount, *Landscape with Skull,
Mojave Desert*, 1907 (plate 4)

Fig. 22
Margrethe Mather, about 1919
Palladium print, mercury toned
24.6 x 16.7 cm (9¹¹⁄₁₆ x 6⁹⁄₁₆ in.)
The Lane Collection
Museum of Fine Arts, Boston, 2017.1622

Fig. 23
Paul Jordan-Smith, 1918
Platinum print, mercury toned
24.3 x 19.5 cm (9⁹⁄₁₆ x 7¹¹⁄₁₆ in.)
The Lane Collection
Museum of Fine Arts, Boston, 2017.1614

Fig. 24
Paul Jordan-Smith, 1918
Platinum print, mercury toned
24.2 x 19.4 cm (9½ x 7⅝ in.)
Collection Center for Creative
Photography, 76.5.17
Copyright ©1981 Center for Creative
Photography, Arizona Board of Regents

Fig. 25
Margrethe Mather, 1920
Palladium print
23.8 x 19.2 cm (9⅜ x 7⁹⁄₁₆ in.)
The Lane Collection
Museum of Fine Arts, Boston, 2017.1637

Fig. 26
Margrethe Mather, 1920
Palladium print
21 x 18.5 cm (8¼ x 7⁵⁄₁₆ in.)
Collection Center for Creative
Photography, 81.207.13
Copyright ©1981 Center for Creative
Photography, Arizona Board of Regents

Details
Page 2: plate 57
Page 8: plate 25
Page 58: plate 31
Page 118: plate 87
Page 168: plate 69

ACKNOWLEDGMENTS

First and foremost, we are deeply grateful to Saundra B. Lane for the inspiration and support she has provided to the departments of Photography and Paper Conservation over many years. The longstanding commitment of Saundra and her husband, William H. Lane, to the work of Edward Weston has led to numerous MFA exhibitions and publications, drawn from the more than two thousand photographs by the artist in the Lane Collection. This book focusing on the first two decades of Weston's career highlights the breadth and depth of the Lanes' holdings of his work and celebrates the gift of all of the photographer's prints in their collection to the Museum in 2017. We would also like to thank Matthew Teitelbaum, Ann and Graham Gund Director, and the many members of the Museum staff who gave of their time and talents to make this book a reality. We gratefully acknowledge Anna K. Barnet, Katherine Campbell, John Carleton, Michele Derrick, Schorr Family Associate Research Scientist; Gail English, Kaeley Ferguson, Sean Halpert, Anne Havinga, Estrellita and Yousuf Karsh Senior Curator of Photographs; Kelly Hays, Jill Kennedy-Kernohan, Debra LaKind, James Leighton, Anne Levine, Alison Luxner, Annette Manick, Susan Marsh, Julia McCarthy, Terry McAweeney, Saravuth Neou, Katrina Newbury, Saundra B. Lane Associate Conservator; Richard Newman, Catherine O'Reilly, Kay Satomi, Jennifer Snodgrass, Hope Stockton, Benjamin Weiss, Director of Collections and Leonard A. Lauder Curator of Visual Culture; and John Woolf. Special thanks go to the former head of publications, Emiko K. Usui. We are also grateful to Claire and Richard Morse for their support of the Claire W. and Richard P. Morse Fellowship for Advanced Training in the Conservation of Works of Art on Paper.

For their assistance and support of our research, we are indebted to many individuals and institutions. We extend our warm thanks to Denise Gosé, Jae Guttierez, Rebecca Senf, Leslie Squyres, and Emily Weirich at the Center for Creative Photography, University of Arizona, Tucson; Lesley Martin at the Chicago History Museum; Ross Knapper, Zach Long, and Taina Meller at the George Eastman Museum, Rochester; Sarah Freeman, Mazie Harris, Art Kaplan, and Corey Mack at the J. Paul Getty Museum, Los Angeles; Adrienne Lundgren at the Library of Congress; Connie McCabe at the National Gallery of Art, Washington, D.C.; Sarah Oakman and Shannon Perich at the National Museum of American Art, Washington, D.C.; Jason Dibley and Toshi Koseki at the Museum of Fine Arts, Houston; Lisa Barro, Nora Kennedy, and Katie Sanderson at the Metropolitan Museum of Art; Lee Ann Daffner at the Museum of Modern Art; Matthew Kluk and Adam Ryan at the San Francisco Museum of Modern Art; Dan Kirby of Dan Kirby Analytical Services; Aniko Bezur and Paul Messier at Yale University; Diane Tafilowski and Mariah Azoti at Paul Messier LLC; and Patrick Ravines at University of Buffalo, The State University of New York. We also thank those who generously shared their knowledge and enthusiasm for all things platinum and early twentieth century: Mike Ware, Rob McElroy, Nicholas M. Graver, and Alice Cannon.

This publication would not have been possible without the groundbreaking scholarship of Amy Conger and Beth Gates Warren, or without the information generously shared with us by Weston researcher extraordinaire Paula Freedman, Paul Hertzmann, and Susan Herzig. Special thanks too to Michael Mattis and Judith Hochberg, Dennis Reed, and Stacey McCarroll. Generous support for this publication was provided by the Andrew W. Mellon Publications Fund.

Last but not least, we thank Greg Heins and Alex Brown for their unfailing humor and encouragement throughout this project.

KAREN E. HAAS
Lane Curator of Photographs
Museum of Fine Arts, Boston

MARGARET WESSLING
Former Claire W. and Richard P. Morse
Fellow for Advanced Training in
Conservation of Works of Art on Paper
Museum of Fine Arts, Boston

INDEX

BOSTON

MFA Publications
Museum of Fine Arts, Boston
465 Huntington Avenue
Boston, Massachusetts 02115
www.mfa.org/publications

Generous support for this publication
was provided by the Andrew W. Mellon
Publications Fund.

The Museum of Fine Arts, Boston,
is a nonprofit institution devoted to
the promotion and appreciation of the
creative arts. The Museum endeavors
to respect the copyrights of all authors
and creators in a manner consistent with
its nonprofit educational mission. If
you feel any material has been included
in this publication improperly, please
contact the Department of Rights and
Licensing at 617 267 9300, or by mail
at the above address.

While the objects in this publication
necessarily represent only a small
portion of the MFA's holdings, the
Museum is proud to be a leader within
the American museum community in
sharing the objects in its collection via
its website. Currently, information
about approximately 400,000 objects is
available to the public worldwide.
To learn more about the MFA's collec-
tions, including provenance, publica-
tion, and exhibition history, kindly visit
www.mfa.org/collections.

For a complete listing of MFA publica-
tions, please contact the publisher at the
above address, or call 617 369 3438.

All illustrations in this book were
photographed by the Imaging Studios,
Museum of Fine Arts, Boston, except
where otherwise noted.

Edited by Jennifer Snodgrass
Proofread by Dalia Geffen
Photography research and permissions
by Anne Levine
Designed by Susan Marsh
Production by Terry McAweeney
Typeset in Fournier by Matt Mayerchak
Printed on 150 gsm Mohawk Superfine
eggshell white
Printed and bound at Trifolio,
Verona, Italy

Distributed in the United States
of America and Canada by
ARTBOOK | D.A.P.
75 Broad Street, Suite 360
New York, New York 10004
www.artbook.com

Distributed outside the United States
of America and Canada by
Thames & Hudson, Ltd.
181A High Holborn
London WC1V 7QX
www.thamesandhudson.com

FIRST EDITION

Printed and bound in Italy
This book was printed on
acid-free paper.